Weekends with O'Keeffe

Weekends with
O'Keeffe

C. S. MERRILL

UNIVERSITY OF NEW MEXICO PRESS
ALBUQUERQUE

"Summer Morning Song" by Nanao Sakaki
was originally printed in *Break the Mirror*
by Blackberry Books, 1996.
Reprinted here with permission.

15 14 13 12 11 10 1 2 3 4 5 6

Library of Congress Cataloging-in-Publication Data

Merrill, C. S. (Carol S.)
Weekends with O'Keeffe / C. S. Merrill.
p. cm.
Includes index.
ISBN 978-0-8263-4928-6 (cloth : alk. paper)
1. O'Keeffe, Georgia, 1887–1986—Employees.
2. Merrill, C. S. (Carol S.)—Diaries.
I. O'Keeffe, Georgia, 1887–1986.
II. Title.
N6537.O39M47 2010
759.13—dc22
[B]
2010028694

Drawings provided by Katherine Chilton.
To contact the author e-mail her at: cmerrill@well.com.

[Contents]

[Acknowledgments]

The following people have made this volume possible.

A special thanks goes to Elizabeth Hadas, editor with the University of New Mexico Press, who has followed the progress of this book for decades. Her encouragement, her humorous perspective, and expert guidance have brought this dream to fruition.

Deep gratitude to Barbara Buhler Lynes for granting me a summer at the Research Center of the Georgia O'Keeffe Museum in order to transcribe the journals.

Paul Paletti encouraged me to write that very first letter, and his friendship, grand humor, and expert advice have guided this work for many years.

Jeff Radford has granted space, time, and good professional advice for many years. His patient friendship, absolute integrity, wide experience, and generosity with his time have made this book possible.

JB Bryan's La Alameda Press published my poems, some of which appear as chapter openings in this book, in *O'Keeffe: Days in a Life*, in 1995. I am grateful for his support.

Kathy Chilton rendered my pencil sketches into the beautiful drawings that are included in the book.

Extensive gratitude also to the following:

William Baker, Durwood Ball, Deb Bendler, Amon Carter Museum, Carol Connoboy, Elizabeth Ehrnst, Maya Elsner, Geary Hobson, Jan Cagle Hoke, John Howarth, Meredith Hughes, Tina Kachele, Agapita Judy Lopez, Manuelita Lovato, Mike Moffett, Suzann Owings, Joseph Rael, Elaine Smith, Eumie Stroukoff, Michael Weinberg, and Jim and Carla Wright.

[Introduction]

Miss O'Keeffe's first words to me at the gate in Abiquiu were, "May I help you?" Over the next seven years I was her librarian, secretary, cook, reader, nurse, and companion on weekends. She did, indeed, help me in many ways. I told her at the gate that I wrote a letter, and she had invited me. This is what I remember. What I wrote in my journal is somewhat different. That is the problem. How much of this book is true, really what happened, what was said?

For the most part, I wrote in the journal about Miss O'Keeffe within twenty-four hours of the experience. What I remembered later is in italics and parentheses.

I wrote a letter to Miss O'Keeffe in November 1972, and she invited me to visit her in Abiquiu. My letter to her simply said, "Dear Georgia O'Keeffe. . . . I want to meet you. I do not want to intrude upon your privacy—your solitude. I would like to see you, to be near you for just a few moments and learn if I have the strength and power to proceed in my work by witnessing your will. . . . I have nothing to offer you but myself and a need to see more fully. . . ." I sent a photo of myself at the typewriter at my desk in the Zimmerman General Library at the University of New Mexico. As an afterthought, I included my return address. She answered briefly with a simple invitation to come meet her.

I didn't answer immediately but kept her letter folded in my pocket or backpack for some time. Eventually, I showed it to a dear artistic friend, Paul Paletti, over a dinner of spaghetti. He scolded me strongly and admonished me to write an answer or call her immediately. He said that she seldom offered invitations like that. Everything I had to say to her at that time was in the letter. What could I say in person? However, I made the appointment and, for the most part, never regretted that I did. She said I could visit her for one hour on the morning of August 12, 1973, a Sunday.

This volume would be different if I had begun my journal entries about Miss O'Keeffe with the intention of doing a book and asking all the right questions. Instead, it was part of my personal record of experiences to re-read and re-live someday, with the most salient moments meant to re-stimulate a reverie of what went on in her world. Initially, there was no focused intention to share. As time went on, it seemed some things she shared might be of some use to artists, historians, women of the future.

Because she was going blind with macular degeneration, her vision was limited to peripheral impressions. Often she asked me to describe what was around as we walked a mile a day. Consequently, Miss O'Keeffe helped me find my own voice in poetry as I made vivid in words the beauty of the world around her, the shape of a cloud, a tree, a rock, a sunset, a rainbow. She taught me to look, really look at things to tell her more about them better. Once at Echo Amphitheatre she spoke strongly, "Look at that tree. Really look."

She said a doctor once told her to walk a mile a day to add a decade to her life. So we did that, sometimes twice a day on the dirt roads of the Ghost Ranch or round and round the driveway at her Abiquiu house. She lined up small rocks for the number of times around to add up to a mile. She moved a rock to one side to mark each time we went around the drive. Many of our talks occurred on these walks or lingering over a meal since the first three years of weekends consisted of eight hours

a day hard work listing or roughly cataloging the shelves and boxes of books in her library. That was my job at first, to take care of the book room.

With Miss O'Keeffe at my side, I made my first soufflé. She said, "Never mind if it doesn't rise, we will call it a timbale and never let on that we intended it any other way."

Miss O'Keeffe showed me how to make simple fresh food my medicine. Over and over, we read health food articles and books such as Adelle Davis's *Let's Eat Right to Keep Fit*. She gifted me with an appreciation for herbs and teas. Every night we had a hot pot of orange blossom tea. The ritual of swathing her arthritic parts in soft wool and heating pads showed me the art of being an elder.

Another book she wanted to hear repeatedly was the Taoist volume entitled, *The Secret of the Golden Flower*. When I objected to reading a text that made women sound inferior, she said, "Never mind, that's just the boys."

One of my favorite moments was when Miss O'Keeffe was listening to the Orchestre de Chambre Jean-François Paillard playing Pachelbel's Canon as she arranged and rearranged five smooth dark stones on her white plywood table.

I will never forget the hushed moments of assisting her at the easel one time, arranging her palette, blending colors, and cleaning up afterwards. She had to see the painting with her peripheral vision. Her table, her brushes, the small porcelain dishes with color on a white table covered with a white Hopi cloth with long fringes seemed so formal, almost an altar. She declared strongly that I was not a painter, that she could not trust me to tear into it as I should. I reminded her that I had told her I was a poet and not a painter. I did my best, but that was the only time I joined her at the easel.

Another favorite story was when she described how it was to stretch a canvas for her huge twenty-four-foot cloud painting with the help of the old sheepherder Frank who set the grommets and helped her redo it when it wasn't right. She liked to

reminisce about walking at the Ghost Ranch and seeing a piece of the sky (her huge painting) coming out of the garage.

She had much to share from her long life. I seldom asked direct questions but waited for her uninterrupted thoughts. Once Miss O'Keeffe surprised me when she opened a drawer of her desk to show me a print by Stieglitz of her naked when she was young and in love. She was in the process of selecting photos for a book or a show. She said to me, "Look what you come to if you let yourself be photographed like this."

During the first days I was working in her book room, one member of the household advised me that if I wanted to last there, I must consider it like a medieval court and keep a very formal relationship with Miss O'Keeffe. Consequently, I could never call her a close friend though we had many friendly moments of confidential sharing and laughing over the intrigues of the household or the gossip from the University of New Mexico where I worked or occasionally the dramas in our respective lives. I read her some of my poetry, but she didn't care for poetry in general, so there was never a meeting of minds over verse.

She surprised me when she said her early years were the best of her career because she was surrounded by people who didn't care. She was free. Young artists she tried to help didn't understand about her free years. Miss O'Keeffe spoke to me in my free years in my twenties, and she in her eighties and nineties.

Casa del Sol
Ghost Ranch, New Mexico
May 2009

The roofless room with vigas and screen
two gigantic jade trees in pots.
Against the far wall a slight niche
with a huge black rock there
On the whole white wall, a slight shadow
and that rock. O'Keeffe's sight so poor
she doesn't see it, but knows it's there.
Also one moonflower plant blooming wide open
and onions drying on screens, fragrance of earth.

<div align="right">

August 1973
C. S. Merrill
O'Keeffe, Days in a Life

</div>

[1973]

1

August 12, 1973, Sunday night, very late

—First visit with Georgia O'Keeffe

I have a very tired body after too much driving, but my spirit is happy. I told my parents that they would never ever see me any happier. Today, after staying overnight at the Lawrence Ranch, I drove to Abiquiu to keep my appointment with Georgia O'Keeffe. I must record my first impressions in utmost detail. Because of my weariness I will tape my memory and transcribe later. I do this recording of the meeting out of responsibility to women in the future who must know what a strong, great lady Miss O'Keeffe is. Miss O'Keeffe has asked me to return next weekend to put her library in order. That will be quite an enormous chore. So there will be more. Because my eyes burn after much driving, I resort to my Panasonic tape recorder now, not out of disloyalty to Miss O'Keeffe's privacy, rather out of affection for the freer ladies of the future who may need a toughening influence from this great lady. But I promise that I shall never betray any confidence the lady places in my hands as a secret, should I be worthy of such trust.

—Transcription of the tape:

The sounds in the background of this tape are cars speeding out on Lead Avenue. There may be an occasional cat meow, so the tape will be far from perfect, but it's meant as a record to key my memory so that I can transcribe from it later. This has been one of the most important events of my life. Today, August 12, after leaving my parents in Taos, I drove down to Abiquiu and visited Georgia O'Keeffe. The instructions were to go to her house, honk once, and someone would answer at the gate. I arrived in Abiquiu one hour early just to make sure I could find the place, parked a ways down the road from her house and walked around the village for a while to get my bearings and to relax from the hot driving. It was a Sunday morning. There were Spanish voices in the adobe houses. In a big square, some fellows were leaning against a fence talking. There was a girl running across the square. There was a group of men picking apricots off the overloaded apricot tree. There were smells of breakfast. A man was shouting at his child, and then the child was crying when he got hit. Soft gravel was underfoot. It was a rather cloudy morning, but very warm, and I remember hearing a stream flowing past. As I walked, no one seemed to question my presence. No one seemed to slow down. And I felt quite comfortable in this little hillside town with beautiful ridges and mountains around. Red cliffs and grey cliffs were etched with white, and there were clouds, lumpy bumpy ones like Miss O'Keeffe paints in the book I have of hers. I was very edgy and eager but knew that I must be polite and wait until the appointment was to begin. So at ten o'clock I walked back toward the car and sat. As I was sitting, I noticed a little boy who I had seen earlier walking down the street with an air rifle back on the O'Keeffe grounds. And then I heard the squawk of a bird, flopping around on the ground with a lot of noise. A black cat came out of the bushes and pounced on the bird, and there was no more noise. One of the most enduring symbols

of my life has been around unhappy occasions; there seems to be the omen of a dead bird, but usually an already killed bird. I decided that this was not a very good thing to be happening three or four minutes from the moment before I go into her house, but I steeled my courage, ready for a disappointment, ready to meet a senile old woman, ready to meet an angry witch, ready to meet a real let-down, ready to be supported only by her paintings, not by the personality that would be behind the work. I drove into the parking area up to the locked gate with a sign that said, "Beware of the dog." It was a round drive outside of the locked gate. Covered with loose gravel, it looked as if it would accommodate many cars. There was a kind of cliff-like effect looking out over a vast space from this hillside over orchards, green valley, pasture, horses, and then red barren cliffs again, the blue sky and the white clouds. No one answered at the gate even though I honked. So I stopped the motor, put on the brake and waited. I opened the car door and saw a form moving from the bushes over at another gate. It was O'Keeffe. I could tell from the recent pictures that I had seen of her. She was wearing a loose-fitting white gown which was really just a billowing white dress made of a satin-like material that looked like stripes of satin ribbon interlaced with stripes of just plain cotton. She had a blue shiny shawl around her shoulders, and she looked quite frail, but curious about who was honking. So I stood and closed the car door, oblivious of leaving the key in the ignition and the door unlocked, all of the things in the car, just walking to see the great lady who I had wondered about for so long. She stood there, and as I walked toward her, she made a startled movement like she was just a little frightened. She moved toward the gate and I stopped, as if to say that I meant her no harm. I didn't mean to rush her; I didn't mean to surprise her, and she gestured impatiently, "Come on." I walked up to her, and extended my hand, and introduced myself, and she inquired if I had someone else with me, and I said, "No."

She said, "Are you the one who wrote?"

And I said, "Yes."

And she said, "Well, don't you have your husband and two children?"

And I said, "Well, I'm someone else who wrote."

She smiled and took me inside the little plaza inside the door, and we walked across the plaza which was enclosed on all four sides with hallways leading off, and the roof was the sky and the plant inside was a sagebrush. It was like being still outside but quite protected. And we walked to one of the doors straight ahead along the flat stones set in the ground, bricks set in the ground, and the door was covered with slatted bamboo shades. She couldn't find the doorknob too well, and I recognized the fact that she couldn't see so well, so I helped her open the door and we walked inside to a very cool, spacious room, a long room. At one end of the room was a window looking out on a salt cedar tree. She asked me to raise the blind a little more and bid me not to stand on the rocks that were in the window. There were many smooth rocks, some large, some small, all smooth-edged different colored rocks. So I stood on the edge of her sofa and lifted her shade. It was just down about a foot. The window went from maybe a foot off the ground clear to the ceiling, which was maybe twelve feet. She had me sit in a chair next to some lilies, which smelled very sweet. She sat next to the window and asked who I was, where I worked, and where I had grown up. In the meantime I noticed the sweet smell of the lilies, and she asked me how many were blooming.

I said, "Four, and one is opening."

She said, "That's funny. There were five full blooms yesterday."

Later when I stood up, I saw that there were five blooms and one other one was opening. They were white lilies with pink dots on them, very tall, about six feet tall, twining up out of a small pot.

She had a phone call, and while she was gone, I was walking up and down the long room getting the feel of the place,

looking at the African violet and the huge pine cone on the glass table. It was one huge slab of glass on a stump. It is surprising how much I didn't see while I was there though my eyes were moving at all times. I walked back toward the dining room, and a lady came out of the kitchen. She gestured me in. She was wearing white, and she had curly hair and was obviously Spanish and couldn't speak much English. I thought she must be from the village, and she was showing me how she was making apple pie. Miss O'Keeffe walked back into the dining room. She seemed startled not to find me in the chair where I had been sitting. I didn't know how long she would be on the phone. I went back to the chair and we talked more then.

And she's very graceful, the lady, Miss O'Keeffe. All the wrinkles on her face merely make her more expressive to my mind. She was very interested in the fact that I work in a library and said that she had a lot of books but that I probably wouldn't want to look at them because I spend all of my week with books, and this was probably a vacation.

I said, "Well, I enjoy books, and I would be very happy to see them."

She thought at first that I might be a librarian, and I explained that I was a secretary at the university library. She took me back out onto the open plaza. I looked more closely at her living room a little later when I was invited to lunch. We went out onto the plaza, back down to the door where it went outside, and I noticed to the left was a huge skull with antlers, a big elk skull hanging on the wall. And underneath it was a big blue pan with some rocks, and there were more rocks on this sitting place, the banco made of adobe. To the right there was a door, a screen door, and inside the screen door, another door, a black door. She had forgotten her keys so I went back for them, this time through another door, which was more to the right of the door that led to the living room and went into the dining room. On the corner of the table was a brass key ring. The table was made of plywood. Walls everywhere were adobe, smooth

and beautiful. I saw another plaza in front of me as I walked into the dining room. But I took the keys and went quickly back to Miss O'Keeffe across the little courtyard with the sagebrush. She opened the door into her library, or book storage room I would call it. There I was met with a single window and shelves and shelves of books.

She looked at me with a half smile and said, "It's really hopeless, isn't it?"

I said, "Well, you may need more shelves."

There were crates of books and boxes of books; books stacked upon books on some structure in the center. I believe it was a table. When we looked around, she showed me her collection of books from Mexico. Poetry books weren't very high up on the shelves because she said with a laugh, looking at me, that she didn't like poetry, that she couldn't understand it. And she has the *Time-Life* series of travel books and interesting books on animals and places. She has a set of books on cooking: Scandinavian cooking, New England cooking, and Southern cooking. She has numerous art books, though she said most of her art books had been given away to Fisk for a song because she got really tired of them when she moved here. She showed me a box of her correspondence. She kept a typed list of whatever was in each box, and she needs to be able to find books when she wants them. I noticed later in her living room there was a very powerful reading lamp and a magnifying glass and a case. So apparently she does some reading, but not without difficulty. I'm sure that she has trouble finding the books so she needs assistance. She told me that she needs assistance in placing the books in some order so that she can find them when she wants a cookbook or when she wants a book on herbs, on gardening, or on Mexico. She wants all of her books on Mexico all together. I told her I would like to help her, but I would have to think about it. I'd have to look things over. Of course, I'm trembling with delight all this time that there is actually something that I can do besides just ask her questions. It's one reason I

came to ask if there was any way I could assist her because I admire her art, her work, her life, her being.

This taping is going to take much, much work, because I can remember details of the things that I saw, but they will be difficult to describe. Perhaps later when I am transcribing, they will come out more clearly in words as I am writing.

To speak is so very different from writing. The woman looks very thin but very vital. She hears well. Her eyes, one eye is different from the other. The left one seems more open than the right one. The right one seems squinted down. She expresses herself with her hands very well. There's something about the delicacy of her fingers and her gestures that is really quite taking, quite entrancing. She did notice some things about my movements, though. I think she saw my grosser movements, not my finer ones, because I think she cannot see so much. She left me in the library because two ladies came to the door. One was a grey-haired woman who looked about the same age as Miss O'Keeffe, saying, "Georgia! Georgia!" This was apparently the lady who she had been expecting along with another woman. They proceeded on toward the living room. She said that I should stay in the library if I wanted. I was really pleased at that, because I wasn't ready for any more company at the moment. I'd been waiting so long for this meeting that I must confess I was not completely with all my wits. I was so astonished at her presence. She does have a presence. She is very conscious. Yes, there's a consciousness about the woman.

In her library I found Hokusai, books of short stories, biographies, quite a miscellany of things. They remained in really very poor order, but she has two or three shelves of books about India. She has one huge shelf of *Camera Work*. She had one large book by Stieglitz still wrapped in plastic, looked like leather, something about *Sun Pictures* or *Sun*. There was a poster of hers, carefully covered, the pink and blue arches (*Music—Pink and Blue No. 1, 1918*). The place was rather dusty. I felt extremely dusty after leaving a little later, but I was there about a half hour

to forty-five minutes, looking, getting acquainted with the lady through her taste in literature. I looked through the little book of prints by Hokusai. I enjoy Hokusai's views of Fuji so much that I was completely entranced. On another shelf containing books about Japan, I found the Gardens of Kyoto. I found that really pacifying, and saw remarkable similarities to some lines in her paintings in some of the lines in the gardens. I said to her later that her collection of books was very remarkable because there were some things there that I had never seen.

She said, "Oh truly it was remarkable, but I don't know where anything is. It was all mixed up."

I asked her if she wanted them in Library of Congress order or if she wanted them by author alphabetically. She said a friend, a male friend of hers, had alphabetized them by author at one time, but they had gotten mixed up mostly. Some of them were still in that order. In the meantime, she had an appraiser come who had turned some of the books on their sides. Also she had four or five stacks of books she was giving to a private school in Española that she needed a list made of so that she would know what she was losing or getting rid of. I could see I really had my work cut out for me.

And she said, "You know if I had you working here, I think you're so interested in the books, I would find you in here reading instead of working."

I said, "That's an occupational hazard of librarians."

She seemed to enjoy that. But after I sat in her library for a while, I found that it was very warm. There was a kaleidoscope in there too, and it was very pretty. There was a little woven basket-type thing with feathers hanging, very small, like something you might hang from a Christmas tree, and there was an abalone shell filled with marbles, and a basket, an Indian basket with holes in it, and an Indian pot with holes punched in it. It was obviously made for a strainer or something like that. There was one single light in the whole library, and it was right in the middle. The place is heated by a gas heater which is on the wall

next to the door. The window is covered by a simple white muslin curtain, with white shelves around, irregular shelves too. They had their own designs, some extending out a little over space. Everything in her house has a flair, a feeling as if thought has gone into the placement of a rock in a niche on the wall. After I got tired of sitting in the library for so long without her returning, I decided I should wait while they were talking in the living room. I decided to go to the other room I was acquainted with which would be cooler, the dining room.

There by the kitchen door I sat at a chair which was against the wall so that I could look through the wide doorway and see Miss O'Keeffe sitting next to the window behind a small topiary tree, and I could watch her gestures as she talked and the way she crossed her legs with the right foot slightly under the left one extended, wearing white shoes, comfortable like a nurse's shoes. Once while talking to the two women visiting, she picked up a black rock from the window and fingered it and then held it in her palm as if it was a hand-warmer; then she placed it back carefully in the same place where she had picked it up. She was graciously entertaining them. They were talking about old times. They obviously had known each other, at least she and one of the ladies. As I was sitting there, I could look up on the wall and see one of her original paintings. It brought tears to my eyes because I could see there was much more in the painting than there ever was in any print that I had seen of it. It was the blue and pink arches (*Music—Pink and Blue No. 1, 1918*), and it hung without a frame against the brown adobe, simply the only thing hanging on all of the walls in the small dining room. The dining table was two pieces of plywood painted some sort of milky color with a glaze over the top, and I could see the grain of wood quite clearly. It was just almost opaque. Then under that were four pieces of plywood which I will draw a sketch of in my journal that way it was set; it was a very clever design for a table with two pieces of plywood, hinged pieces of plywood holding up the table. (*Later I found out that this was O'Keeffe's design*

for a table that could be placed flat against a wall when one didn't want a table. The legs were pieces of plywood hinged like books to support the top which was cut in the middle lengthwise.)

While I was eavesdropping on Miss O'Keeffe and the two ladies, I remember she commented on Ansel Adams and how he seems to be gaining weight lately. She also commented on how motherly and kind his wife Virginia is. She said that Virginia, while the children were growing, would stay at a camera shop owned by her father in Yosemite while Ansel would go out on his travels. As soon as the children were grown and into college, she told him that she would either go with him on his travels or she would go alone. So that's when they began traveling together. I thought that was humorous. Miss O'Keeffe and one lady seemed to have a lot of acquaintances in common whose names I didn't recognize. They were just discussing things like people discuss when they've lived on the range for a while. They were talking about an old Indian woman who lives down by a river, by a railroad track, I think, in Santa Fe. She repairs Navajo rugs. I gathered that one woman had given Miss O'Keeffe a rug at one time, and they were reminiscing a good deal. Miss O'Keeffe would sometimes lean forward and talk and listen and interrogate and sometimes sit back and gesture with her hands. She seems to use her second and third fingers in gesturing a lot. That seemed unusual to me. Her fingers are quite long and very expressive. While I was sitting there in the living room watching her through a big doorway and listening to the other two ladies talk, they started talking about the Lawrences, D. H. and Frieda.

Miss O'Keeffe said, "Angelino was their caretaker who came from Italy. Angelino had married an Indian woman, and he had left his wife. They had separated in Italy, and he had come here to serve Frieda and D. H."

I don't know the whole story behind that, but at any rate Miss O'Keeffe knew them well enough that Angelino asked her, when he went back to Italy for a short time, to pay his $35/month child support. She was paying his alimony. She said

she sat in Taos by the river right by where the Indian women would come down to get their water in the morning right after sunrise and then in the evening about four or five o'clock. She was painting, and she would spend quite a good deal of time there anyway. But she was observing the women, trying to decide which one was Angie's wife. After several days of observing, she decided that the woman who had the better clothing must be the woman because she was getting the $35 a month, and that's a lot of money. So one day she met the woman and asked her if she was Angie's wife, or what her name was, and she said her name was the right one, and it turned out sure enough she was his wife. Miss O'Keeffe guessed right. She was really delighted.

Of the two ladies, later I found out one was Mrs. Waite Smith, and one was Mrs. Cozy McSparron, an old friend who was married to a man who had a trading post and an inn at Chinle, Arizona. It was a lodge which is still open now, but it has a new name. It was a trading post for the Navajo and a place for the white people on their way to Canyon de Chelly. O'Keeffe had stayed there a number of times on her trips there. So they were really good friends. They were reminiscing about old rugs and gifts and people and food and all the things that people talk about. It was really nice just to be eavesdropping. I felt kind of nosey, but I didn't know what to do because I didn't want to leave because that would have been impolite, but I didn't want to walk in on their conversation because they were obviously friends, so I just thought to sit quietly in the cool room and stare at her paintings while I was watching her and listening, trying to drink in as many details in the room as I possibly could.

She didn't have many paintings around. There was one other painting, a plain one, in the living room. It was blue and white. That was just about it. There were shades, gradations within the white and the blue. I couldn't figure out what it was. It looked like a sort of horizon of a really white plain; or just blue and white, just a color study (*Yellow Horizon and Clouds, 1963*). She had a lot of records on one shelf like Beethoven,

Mozart, Chopin, a lot of classical music. It looked like she had a pretty good turntable. I didn't see what it was, but I'm sure she listens to that a lot because her hearing is quite good. In the dining room there was a rigged up light that you could pull down from the ceiling. I'd never seen anything like it. It was way high against the ceiling, far out of reach, but it could be pulled, I'm very sure, way down to the table for close work of some kind. Everything there looked very utilitarian, but it was exquisite. Everything was very beautiful. While I sat there, I looked to my right, and when the conversation got either too low for me to hear or about some people that I didn't even know, my attention sort of veered around, and out to the right was a plaza. It was covered with screen. And so I walked out there. (*Later I learned this was called the roofless room.*) There was a moonflower vine growing out in this plaza, and there were vigas across the ceiling area and then a screen over that. They were drying onions out there. And on the open plaza there was the large sagebrush; they were drying apricots out there. They had all these screens and wooden frames, and the apricots were cut into quarters, and they were shriveling up in the sun. Flies would land on them, but they looked so beautiful, these little orange slices out in the middle of all this brown with the sagebrush. Everywhere I looked it was a visual feast. Out on the plaza of the roofless room there were three gigantic jade trees. That is all I can say to describe them. These pots were about a foot across, and the trunks were maybe about half that. They just spilled over. There was one on either side of the wooden doors that led out to the plaza. Obviously people lived there who loved plants. I could tell. There was a spirit to the house. When I heard the ladies talking inside, O'Keeffe said something like, "There was an old man once, and he never spent much time in his house. He was always traveling.

"He said, 'I wish I had a house like yours.'

"Well, a house has to be lived in, in order to live," she said. "If a house isn't lived in, it dies."

Her house is very alive, but it's very simple. It's extremely simple, pared down to its barest necessity. Everywhere you look there's something beautiful. Out on this plaza against the far wall when you walk out onto it, there are the slats of the sun through the vigas onto this concrete floor. There is just a niche in the adobe on the opposite side, and it goes back about six inches. It curves back in, and there is this one huge black rock. That's all. That is the whole wall. There is this niche with a slight shadow and this black rock. Her sight is so poor I'm sure she doesn't see it, but I know she knows it's there. And there's this little window that looks out onto her garden where I could see this tall corn and all kinds of lush vegetation. In this window there are two pots of ivy, which are just starting. With the young ivy and the old, old jade, there is a great continuity of stuff going on there. There were onions drying, too. Well, I guess it was just that moonflower vine that took up a lot of space in there, and the trumpet flowers were blooming. Then I went back inside. It was hot out there. I went back into the cool room.

The walls of this house are very thick. She was telling them about when she had bought it about thirty years ago. The vigas were falling out of the ceiling, and it was really just a wreck. It's been a very slow process, but she has built it up. It was during the war when she first got the house. She said she first moved to the country about forty years ago. She was living around Ghost Ranch. She bought the place at Abiquiu thirty years ago. She couldn't get nails. Somebody back in New York was trying to figure out something to send her as a gift. She was trying to piece this house back together, and so she wrote back, "Please send me a keg of nails." They were trying to think of something really beautiful to send. Because I was too far away to hear, I couldn't catch who that was who was sending her a gift, but it didn't matter. It was a good story. They were comparing notes about Canyon de Chelly and how things have changed.

At about this time the door to the kitchen opened, which was to my right as I was sitting against the wall looking at

her picture and at her and listening to their talk. This woman walked out. She was a tall, thin woman with short grey hair who looked like O'Keeffe somewhat. But there was a flatter look about her which made her seem different. She had a bright red shirt on and some pants. She looked at me and seemed really surprised. She didn't say anything but gave me a kind of look that questioned, "What are you doing here?"

I said, "Hello, I'm Carol."

She said, "I'm Claudia O'Keeffe."

I said, "You must be her sister."

She said, "Yes. Well, are you waiting? Did you have an appointment?"

"Yes."

"Ah, you were late," she said.

"No, I was ten minutes early."

She said, "Well, why are you out here?"

I answered, "Well, I was looking around in her library, and apparently some people have come, and I didn't want to interrupt them."

Claudia looked at me with a puzzled expression then walked clear down to where O'Keeffe was and excused herself and said, "There's somebody else here."

Miss O'Keeffe said, "Oh, I'd forgotten all about her. Is she still in the library?" She thought all this time that I was out in the library for about an hour and a half.

Claudia replied, "No, she's sitting in the dining room."

I think Miss O'Keeffe got up, and Claudia disappeared somewhere in the big room. Miss O'Keeffe said, "Is lunch about ready?"

Claudia said to Miss O'Keeffe, "Lunch is about ready."

Miss O'Keeffe said, "We'll have to invite her to lunch, then."

My heart went clear to my throat, and I thought, "Wonderful." Claudia came in where I was and didn't invite me to lunch, but just said, "Why don't you go on in there?"

Miss O'Keeffe got up and introduced me to both of the ladies. The ladies were obviously accustomed to being recognized by name. I said, "How do you do? How do you do?" and sat down. Then I was quiet, and nobody said anything. I thought, "Obviously, I'm the low person here, and I'm supposed to say something praiseworthy," but I didn't know them. One was Mrs. Waite Smith, and I've heard her name, but I don't know who she was. The other one was Mrs. Cozy McSparron. Both of these ladies are living north of Phoenix about 116 miles away in a little village surrounded by all kinds of ghost towns. They are really remote. They're close friends.

Miss O'Keeffe broke the ice, bless her heart, and said something like, "We knew each other back when she had a place in Chinle, and I would go through Gallup and out to see Canyon de Chelly. Mrs. McSparron would feed me home-cooked meals. We became very good friends. We have a lot of friends in common."

So I said, "Oh, you must have a lot of stories to tell. You've had all kinds of adventures."

She said, "Oh, you bet." This was from a very proud, very large woman dressed in a blue suit. She was quite nice. I thought she was very wealthy because they were talking earlier about all of the baskets and things that she had collected over the years that had tripled, quadrupled and really increased in value. She has a house lined in Indian baskets, beautiful ones, and rugs everywhere you look. She has a change of rug for every season. It was really delightful. She changes her rugs like she changes her clothes. She was very likeable.

So I said, "Oh, well, you must have given Miss O'Keeffe this rug." There was a rug on the floor. It was a double-weave diagonal type design.

"No, as a matter of fact, I didn't." They started discussing weaves of rugs so all of a sudden I was off the spot much to my relief. Mrs. Smith was just sitting there quietly enjoying both

of the ladies reminiscing. She was obviously not there to participate but more just to enjoy. I have discovered that there is a passive way of participating. You can listen very attentively, and you're participating. You don't always have to be saying things. They were talking about events I couldn't relate to because it was so far in the past, and there is so much that I just don't know. Claudia rang a bell at the table, and the Spanish lady was out there, and she had just finished cooking. Things were being spread out.

Claudia said, "Lunch is served," and waved to us all.

They got up and headed into the dining room, but I paused because Claudia hadn't invited me to lunch. I thought maybe there was something I should be cautious about. Maybe there isn't enough food, or maybe they hadn't planned, or who knows? Maybe I offended her. Who knows what has happened?

Miss O'Keeffe came over to me and said, "You're staying for lunch, aren't you? Claudia invited you didn't she?"

I said, "Well, no."

She said, "Well, stay."

There was another chair and another plate set, so I was welcome. It was OK. We sat down. I was to Claudia's left and Cozy's wife, Mrs. McSparron, was next to her. I love her husband's name. Cozy was raised in Navajo country. He was just entirely from this country. Mrs. Smith was to my left, and Miss O'Keeffe was at the other end. Claudia served everything. We had beef, and two kinds of fresh sweet squash straight from the garden. I had seen, while I was sitting there, the Spanish lady walk by the door carrying a full bucket of squash. She had just picked them, cooked them, and put them out on the table, so they were really fresh. The squash was cooked heavily in butter, and they had thinly sliced carrots cooked in butter and dill. Everything was so sweet and so good and so perfect. The vegetables were still alive. So I stuck to my strict vegetarian diet even though the meat did smell good, and Claudia couldn't believe that I wasn't eating their meat. She kept pushing the squash at me.

"Have more; you have to eat more." She was really taking care of me. She would make sure that everything was just right, you know, that all of the spoons, glasses, and everything were in place. The drink was fresh raspberry juice mixed with mint tea over crushed ice with a sprig of fresh mint on top. Claudia said that Miss O'Keeffe usually included currant juice with the fresh raspberries. Perfect, everything was just perfect, completely plain. The plates were cream-colored. The glasses were plain with no design. There was absolutely nothing fancy about the table or anything. There was a place mat, a dish, knives, forks, and spoons. There was no design on the spoons or forks.

They asked who I was and where I was from. Claudia announced that I had brought gifts of apricots and plums. On the way down from Taos I had stopped to pick up fruit for her.

Miss O'Keeffe said, "Well, the plums are very welcome, but I'm afraid we have an excess of apricots here."

We had such a good time talking. We must have eaten for an hour. There wasn't that much food, but there was so much going on. I tried to piece together the conversation, but it didn't follow any general flow. Mrs. Smith and I were mostly listening, though occasionally when it seemed appropriate, I would add something. They were reminiscing so much it was fine to listen. Besides, I know I couldn't have said that many meaningful things to Miss O'Keeffe. Her friend was able to relate closely to her, and they were laughing and reminiscing. It was really healthy.

I was very pleased to see her in such a good mood. I had heard such stories of her temper. She was really nice, a very thoughtful hostess.

"Is everyone all right? Do you have enough squash?" Miss O'Keeffe was passing things around.

They reminisced about one woman who had a home in Los Luceros, which is between Española and Taos. Her name was Mary Wheelwright. Her house is up for sale now. So I take it she isn't living out here now, or she is possibly dead. She had a yacht that she sailed up and down the coast in the East, and

Miss O'Keeffe said she had a house in the East, and around this house was a real beautiful beach that Miss O'Keeffe had never visited herself. One day when she saw some beautiful rocks in Mary's house, Miss O'Keeffe said, "Where did you get these rocks?" Mary always had a habit of picking up rocks wherever she went, if she liked the place, and carrying them around and putting them in her purse.

Mary Wheelwright told Miss O'Keeffe, "Well, these are from my home in New England."

And Miss O'Keeffe said, "Well, how come you never sent me any of those?"

Mary Wheelwright had replied, "You never deserved them." Apparently, they had a bantering kind of affectionate relationship.

Mrs. McSparron agreed that Mary was a character of that ilk. Her house was two stories. She had two hundred acres of fruit around it. That was her house. It was not too far away. They probably did things together. Miss O'Keeffe had a coat of hers, a coat that had belonged to her that came down to the calves of her legs. She put this on after the lunch. The coat was white silk, and it was a very heavy woven silk, kind of double or triple weight. The collar was mandarin style, but it fell back from her neck, and it had buttons all down the front. It had really low sloppy pockets.

When she stood there, this was a moment that I really had great affection for her because she was standing in this large dress, and she had this bulky full coat on her which fit her, really perfectly full, maybe from the thirties. She was standing, and I could only probably describe it by standing in a comparable way, but my body is bigger than hers, so it won't give the feeling. Her palms were out, and she was just open. There was something about the way she was standing that was very vulnerable. I got the feeling that she was standing in a very sensitive position as if she was open to all kinds of experience, pleasant and unpleasant. I got this feeling like that. And there were times when I

remember sitting at the table, when I felt she was looking at me, but she wasn't using her eyes. It was really strange. I can't describe it except that while we were sitting at the table, I would look at her face sometimes, and she would be eating or looking down. She handled her utensils very well for not being able to see very well. She's very graceful. Miss O'Keeffe is graceful even if she's fumbling for doorknobs or something. She didn't stumble around the house. She knows that house very well. So she has no trouble with that. I think she can see gross things. I don't think she can see detail. She couldn't tell across the table that I had cheese at one time. At the end of the meal we had a delicious apple pie. After that we had a big plateful of apricots and a big plateful of apples. We each had our little dishes, and we were passing around cheese also. She had the cutting board with this slab of cheese, and she was offering me some cheese, and I held mine up, forgetting for an instant that she couldn't see. Then I explained, "Well I have some. Thank you." Somebody else was talking at that time so she was still offering me cheese. It was a very awkward moment. She couldn't see what I was holding. It was about four inches long and about one half to one quarter inch thick. So she couldn't see that across the table. She could probably see my gesture, but she couldn't pick out that detail. It made me feel wretched after awhile when I realized that she couldn't see. After I left, I was near to tears when I realized what a loss that is for someone who is so visually oriented. But she's quite noble, and she never says anything about it. She never did while I was there. It was just quite obvious.

In the center of the table there was a bowl, a clear bowl, and it had about two inches of water and there were Hibiscus flowers floating in it. There were three brilliant pink Hibiscus flowers, large ones which were the size of my hand. There was also floating a kind of fern-like leaf. The lady across from me, Mrs. McSparron, picked up one and smelled, "Ah, tansy."

Miss O'Keeffe said, "Yes, you've made tea out of that. It is very good for a miscarriage. It will cause you to miscarry."

Claudia said, "I think they used to make a women's potion for that including tansy." Claudia had trouble hearing the word *tansy*. I had to say it several times to her before she could completely repeat it. That seemed sort of strange. Otherwise, she could hear perfectly well. It just seemed she was having trouble with that one word.

Miss O'Keeffe kept reiterating that tansy had some other properties. She said this about three times, "I'm sure that tansy has some effect other than miscarriage on the female parts." The way that she said it among us, five women sitting there, there was created a strange sort of unity, anatomical unity. I can't explain it except that when women begin to talk about those things, and we're eating together and really enjoying the food, there's a kind of bond. It just seemed like an intimate kind of lunch, and I felt terribly privileged to be in the midst of all this laughing and chuckling and carrying on and talking about herb teas. A little bit later I found out that Miss O'Keeffe and I really enjoy tea. We have that in common. We both like cream in our tea as well. She doesn't like to drink coffee, and Claudia is really a coffee drinker.

Claudia was an interesting person sitting there. She was very quiet most of the time. Occasionally she would say something about the plants or what we were eating, or "The young squash are very good," or "Will you have more food?" Miss O'Keeffe, of course, dominated the whole scene, and everyone always looked to her during the talking. I began to feel that Claudia could perhaps have something to say. Miss O'Keeffe and Mrs. McSparron were talking about things that had happened between them, and I felt rather like I was intruding to be always listening to them. So I began chatting with Claudia a little bit. I found that the table we were eating on, that I described a little earlier, Miss O'Keeffe had brought that out from New York. If she had made it or had it made, that occurred in New York, and she brought it out; just miscellaneous things here and there. I found out from Claudia that the lady who cooked was from

Cuba, not a Spanish-American lady from Abiquiu. She had worked for the O'Keeffe family for seventy-three years. She worked first for Miss O'Keeffe's brother, and now for eight years she's worked for Claudia in Pasadena, California. Claudia said her home is in Pasadena, but she seems to find herself living in Abiquiu, New Mexico. Everyone was really chuckling about that. It was beyond her power. She just found herself there, and she's taking care of the garden. She's been there eighteen months. I gathered that she missed the California scene. She said later that the garden was her pet. She had a lot to do there. Miss O'Keeffe spends all of the week at Ghost Ranch and then Sunday and Monday or Saturday and Sunday at Abiquiu. Claudia said that she, herself, is the city girl. She stays at Abiquiu. City girl; 250 people in Abiquiu, and she calls it the city. She laughed at that. Miss O'Keeffe is the country girl.

Miss O'Keeffe said that Claudia doesn't like the ranch. Claudia contradicted her and said, "Oh, I like it there, but I prefer it here. I like it here. I like this house very much." There's a tenderness between them.

We just kept staying and staying. I thought, "Are we just going to stay?" We had already refused coffee. So finally, the Cuban lady fixed coffee for us and brought it out, and we had little fine white tiny china cups that had a rice pattern on them. I have seen those with grains embedded in them when they are fired so you can see through the sides with little rice grain shapes. The coffee was very good, and we had mints with the coffee. That was a nice touch, and Feta was walking around passing out the mints. By that time we had all gotten up and received big sacks of apples and apricots. I had brought a few apricots, and they sent me back with more fruit than I had brought, enough to make an entire pie. We were all sitting there with our sacks of apples, drinking our coffee, and Feta was walking around with these mints.

"Somebody give Feta another mint. She really likes these. She likes the sweet things," said Miss O'Keeffe. Feta was so embarrassed, like a little girl. She's an old lady. She's as old as

the sisters I'm sure, but she's very agile, very alive, and an excellent cook. She was embarrassed, bowing back and giggling. It was a cute scene, a very domestic scene. Miss O'Keeffe was looking after her and making sure she was happy and felt honored and that she got attention.

There was so much that was beautiful. Right off the kitchen, they had an area where they were drying fruits or they were keeping them where it was very, very cool. There was, I think, a window out onto the garden there. That's where they kept all the apples and apricots, and I went back and they were in a sack. I felt too greedy, and Claudia kept prodding me, "Now get back there and get some apples."

Then Miss O'Keeffe said, "Go get them. We just have so many that we're throwing them away."

Claudia said, "I take a bite, and I throw one away." They're just really opulent there with fruit and vegetables.

The kitchen is completely white, spacious, and airy. There's a huge window on one wall, which looks out onto a patio which looked down onto another area. So I think she has much more land than I saw out by the garden. There is some that goes down toward the highway.

The reason I keep reiterating details is that I think a person's lifestyle and a person's surroundings are expressive of what's inside. I felt that by walking through her house I was walking through her being. Every detail is exuding her, every detail of her life around her. I have a feeling since she spent so little time at Abiquiu, that probably the Ghost Ranch would be more indicative of her life, of her inner life. Still, it's very comfortable there, and she appears to be happy.

I went to the bathroom at one time, and the bathroom is the size of my small kitchen, no, maybe two of my kitchens, easily. It has one side lined with closets, half of them with black knobs and half with white knobs, but other than that, it was just completely white doors, just a completely white wall with light coming in from the ceiling. It was so beautiful, I imagine

like walking into a Japanese garden. There was something about the preciseness of where everything was. There was a heater in the wall, a gas heater, and in front of that was folded very carefully a rug. In front of that was an old-fashioned scale. It was just there. Everything was just there, precisely where it should be. There was a boudoir mirror with three sides to it sitting on a table with some grooming things out, just brushes and things you have around a bathroom. There were a couple of towels hanging very simply on the edge of the sink. The sink was very ample and large. The bathtub had legs. It seemed a little out of place, but it wasn't. The bathroom was quite spacious.

Most bathrooms are the little tiny place in the house, but it was a huge room. That was really nice with an airy, clean feeling. It opened out onto the plaza. I guess in the winter they count on it being warm enough that they can walk through the plaza to the various rooms. The library, for example, opens onto the plaza, the open one with the sky as a roof. One of the bedrooms I saw opens out onto the plaza.

Claudia and Miss O'Keeffe had been walking earlier in the morning, and they had picked a bunch of apricots. They were thoroughly ripe, and they were large. They picked them from an apricot tree they didn't even know they had. It's so lush and full of stuff there they can't keep up with everything that's growing. That's really nice. Miss O'Keeffe was giving us all of these apricots from a big tray. Claudia came back from the kitchen. She had been doing something with Feta, getting some things straightened out about the coffee, and she looked at us, and she said, "Georgia, you don't want to be giving those away." Claudia was sentimental about the apricots since they had spent time together in the morning picking them. So she emptied them out of all of our sacks and took us into the back to get apricots that had been picked by somebody else from another tree because they were obviously much smaller. I imagine that Claudia has this need to be very close to her sister, and these apricots were a symbol of the closeness to her. I was very understanding. I

thought that was beautiful. I really liked that. I have little symbols like that too. Miss O'Keeffe couldn't understand why Claudia was doing that, but she was looking down, and maybe she thought that the apricots were not at all pleasing. She was frowning and had that helpless stance again. I had a feeling of the vulnerability of age at that moment, but she's so open with it in just the way she stands.

Miss O'Keeffe has the weakness of age, but the strength of wisdom. She has a lot of experience behind her and a lot of perception about things around her, but she is losing her sight and growing weaker. I felt her helplessness at that moment, and I had tremendous compassion and wanted to hug around her and protect her. It was a really weird feeling on my part. It was completely non-verbal. I was entirely on the other side of the room, just watching the sisters interact.

After the sweets, Miss O'Keeffe said she would introduce us to her chow that protects their things from being stolen because the place is so open that anybody could walk in and walk out with valuable things. She has a chow named Jingo that stands about a foot and a half off the ground, has long red fur, and was asleep in the other room. When I first drove up, I remember, there was a sign that said "Beware of the dog." I remembered stories of people being bitten by that dog so I was really cautious to stay close to the car where I could jump inside. Claudia was going to go after the dog, but Miss O'Keeffe said, "No, let me go get Jingo," and left. There came back (I expected a little tiny chow, but it was huge) a big dog with a feather tail curled up tight with brown and golden eyes, a beautiful dog. In the meantime, while Miss O'Keeffe was gone, Feta had rushed in, picked up one lady's purse and put it on the table, picked up all the apricots and apples and sacks and put them on the table and said to get everything off the floor because she'll chew or knock over things and do some damage, and I thought, "Good Lord! Let me get on the table!" In walked this big dog, and I was the closest to the door. Who does she or he walk right up to, but

me! I had just read an article on how to handle a vicious dog. It said, "Don't move." So I didn't move, right? I extended my hand just a little bit for her to sniff, and then I turned it over because that's supposed to be a submissive gesture to an animal, and I thought, "Well, now we'll be friends." Humpf, fat chance. She was sniffing my hand, my palm, and Miss O'Keeffe was standing very close by. I said, "Hello, chow," and it sounded like I was barking, like "Bow." The dog "Ruffed," and I jumped.

Miss O'Keeffe said, "Oh, don't pet her. Don't touch her."

So I didn't know whether she was not to be touched because she's not to be affectionate with strangers or because she actually is vicious, and I suspect both. Miss O'Keeffe went back to her chair, and Jingo went around sniffing all of us and walking under the table sniffing our feet. We were all stiff sitting there very still. The house across from her had been robbed, and she's really uncomfortable about her squash blossom necklace that she had specially shortened so that it could hang on a hook just right and look pretty on the wall. I didn't see it hanging anywhere. She had just described it, and she didn't want to lose that so she has this chow around to protect her things. She reached out and patted Jingo. The dog and Miss O'Keeffe had quite a rapport between them. Miss O'Keeffe was telling little jokes about her, like she's so huge that she would run up to you and affectionately jump on you and knock you over, and she would walk halfway around the house in the morning just to avoid her because she's so huge. She said to her, "Jingo, you know the most beautiful thing about you is your tail." She patted her. Jingo was really elegant with this curled tail with long fur feathering out onto her back.

Earlier in the meal we had been talking about clothing, and Miss O'Keeffe said she had a kimono that she really loves to wear. She had worn it so much that she wore a hole in the seat of it. She patched it with a satin patch, then she wore a hole in the satin patch. She said, "I haven't yet come to patching the patch," a statement which I liked. She was talking about

these humorous thoughts. Everything was very light and enjoy-
able. I felt very much a part of everything though I didn't really
say much, didn't ask many questions or pry into anybody's life.
I enjoyed just being there. I felt very much accepted and very
present. It was nice.

Mrs. McSparron from Chinle said, "I'm really glad I'm old."

Miss O'Keeffe said, "You know, I am, too. I'm glad we were
young when we were young. I wouldn't want to be young these
days." They all four turned to look at me. I think Mrs. Smith is
probably in her sixties, very well preserved.

I said, "Well, I don't blame you."

Mrs. McSparron from Chinle said, "Time just goes so
quickly for me now. I think that maybe one day has gone by,
and it's been a week. I think I've been in this little town where
I've lived maybe six months, and I've been there three or four
years, or ten years."

I said, "Well, some say time is relative. When one is enjoy-
ing one's self, time goes quickly. So maybe when one ages, one
learns to live very well, and enjoy life."

Then she said, "You know, that's very good. I think I've got
a lot of wisdom now that I didn't have when I was your age."

Some people, when they get very old, feel very privileged
because they were great ladies. From hearing them talk I got a
great feeling about the way they had to be very strong to live out
there, killing rattlesnakes, riding on muddy ground with the
arroyos overflowing, and all the things that happen out there
without very good roads and doctors miles away. They didn't
talk about that, but I got a strong feeling of the courage it took
to lead the lives that they had led. Though, I'm sure that there's
much more that I don't even know about. There was much that
passed between them that was just an understanding. I was only
an observer, an outsider.

In this discussion about age and time, I said that I think a
lot of people in my generation agree with you because we wear
long skirts, high-topped boots, and old-fashioned clothes in a

kind of nostalgic reminiscence leaning back to the past, wishing for those things which were.

Miss O'Keeffe said I would have to run hard to catch up because they are far ahead of me. We all laughed at this.

Claudia was amazed by what I had said about old-fashioned clothes. She said, "Do you think so? Do you really think so?"

I said, "Yes, I honestly think so. I know that's why I wear long things sometimes."

Claudia said, "I never thought of that," and she seemed truly amazed.

I thought, "Wow! I have found somebody who would listen to me and would appreciate what I say." The whole day was made worthwhile since somebody actually cared what I said. I made sense to her. I had heard that Miss O'Keeffe likes to sleep at 1:00 or 2:00 in the afternoon, and it was already past 3:00, going on 3:30. So it was time for us to get up, and we all stood at the same time.

Mrs. McSparron from Chinle was saying, "I'll leave my address, and we'll write." She began crying, and then she looked at me. She was holding Miss O'Keeffe's hand, and she looked at me. She had this look of pain on her face. It was a parting. They are both very old. It was a stronger parting than I have ever witnessed between people. There is a great affection between the two women. I was completely transfixed by this. Then she walked around the room trying to hold back the tears. Then she walked back to her friend and got her sacks of apples. We were going out to look at the garden with Claudia because Miss O'Keeffe would retire for a nap. Since I was watching Mrs. McSparron so closely because she had such strong emotion, I had forgotten that it was my turn to say goodbye to Miss O'Keeffe. There I stood like a nit. Miss O'Keeffe was standing there facing me, waiting and looking, standing with her arms to her sides. Many people hold their arms or cross them or fiddle with their fingers. She just stands.

I walked to her, and she extended her hand, and I held it with both of mine, and I said, "Thank you very much for

the delicious lunch." She laughed. I don't know why. I don't know what she expected me to say, but it was as if I had said something that she completely didn't expect me to say. Maybe she expected something like, "Oh, it's great to meet you," or "You're such a great lady," or "I like your paintings," or something else. But a comment on good food she didn't expect. Then I said, "Be sure to let me know if I actually can do something about your library. I'll be glad to come again next week like you said."

Then she said, "Oh, let me get your name and all." So we went off into the kitchen, and all the other ladies were going into the living room.

She said, "Well, we have to find a piece of paper," and she asked Feta for a piece of paper.

We had her address book. I was standing there, and I was writing my name in the address book in great huge print like I used to do for my grandmother when she couldn't see very well, and then my address. I couldn't remember my phone number. I could remember my office phone, of all things, so I wrote that down and said, "This is my office phone, and it's during the day." She said to put the time from 9 to 5 or 8 to 6. So I wrote my office phone. Finally, my home phone number came to me, and I wrote that, too.

She was looking at me while I was doing this. I don't know what she was seeing, but I really felt good. I felt looked at. Maybe I fantasize a good deal about her presence because she evokes a lot from me, just her presence does. If that's the sort of thing that she evokes, then, wow, it's really worth it to be around her. Then we went back into the living room after she had taken my address and phone numbers. She said that she could arrange a way for me to come up there with her secretary. I said if not, I would figure out some way of getting up there. We agreed on ten o'clock on Saturday. She said that Sunday and Monday are more convenient for her because she likes to be at

the ranch through Saturday, but that she could arrange to work on Saturday and miss on Monday.

And she said, "Oh, well now, don't give your boss any ideas that you're going to quit him; that is, unless you want to." It was really cute. It was like saying, "Don't ever do anything." I've extracted a lot just from the tone of her voice, and probably I've extracted too much. I got the feeling of, "Always be in control of what you're saying and the impression that you give to people." If I would give my boss even the slightest impression that I was leaving him, it might make him insecure, and he'd start looking for someone else. It was a sense of power and strength and awareness of how to handle oneself. I thought, "Oh, I'm really learning a lot just in a simple statement, so much was carried." It was the humorous way she said it. I'm wide open for learning all kinds of things from her because I have such reverence for her, probably to the point of foolishness, but I hope not. It would be very good if she would become quite human for me because then maybe the power of her personality which I sense can be evoked from me not through her presence but through the strength that I actually have, but that she evokes from me.

I remember when we were in the library, she was fumbling around with some books. She was saying half under her breath, "Imagine meeting someone who can actually help me." I imagine there are a lot of people who come there to take from her, to get something from her. I came here with a feeling that I wanted to gain from her a sense of vision and a sense of her strength and her solitude. There is something that is just solitary about her. I want to learn about that. But I had a feeling that I wanted to offer something to her. This was one of the strong motivating factors for being there. That was one of the reasons I brought the fruit. I don't have much to give, but what I have, let me give. It is really nice that she's taking full advantage of that willingness in me. That's good.

Then we walked into the other room with the two women, and Claudia was taking us out to look at her garden. Miss O'Keeffe was worried that we weren't used to the sun and that we might need hats, and she didn't have hats. She was most attentive to our needs. We explained that we wouldn't be out there long and not to worry. We went outside and walked among plants growing everywhere. There were five different kinds of squash, cucumbers on long beautiful vines and lamb's quarters. Claudia showed me the lamb's quarters also called *quelites*. The two ladies were already out in the garden while Miss O'Keeffe and I were talking inside together for a little bit. We were making arrangements for when I would return.

Then I was walking out there alone a little ways among blackberries, gooseberries, currants, and green plants everywhere, very lush. Claudia said they irrigate every Thursday. Miss O'Keeffe came running out of the house to get Mrs. McSparron's address. Claudia and I walked on through the garden. Claudia led me to one area where there weren't many flowers. She pointed out two bushes and announced, "This is really beautiful in the spring. There's purple there and white over there."

We looked down, and there was brilliant pink. Claudia had not said a word, but she walked us up there and she watched me. I couldn't understand, and then I noticed this beautiful pink and said, "Ah, gorgeous."

She said, "It's quite a relief, isn't it?" I think that she might have an intense appreciation of flowers and color that her sister Georgia has as well.

August 13, 1973, Monday

Sitting in the shade on the lawn in front of the University of New Mexico Zimmerman Library relaxing on break, eating one of the apples from Miss O'Keeffe's table. It is a sweet, tree-ripened apple. I have a light pink and grey rock in the sun that I picked up off one of the streets in Abiquiu. Last night I read my thoughts into the tape recorder until 1:00 a.m. I was falling asleep at the

tape recorder, and I had only covered the first hour of a five-hour visit. There is much I have to cover before the fragile details fade from my memory. I will outline what occurred and try to fill in the blanks.

I spoke to Ellen Brow, the Latin American Librarian at the University of New Mexico Library, and this morning she said that in order to arrange a personal library an author card on each volume should be sufficient for Miss O'Keeffe to find them easily. Today I celebrate my good luck to be around Miss O'Keeffe for a full day, a night and a day again, to touch and hold things that belong to her and inspire her. Such rare pleasure to savor this is. I would like from her a sense of her strength and an ability to see—to SEE. I think her paintings are as if from my own senses, generalized sensations.

Miss O'Keeffe was pleased during lunch when I mentioned that I had spent most of the weekend at the Lawrence Ranch. She used to go there before Frieda (Lawrence) died. She continued that the trees had grown, and the view was not so full as it used to be. When I commented on one of her paintings called *"The D. H. Lawrence Pine Tree, 1929,"* she replied that she found rest under that tree and spent much time there.

August 20, 1973, Monday

Saturday morning I was unable to catch a ride with a friend or to rent a car, so I called the daughter of Virginia Robertson who was Miss O'Keeffe's secretary and got Miss O'Keeffe's telephone number. Then I called Abiquiu. After two rings Miss O'Keeffe answered. I recognized the resonance of her voice. I explained that the car I was going to use had broken down, so I would have to take time to rent one. She replied quickly that was too expensive for me, and that we should postpone until next weekend. If I could catch a bus Friday night to Santa Fe, she will see that a car comes to pick me up. I agreed. Mrs. Robertson took my phone number and address, and I agreed to check on buses Friday night and Saturday morning, then wait for word on where to meet the car.

August 30, 1973

Here I am in Abiquiu tonight and barely believing it! I have spent the entire day and evening here. Now I am lying in Claudia's bed. Tomorrow I will catch the bus back to Albuquerque.

Tuesday night this week, Virginia Robertson called and asked if I had any secretarial experience. Yes. Miss O'Keeffe needs a secretary. She asked if I could come to Abiquiu before the following Saturday. I could arrange to come on Thursday perhaps. I caught the bus this morning at 8:00 and waited in the Santa Fe La Fonda hotel for Geri and Miss O'Keeffe to pick me up. We drove into Española to see Claudia who has sprained her back and gets traction and heat treatments. Now I am so sleepy after such a full day. We went to Ghost Ranch this evening. Miss O'Keeffe said she would make it very hard on me if I should decide not to come up here to live and work.

Tuesday, September 11, 1973

I have visited Georgia O'Keeffe three times now with an invitation to go next weekend and work in her library. The writing seems to betray a confidence. I appear to be a simple child barely aware of the complexities and greed of the world. Then I greedily put down every shred of experience I can remember of her and the house. The gates are closed. The experiences are tightly secure in mind, but I feel so hesitant to share what I know of her pain, her blindness, and its coming. There are her long memories shared in the shadows of the library. There is her description of love that seeks elsewhere for satisfaction. She has strong political opinions against Nixon. She is very interested in what is going on in the world at large, economically and physically. Mosquitoes land on her but don't bite. (*When I noticed this detail, she said it was because she ate plenty of garlic and Vitamin B in her diet.*)

Juan Hamilton will probably fill in well enough for secretary, and I can work in the library. Besides, he can be handyman for her also, and he is mellow enough to be easy on her being.

(I found out that Juan Hamilton was doing secretarial chores, repairing items, and building boxes to ship her paintings. He was doing whatever was needed around the household.) There are little secrets her old secretary shared with me. One important secret is that I must maintain the mystique. Claudia is very complex and must be humored. I wonder why the secretary is leaving. I get so sleepy. However, sleeping in a room full of original O'Keeffe's is a new experience. I am cooking lunch on Sunday for everyone.

I am riding home with Sheila (Chili) Lipton. The chow Jingo is fondly called "Jinxy."

(A memory that was not recorded in my journal but is clear in my mind was one day when I first saw Juan Hamilton as he came to the sliding door of Miss O'Keeffe's studio. He offered to do an odd job such as trimming the Russian olive hedge. She turned him away at first, then changed her mind. By the following week, he was doing all kinds of useful things. I remember that as he walked toward the door, Juan said the great painter should not be scuffing around in unpolished shoes, and he oiled and polished her very worn shoes right there with Miss O'Keeffe watching. They looked really slick and almost new.

Years later the secretary Virginia Robertson said she had a dream that was like a premonition of some trouble coming, but she was unsure what. She said it was probably the future lawsuit between Juan and Doris Bry, Miss O'Keeffe's agent, about which Virginia Robertson had the premonition of impending disaster. This memory was written July 9, 1987.)

September 13, 1973, Wednesday, Albuquerque

I have much to write about the last two visits with Georgia O'Keeffe. Sitting privately in her library, we were deciding what books to discard by giving them to the McCurdy School in Española. She said that she lost her eyesight slowly. She was in a store in Santa Fe and walked out into a dim day and felt astonished that the day was so overcast. The next day she could see that the day was not overcast even though it appeared so to her. The left

eye does not have edema but has a blood clot in such a place that she has to look to one side to pick up whether a person has eyes or glasses. As we looked at the books, she reminisced, and I felt so gratified to have my curiosity fed. My coffee break at work is over now, and I have so much to write. Here I am straining at my tether snapping for a few more moments.

September 14, 1973

I am writing while standing in line at the bank waiting to cash a check.

Juan Hamilton with his slow drawl called me this morning at 7:15 to arrange for me to go to Abiquiu tomorrow. I will catch the 8:00 bus, and he will meet me at 9:30 at the Santa Fe bus depot. He is tall and fairly lean with shortish brown hair and a slow-moving manner about him. When Miss O'Keeffe asked him to dinner last Saturday evening, his reply was that he was not dressed very well. At that she laughed a low chuckle that could be compared to the snuffing noise her chow Jingo makes. I say that affectionately. Miss O'Keeffe is very responsive to Jingo. She has had chows around her for years because they warn people away.

September 16, 1973, Saturday night

I am writing while in bed. Today was difficult, and yesterday was also. Knowing the whole while that Juan Hamilton is Miss O'Keeffe's new secretary, I continued to go through the motions of applying. I am to return in two weeks and continue work on the library. That room has grown musty and messed up over the years. Today I opened a book about Marin, the watercolor painter. The dedication was "To Georgia O'Keeffe, a friend for keeps." She indicated to me that she felt very warmly toward him. She was trying to find two letters from him.

Miss O'Keeffe's face to me takes on many aspects. And her splendid hands are memorable. After eating, she always carefully

folds her white cloth napkin into a rectangle and straightens the fringe and smoothes the folds over and over. I grew closely acquainted with the graceful curve in the inside of her palms and the dexterity of her long fingers as she smoothed the cloth.

September 18, 1973, Tuesday morning

Last Friday night I went home to sleep and get up early to catch the bus for Santa Fe where I met Juan Hamilton. We rode back together with the cats newly fixed at the vet's. Bob, a painter, was in the back seat for a free ride.

Juan Hamilton, so far as I can tell, has the job of "secretary" for Miss O'Keeffe. He speaks Spanish and can deal with the villagers. He knows about nutrition and foods so he can help her arrange her meals wisely. He has a quiet voice so he can help her preserve her energies. He mentioned to me the possibility that he is reincarnated Stieglitz, and he shows care for small things around her. He can build and fix things so he makes a good handyman. The only difficult thing is that he grows impatient with tedious details and typing. Last Sunday he said perhaps I should come for four days a week and do the heavy correspondence and typing, and he could be there. I agreed it would be very good if he and I could spell each other so neither had the full weight and responsibility. I wonder if he meant it. At any rate I am invited weekend after next to work again in the library. I remember little chats with Miss O'Keeffe, and I feel very lucky. My disappointment at not getting the full job was humorous to me, because a few weeks ago I would have been happy for a few minutes with the lady.

September 21, 1973

I found out that my neighbor, Meridel Rubenstein, knew of my visit with Georgia O'Keeffe through my professor, Nancy Tomasson, who apparently didn't keep quiet as I requested her to. I spoke to Nancy as a trusting student. Perhaps she didn't understand. At any rate, Meridel doesn't seem excessively patronizing with the

knowledge, still very genuine. I have very much to write about my first visits with O'Keeffe. Yet the subject seems taboo, filled with too much power, unassimilated yet, without a handhold. I could describe the subjects of conversation, her room, the architecture of the house, her sister, the paintings in her sister's room, her clothes, her hand movements. There is her perceptive glance. Even though I know she is nearly blind to light, I feel other penetrating vision. There is the love of music, her humble thoughtfulness. She actually said, "My opinion is not worth much." All pretension is stripped away. There is her tenacious toughness. I am mystified by my tenderness toward her. As she emptied the sleeve of her Chinese coat of fuzz, I carefully picked it off the rest of her coat where it blew. There is her affection for her dogs. There is her fearlessness about staying alone. I enjoyed her description of Christmas in the village. There is her delight over the stories about people who write of coming to visit. There are her moments of nostalgia in the musty library. She stood at the door as I left in an inviting way. We locked the door of the house together one night. There is her curiosity. There is her childish open way of viewing a large poster of red with purple splashes from California. There are the rocks, skull, shells, Datura, black and white bedroom. During our walk on the driveway together at dusk the light faded, and she gestured toward the mesa behind the house, "Let's go in now. The magic is gone. It will be chilly soon."

She eats corn on the cob all around the cob (*like a roller*), not side to side (*like a typewriter*). She butters and salts a few bites at a time, turns the cob around.

We were in the library when I was telling her about my eyes. (*I had reddened eyes from riding my bicycle in a sand storm.*) She said that I should get a weak salt solution and an eyecup. I said I had not tried that, rather used eyedrops. I had never even thought of using an eyecup, never even heard of an eyecup.

She replied, "You're not even prepared to live, child."

I responded, "No, no, don't be so harsh. I'm taking care of myself."

September 27, 1973, Saturday afternoon

Yesterday, I called Abiquiu to explain that I would spend the weekend finding a car so that someone would not have to come to meet me each weekend in Santa Fe. Juan Hamilton said that Geri is in the hospital with stomach pains. Miss O'Keeffe insisted that she have tests. Geri is nurse-attendant-cook-driver-valet for Miss O'Keeffe. Geri told me that she had a husband around the time of the Second World War. He left her. He returned several months ago and upset her present married life.

I am reading Jung's autobiography and enjoying Jerry Uelsmann's photography. I am thinking about the integrity of the life of Georgia O'Keeffe, sometimes when I am looking at my hands moving while doing Tai Chi and practicing transcendental meditation, feeling for my center.

October 5, 1973, Friday

About Juan Hamilton I have decided to consider that he got the job out of chance and circumstance. My ego is not so bruised if I think he is not necessarily the best person for the job. He does handyman chores, also, and he lives close by.

October 7, 1973, Sunday night

I spent the weekend at Abiquiu working on Miss O'Keeffe's book room. Saturday, Juan met me at the Santa Fe bus station. We shopped for a couple of things, and then we drove to the house at Abiquiu. We talked the whole way. Juan had just cleaned the drain in the kitchen at the ranch. I told him he should be difficult to get along with this weekend to bring me down a little because I had just published a poem and was too high. He was very curious about Ed Steinbrecher and Active Imagination Meditation. He believes that ESP and future knowledge are possible and carry great power. He talked more about his former wife and how he wanted to go with Miss O'Keeffe to New York in the next weeks sometime. He would get some of his things and head back to New Mexico. Miss

O'Keeffe was at the house when we arrived and met us in the book room. I passed around my apple bread, and Miss O'Keeffe said to leave the recipe with them. I have the following duties:

> Type the lists of books and send apple bread recipe
> Find book of short stories for Juan, Tolstoy's "Land Enough"
> Locate the schedule for Russian dancers
> Find the Japanese book title for Catherine

October 8, 1973, Monday

Here I am waiting for my bus. Saturday, Miss O'Keeffe left instructions to file her letters and list the Egyptian and African books. She introduced me to Arturo Sandoval who was painting the dining room white. I showed her my Japanese coat from Kyoto. A friend gave it to me, and she liked it. She was wearing a black coat that looked oriental, and she held her arms out to emphasize the square cut. She looked like a cross.

October 11, 1973

Miss O'Keeffe has graying hair that reaches to her shoulder blades. She wears it twisted loosely into a circle on the back of her head held by clear plastic hairpins. Several times I have seen her wearing a plain white or plain black scarf, placed on her head then corners with strings drawn toward the back of her head and tied, giving just slightly the appearance of an Arab or a nun.

October 19, 1973

Tomorrow I go to that damp chilly library in Abiquiu to make lists of amazing books, to be with that amazing lady, and Juan. I wonder how he will change over the next year.

October 20, 1973

I like my energy after visiting Miss O'Keeffe for two days and looking at her surroundings and seeing her face and her movements and knowing more of her life.

October 28, 1973, Sunday night

On Saturday morning at 8:00, I called Abiquiu to explain to Miss O'Keeffe that I couldn't make it to work in her library because I had a cold. She said I talked like my nose was stuffy, and I should stay in bed. Then she abruptly hung up. I slept until early afternoon.

November 25, 1973, Sunday

I am librarian to Georgia O'Keeffe. I listed and typed book titles, authors, and publishers. She wants a list of all things in the book room. She called me early Friday morning and said that she and Geri could pick me up in the evening at La Fonda.

We rode to Abiquiu and ate a light supper in the adobe painted white dining room. Miss O'Keeffe told me that the room is painted white so that she can see more easily. Juan was on his way home. Claudia and Feta, her Cuban maid, were back from California. Geri was busy with this and that.

I was invited to sleep in the studio since all the bedrooms were taken. Miss O'Keeffe and I listened to music awhile, then she retired to bathe, and I typed on the lists of books from the trip before. We listened to Richter playing Schumann. She sat very still, occasionally re-crossing a leg, listening with eyelids closed. I gazed around the room at the various paintings displayed at the office end of the room. There was a rock on a stump with clouds. On the south side of the room, a painting with a black V, light forms below and blue shades above (*In the Patio IX, 1950*). Saturday night she, Juan, and I sat talking for a long time. She gazed at that painting and said it exemplified very well what she was trying to do, but the public didn't understand and seemed to like other things that she didn't.

Juan had Dorothy Norman's book on Stieglitz on the studio floor asking Miss O'Keeffe questions about this and

that. He was teasing her about there being nothing of value in the book. She commented on a photograph of the house at Lake George where she had a porch taken off to let more light inside a room. Alfred didn't like her doing that, not so much because he wanted the porch, but that she just did it without asking anyone.

We listened to *Castor et Pollux*. Juan griped that he shouldn't have been made to shave off his mustache because Stieglitz had a mustache. Miss O'Keeffe said that he and Stieglitz had very little in common. Then she commented to Claudia how beautiful Stieglitz's mouth was. She commented that his photograph "The Steerage" is worth $700 now, and that would make Alfred roll over in his grave. Later after Claudia headed for bed, and Juan left for home, we listened to Schnabel play Beethoven Sonatas, numbers 3 and 13, while we drank Orange Petal tea fixed on a hot plate in the bathroom. She told me that she was surprised at how readily she has adjusted to her blindness. She has tried lasers. I told her if it could be done, she could have one of my eyes. She said she didn't think that was possible though it might soon be since they can transplant hearts and kidneys.

She told me that Thomas Merton visited her and they had a good talk before he went to the Far East. I read the book with his photographs before sleeping. Now, again I must sleep after a day of typing and the bus ride. More writing to come about Maria Chabot, and O'Keeffe saying, "I am so perfect you should be watching me all the time." She said this with a little sarcasm, but it's hard to tell.

There will be a trip to Morocco with the Girards. She has said more about Merton. There are photographs in the book room. As I left tonight, I explained that I was surprised my meager talents could be of some use to her. I am glad to help, and she simply replied, "Thank you."

Juan keeps her laughing, and it is good to watch bright pink come to her cheeks.

November 27, 1973

Juan Hamilton has invited me to stay in his house while he is gone with Miss O'Keeffe and her friends, the Girards of Santa Fe, to Morocco in January. That would give me some weeks cooking, walking, and tending a wood fire alone with my thoughts and some poetry. The prospect is tempting. That would be a very purifying time. I could develop more of a feeling for that land. But I must consider the feelings of my parents if I do not go to Tulsa to spend vacation time there at Christmas. Yet there are many things that I need to sort out. That takes time and solitude.

November 30, 1973

Last Sunday after breakfast Miss O'Keeffe and I lingered at the dining room fire. She took off her slippers and warmed her feet at the fire as she told me of Maria Chabot, who built her house. She had a strong memory of Maria standing stark naked with a pasteboard box over her hair in driving rain as she watched the water flow down the arroyo. Miss O'Keeffe said Maria was one of those oddly sexed girls. They used to pack a dinner and go up to Echo amphitheatre to eat and sleep there. If they took wine, which they often did, Maria would usually drink too much, and Georgia would drive them home. Miss O'Keeffe said she had to ask Maria to leave the house when she got too demanding, as if she owned the place. They haven't seen each other for two to three years. All of these comments came when I mentioned that Maria Chabot was going to be in my Tai Chi class in Albuquerque.

Then she told me the story about the river float trip in a rubber raft when everyone had a place in the raft facing the center with a bunch of rocks collected into the place. Eliot Porter put a potato among her rocks, and she noticed it right away. First she said, "What an odd rock." Then she felt it and knew. (*They were competing to keep a truly fine rock and he had replaced it with a potato. It was a friendly rivalry.*)

After lunch she sat in the library looking at photographs. Juan and I stood close as she reminisced. When I mentioned that I saw Eliot Porter's photo of her next to a plaster head, she said, "That old thing?" She concluded by saying one should never think too much of the past. Where her eyes are very dim, she still recognizes shapes and sees better if something has a white background.

December 5, 1973

I just remembered yesterday that O'Keeffe told me, warming her feet by the fire at breakfast, about her time (*as a student*) in a convent school.

December 14, 1973, Abiquiu

I get in mind so much to write, it feels good, very good, to have a quiet moment at sunrise to let some of it out. I remember Miss O'Keeffe said to me last time I was here, that when she first came to this area, she didn't notice the houses along the river because the land was so huge. It is very clear to me why that was so when I look about the studio window overlooking sky and stars, then slowly lightening cliffs and contours of great forms. I am feeling very frisky this morning after a ride with George Miller, my boss at the University of New Mexico Library, to Santa Fe and from there with Juan Hamilton to Abiquiu. George and I talked of despair by Kierkegaard and by Galen. We discussed the disease of the spirit and disease of the body.

Juan and I talked of the Arica Institute and his trip with Miss O'Keeffe to Morocco. He is changing. Now he is making pots again.

December 22, 1973

My neck hurts. I am tense when I sleep these days. The plan is that I will spend January 1–15 at Juan's house close to Abiquiu while he and Miss O'Keeffe are gone to Morocco. Silda Rivas-

Quijano, my friend from Nicaragua, who I know from working at the University of New Mexico General Library, will come to the house with me for ten days. Her boyfriend will come with her. They will help me take care of Juan's house. I will take along the book James Agee's *Let Us Now Praise Famous Men* and paper to write on. I expect to be busy taking care of the wood stove and walking. I will spend some time at Miss O'Keeffe's book room to list some more of her books. One day I will go to Santa Fe to the Arica Institute to learn Chinese self-massage. One day I will go to Ojo Caliente to cook out the impurities. Then one friend told me that he could drive me to Christ in the Desert Monastery.

December 23, 1973

Last night I went to Louise Trigg's party. Louise and her daughter Robin had a costume party at their home in Pojoaque. Juan was there, and we danced. He was surprised that I knew how to dance. Louise is an old friend of Miss O'Keeffe's. As we were riding to her home after dinner at Abiquiu two weekends ago, Louise told me that she met Georgia years ago in New York then didn't see her for awhile. Later when she found out that Louise was living in the area, Miss O'Keeffe invited her over to her home. Once Georgia invited Louise and asked her not to bring Robin. Louise put her arm around Robin in the car and said, "Not that she didn't want to see Robin, but she never entertained more than, say, one or two people at once." That night we were driving together, and earlier at dinner there was a real crowd: Louise and Robin McKinney, Robert Shaw, Miss O'Keeffe, Juan, and myself. Louise said that Georgia has changed because now she is entertaining so many people.

Earlier that same weekend I remember sitting at a meal across from Miss O'Keeffe as she described the time a bird crashed into a window flying toward a plant inside the house. The bird was knocked out. Miss O'Keeffe said she retrieved it to rescue it from the cats. She brought it in and examined it, then

fixed a mixture of warmed whiskey and water and spooned it down the bird's gullet. The bird came to, hopped about, looked all right, and flew off. She told me about a robin that would eat juniper berries by her bedroom window, then walk around drunk on the low adobe wall with tail and wings dragging.

I remember one evening watching Miss O'Keeffe rearrange five dark smooth rocks on her desk while we listened to Pachelbel's Canon in D Major. For some reason my eyes watered. My emotions are very strong where that lady is concerned. Sometimes I look around her studio and the place looks as familiar as my apartment or my old home in Tulsa.

December 24, Monday, 12:00 a.m.

Bus station in Santa Fe, snowy, waiting after a trip to a friend's home in Los Alamos.

Last night at the Triggs' party as I chatted with Juan in an ivy-draped hall, I mentioned to him that I felt I should simplify my life much more. He replied, "Move to Abiquiu. Miss O'Keeffe and I have begun work on a project that takes much of our time, and we think we may need a secretary to send letters and thank-you notes." After our conversation, I knew he had begun work on Miss O'Keeffe's autobiography with her. Mrs. Robertson's daughter had told me about that project inadvertently once when I called to inquire about Mrs. Robertson's health after an operation. Juan said that no one is to know of the project or there would be countless publishers hanging out around Abiquiu. Doris Bry, Juan told me, has wanted to work with Georgia on this for years, but Doris is too academic. Juan said sometimes he wished that he had never seen Abiquiu or had left immediately when he first arrived. He seemed astonished at such responsibility. At first I was filled with envy of his position, then in a moment I was equally filled with gratitude that Miss O'Keeffe had found someone she is comfortable with to write a book of her own about herself. Far better than if years

from now a scholar should question people who knew her or write about her from articles in books and magazines.

December 31, 1973, Abiquiu

I am at the huge wooden desk at Juan's house. Silda and her boyfriend Gary are off in the other part of the house. We have the wonders of wood stoves to experience. This is a thick-walled adobe house with wood floors and deep windows. Tomorrow morning at 7:00, Miss O'Keeffe and Juan leave for Morocco for four weeks. I will be here two weeks, then back to Albuquerque. Here tonight I feel a certain power, a strength for sure. I want the wondrous beauty of this area to flow through me and out onto pages into words when I have time to write at night. On the last page of this journal are last-minute instructions that Juan left me. I brought my Latin books. I want to translate some. Then I also have books on education and Agee-Evans, *Let Us Now Praise Famous Men*. I would like to write some haiku as well as start a poem series about Tulsa. What a fine way to bring in the New Year!

I look on a white wall to my left, and there is a print of the pink and blue arches (*Music—Pink and Blue No. 1, 1918*) by Miss O'Keeffe. It is my favorite. What an inspiration! My feeling here is comparable to what I felt in Caernarvon, Wales, when I stood on the highest hill in the wind, intoxicated by beauty. I remember on the train to Bangor, Wales, I awoke, and on my right at sunset the ocean tide was rolling in, and on my left there were mountains in heavy evening light. There was green everywhere, and I promised some women of the future yet unborn that, yes, I would precede them and trace for them some avenues of strength. I must remember to pause and feed the fire. It gets cold in here.

O'Keeffe gestured to different parts
of cliffs at Ghost Ranch
her favorite place,
didn't go
where there were rocks
and most likely snakes
stuck to the good earth
where there were cliffs
like curtains
wandered and wandered
Looking for
the base of the pillars
finally by accident decided to go
up an arroyo and found herself
at the base of the pillars.

October 1974
C. S. Merrill
O'Keeffe, Days in a Life

[1974] 2

January 1, 1974

> Ajit Mookerji, *Tantra Art*
> 1966, Ravi Kumar, New-Delhi.
> Dorothy Norman, *Alfred Stieglitz*, 1973

While Estiben clears the snow, I have busily read the above volumes. (*Most people spell this name Esteban, but this man and his family had their own spelling of the name.*) The snow is coming down in pillowcases full. We have six inches, and Estiben says we're in for more tonight. Silda and Gary are sitting it out at Juan's house. Juan came for me last night when it began to snow at 12:00 midnight. They needed the Volkswagen bus to go to the Albuquerque Airport. So I waited at Miss O'Keeffe's house until Estiben came at 7:00 a.m. They had left at 5:00 a.m. for a 10:00 a.m. flight. The snow keeps falling. The quiet is roaring. I have had much time for reflection, Tai Chi Ch'uan, and meditation. I feel something very powerful will grow in me as a result of these two weeks. (*It was at this time that I was gazing out of Claudia's bedroom window onto the road toward Española and noticed*

that there was a striking similarity between one of her paintings (The Winter Road I, 1963) *and the line of that dark road contrasted with everything made white by the blizzard.*)

Wednesday, January 2, 1974

I drove to Juan's house where Silda stayed. The fires were out, and she was writing in bed. As I walked down from the road with kerosene, I noticed there was no smoke from the chimneys so I assumed she had left with her boyfriend Gary, but she was still here. Great curds of snow are caught in the tiny limbs of sage bushes. I chopped kindling into smaller pieces, and we got the flames going high in the wood stoves. Then I stacked wood under the eave of the porch to keep it mostly dry. With that I felt very warm and had a roaring appetite. Silda fixed some tea, and we had sandwiches. Now she is making bean soup. As much as I crave solitude, it is still very nice to have a friend here. My down jacket is very warm. No problem. With a foot of snow, my boots are not high enough and my trousers got heavy with snow. My toes got very icy even with two pairs of woolen socks so I may change the way I walk and wiggle toes more with each step. Maybe I will lace the boots more loosely. My body is humming from the exercise, and my spirit is high on the beauty here. This is a good vacation.

I am reading more of the Stieglitz book today. We have fourteen inches of snow, and it is still falling. There were two young men with guns outside when I was chopping the kindling. I yelled, "Ya-hoo," which is the Sufi chant for God, and one of them yelled back with a wave. They were shooting small birds.

Friday, January 4, 1974

This morning there was no water out of the tap. Juan's pump is frozen. I opened the door of the pump house and remembered Juan told me that we would have to keep the pump house floor

door closed down if the temperature went below 15. Last night it was so cold that the inside of my nose frosted up when I was outside. I should have remembered. However, Juan said he didn't expect it to go so low.

Last night a very pregnant dog came to the porch, and I gave her warm milk and dog biscuits then a warm corner to curl up on bathroom rugs on the porch. She seemed to shiver less. I sang to her also. She seems to fear being kicked. When I picked up wood, she shied away out into the snow. Her body is scarred all over, and this morning I saw that her tail was just recently lobbed off. Last night I had dreams of animals. Yesterday, Silda and I walked to the Chama River behind the house one-half mile. The snow was about a foot deep. Silda sat down in the snow and splayed her hands around like a small child playing in the ocean. Wednesday was primarily spent discovering the rhythms of wood stoves. Air-wood-heat-stoking.

After a breakfast of pancakes, I feel like taking the hot coals to the pump house and sweeping the pump house roof for the sun to heat through the dark green tar paper roof. I feel very lucky. Snow on the ground is very thick and there is another storm to come, yet I feel content with a snappy warm wood fire and the comfort of a simple meal. Silda is good for laughing and talking, and my spirit is very bright even though I haven't time for the scholarly pursuits I had planned so ambitiously. I feel I am learning some valuable lessons which are not yet verbal, but show in the strength of my legs and the tone of my full-felt laugh.

Sunday, January 6, 1974

I stopped briefly to see Ford Ruthling, a Santa Fe artist I met several years ago, after dropping Silda at the bus station in Santa Fe. I told him it is very good to get back into the rhythms of nature instead of my usual coordination with man-dictated rhythms of the clock.

Monday, January 7, 1974

Going to bed at 10:00 p.m. Want to see sunrise. Almost finished with Dorothy Norman's book on Stieglitz.

Tuesday, January 8, 1974

When I can no longer escape myself by sleep, by work, or by any other distracting means at hand, then I must write. It always comes to that. I always feel best for days after having written something completely honest from myself. I am at peace this afternoon with the music dropping from icicles and blowing through limbs and falling in great clumps from the roof. Somehow I know what is required of me.

Today I did not talk with anyone. All day I was alone. It was good. I feel at ease. I have pondered many things. I finished Dorothy Norman's book *Alfred Stieglitz* with tears and a desire to have met the man. This house is my spirit shelter. I feel places wounded and undernourished by too much activity, too many people. Now I understand better my need to stay a long time in bed at night, then in the morning. I do not often have the privacy long enough that is necessary to thoroughly nourish my spirit. Furthermore, my apartment, and Albuquerque itself, are very ugly places, though something can be done about my apartment for sure. Beauty is nourishing. Beauty is useful because it keeps my will strong and my spirit high. I don't have power over many things, but the beauty of my immediate surroundings I do have some power over. I have plans, but they will be slowly growing ones.

What a superb man was Alfred Stieglitz. He would have been someone you could really level with. I like his concern for truth and honesty plus his courage in dealing with new art in a world accustomed to convention. I like the way he evoked life through troubling conversation. He inspired intensity, hard work, devotion, and integrity. I would like to talk with Dorothy Norman about the man. Her descriptions of his surroundings;

austerity, usefulness of all objects, plain simplicity; all sound very similar to O'Keeffe's place. Miss O'Keeffe's library means more after reading *Alfred Stieglitz* because many of the authors and painters mentioned in the book are represented in some way in her library.

January 13, 1974

I have three more days of vacation. I miss Juan's house. Mostly I miss the print of *Pink and Blue Music (Music—Pink and Blue No. 1, 1918)* by Miss O'Keeffe. I am treating myself to lunch at The Shed, a small restaurant in Santa Fe, only open for lunches. Yesterday, I drove Miss O'Keeffe's bus up to Ghost Ranch. I stopped and walked awhile among some red cliffs.

January 23, 1974

My feeling for Miss O'Keeffe is that she is a great woman who has given much of beauty in her art. How can I help her? How can I serve her? I am happy in her library doing what no one else would do. I can give her peace of mind to a small degree.

(This memory was not recorded in my journal, but it was written down in 1989:

While I was working at Miss O'Keeffe's library that winter, I remember being very, very cold in the musty book room with one source of heat from a wall heater, but the walls and floor were so cold that I folded up a rug and rested my feet on that and worked with my feet insulated from the floor. I felt like I was doing penance or earning the right to be in the presence of a great woman. I saw that she had the courage to create beauty and I hoped to learn that courage from her. Something in me felt quite peaceful around her house as I looked at beautiful things almost everywhere the eye could rest. In the living room were rocks the size of one's hands, very smooth river rocks. When I first met her, I remember she held one and felt it in detail while we talked. Also in the living room was a black African mask, very dramatic against an otherwise empty wall. Everywhere was something that increased the feeling of

life in one, even a skull with antlers outside the book room. The round
well in the courtyard opposite a very black mysterious locked door, both
were placed to be visually very vital. For an ordinary person it was very
eye-opening.)

February 17, 1974

This was a most amazing day! Juan came by my apartment on
Morningside Ave. in Albuquerque and met my neighbor Meridel
Rubenstein. They both knew many of the same people from
Brattleboro, Vermont. They both left Vermont disappointed
in what they found there. Meridel finally got the contact she
wanted to meet O'Keeffe somehow. It is up to her. She plans to
go up to Abiquiu to photograph Juan when I go there to work
in the library.

Saturday, March 1974

"Well, you probably were getting it when you were so ill . . .
When the reality comes, even more . . . I'm sure you can do it,
but it will be very difficult." This was a fragment of conversation
on the telephone when I went into Miss O'Keeffe's studio to
get a typewriter eraser. Somehow those comments seemed
significant to me. Last night George Miller drove me to Santa
Fe, and Juan picked me up at La Fonda. Juan's dog Flit, lost and
taken for dead, showed up, and Juan drove him back home to
Abiquiu. Back home. Really, I feel very much at home here, very
much. Juan was driving the new car, a white Mercedes Benz. We
laughed and talked all the way. The car even has a sunroof.

When we arrived, Miss O'Keeffe had left the keys in the
gate so Juan would have no trouble driving the car in. We had
a late supper of cheese, bread, salad, milk, soup, and a banana.
Miss O'Keeffe kept us company as we ate. She was wearing a
light blue quilted coat over a light blue cotton nightgown with
delicate white lace at the bottom. I slept well and watched the
sun rise as I did Tai Chi this morning. I had the bedroom next to

the gate this time. Sometimes it is called Claudia's room. This morning Miss O'Keeffe and I had eggs and chile in the kitchen. We had garlic on the chile. Last night Miss O'Keeffe had me put garlic in my tomato soup, which was delicious. Juan arrived at 7:45 and had us really laughing. I told them of my dream last night, that I was reading a comic book to Miss O'Keeffe, and Juan was acting it out.

Then we started work in the book room. Miss O'Keeffe said that sometimes Stieglitz would grab a book off a shelf and stand there reading it as if his life depended upon it. Miss O'Keeffe said she climbed most of the pyramids in Mexico, but would never go alone because whereas she could go up almost anything, it frightened her to come down. The stairs were narrow on the pyramids.

For lunch we had bread, buttered zucchini, steamed celery, and curried lentils with eggs. She said at lunch that she would like to learn Tai Chi. Miss O'Keeffe asked at breakfast how Maria Chabot was doing in the Tai Chi class. I said Maria was perseverant, and she laughed a lot. Miss O'Keeffe responded that Maria had a great sense of humor until she wanted to possess you. Miss O'Keeffe said about Maria that she didn't want anyone even looking at Miss O'Keeffe's house. Miss O'Keeffe said she had other things in mind than just living with Maria in the house with no other interests. After lunch Miss O'Keeffe and I lay in the sun together for fifteen minutes. I felt very warm and saw things (as usual) in the twilight conscious time. Miss O'Keeffe's wrinkles sagged toward her ears, and she looked very old in the heat.

She had told me at lunch that she painted in the car. The driver's seat of a Model A could be unbolted and turned around. The windows were very tall, and it was perfect. She wore an old wool skirt with elastic around the waist, and Miss O'Keeffe said she put her clothes into that skirt and tied one end, balanced it on her head and walked around until she found a place to rest. She was brown all over she said. If while she was painting,

someone came up, Miss O'Keeffe said she had a dress to wrap around and fasten in front.

She slept with her head on a white pillow with a red circle, dressed in black with black velveteen turtleneck and black pants and jacket, silver hair pulled back and netted. We rested. Occasionally, she was snoring. I was breathing deeply. Now I am in the book-room taking a breather from typing, to remember sweet moments. Light warm wind moves white circles of glass for noises.

> In the outdoor passage by the bedroom
> Was a wind chime with circles of glass
> That made a lovely clinking. At the
> Ghost Ranch home she had a single bell
> That rang with slight winds often it
> Seemed when something special was said.

—Saturday night

I am sitting in my bedroom, writing by firelight. The fireplace has a strong draw, the fire is roaring, and I am very warm. It is a well-constructed fireplace. It has a graceful arch which makes it like a sculpture in the corner. Tonight after supper with Miss O'Keeffe, Juan, and Dave McKinsey, Juan drove me to Ghost Ranch to see his pots. They are beautiful round forms, oval pregnant forms, alive presences. Then he took me to his home which he has fixed up in many ways. There is a huge chewed stump in a raked place, lovely wall hangings, and music. He gave me a wooden flute from Morocco and a bamboo tea strainer. That was a gesture of peace. Tonight, after Juan left for home, Miss O'Keeffe invited me into her bedroom to read to her. She was most solicitous of my comfort.

There was a fire in the corner fireplace. I had the most comfortable chair with feet propped up and a quilt over my legs. We read a piece about the integrity of Archibald Cox by Derek Bok, president of Harvard. Then there was an article about women in *Soviet Life* magazine.

About housework: Miss O'Keeffe said she always enjoyed housework. The only thing she doesn't like to do is to squeeze oranges. It hurts her hands. Even though she has done a good many things with her hands, they are still weak. I commented on bathtub rings, and she said at Fisk University, where she gave a large collection of paintings and sculptures, the president's bathtub had a ring. That was Mr. Jackson's bathtub. She stayed in the Jackson home for the two weeks she put her show together. She described all the different problems she and Doris had putting the event together. They were removing light fixtures, taking wood trim off the walls, painting walls white, and searching for non-greasy meals.

Miss O'Keeffe is far from enthused about women's lib. She reported to me that, in effect, if the women screaming about inequality would go home and get on with their business, there would be no problem. I asked what she thought about unfair wages for women, and Miss O'Keeffe agreed that must be changed. She continued that she always had to stretch her canvases better, paint better, and in effect make a better show than her male counterparts. Miss O'Keeffe said that she could have been stopped at any point. There were just a few who liked her work. Later when criticized, she was pleased when she got a headline. Whether it was good or bad, no matter. If she was not on top, then she wanted out. Men didn't like her colors and the subjects she chose. "But no mind," she said, "I would probably have a closet full right now if no one had cared for my work." Miss O'Keeffe said that her early years, when she was surrounded by people who didn't care, were the best years of her career, because she was free. She said this emphatically. Because of this, Miss O'Keeffe doesn't know what to tell young artists who are not recognized. They don't understand when she tells them about her free years.

Then Miss O'Keeffe told me about a scientist who asked her and Stieglitz to keep his thirteen-year-old girl. They did not. During the Second World War, the man shot his younger retarded child and then himself. It haunts her.

Miss O'Keeffe feels that *Soviet Life* contains excellent photography. She remembered a most interesting thing. Mr. Rich of the Chicago Art Institute once said to her that women painters are rarer than women writers because you need more preparation to set up to paint, and you cannot be interrupted. A woman painter needs more leisure than a writer.

April 12, 1974

Tonight at Georgia O'Keeffe's. Resting in bed with my nightgown I washed in peppermint soap and dried in the sun. It is sweet-smelling. I rode to Santa Fe with George Miller, talking and laughing. We were talking about acting styles. We discussed the value of generosity in an actor who allows the other actors their "moments." There was a pleasant drive into Abiquiu with Ida, a quiet easy smiling lady. She taught me more words in Spanish. Miss O'Keeffe met me at the gate in her light blue "wrapper." We fixed a dinner of green *quelite* soup, cheese, and bread. (*Quelites or lamb's quarters are wild plants that grow in pastures in the Southwest. They taste very much like spinach. Miss O'Keeffe used them blended into a creamy soup.*) We laughed and carried on. I told her about deciding to make my own clothes since nothing seemed to suit me. I needed something with pockets. I bought thirty yards of brown, blue, and green material. The label said indestructible denim. These are dark basic colors. We laughed together. We will go on Easter Sunday to the monastery for the 5:00 a.m. service. Miss O'Keeffe says it will take an hour to get there. I'm going to do it. We had a jar of sweet pear preserves for dessert. What a wonderful sharing. I told her about the Castillejo book with a cover dedicated to her with a Datura (moonflower) blossom on the front. She seemed pleased.

Saturday night, 9:00, April 13, 1974

Today was extraordinary! At last I felt fully relaxed and at home with Miss O'Keeffe. For some reason I have been tense around

her until today. Perhaps this is the first day I have spent alone with her pretty much. She seems high. We have talked a lot.

She is very considerate of my vegetarian preferences. I remember several times she told me that she would be a vegetarian if she did not entertain so many people at her table, and it would be difficult to have everyone be satisfied with a vegetarian meal. Over a light dinner of millet, *quelite* soup, mint tea, cheese, radishes, rice crackers, and fresh apples, we talked and talked. We stayed long after the meal, and Miss O'Keeffe commented about a painter named Butor who was so poor in New York that he had to pose as a model in order to have a warm place to be. Last weekend Mr. Spink, the head of the Chicago Art Institute, sat across from her at dinner and described Butor's latest show in Paris. Even though Butor has enough money to be a wealthy man, he still wanders around the same as when he was in poverty. Miss O'Keeffe said he never complained about his lot in life and was really a sweet person. She asked Mr. Spink how her painting was doing in Chicago. He reported, "Just fine."

Then Miss O'Keeffe proceeded to describe to me the process of stretching the canvas and painting a 24′ x 8′ painting, the one on the catalog of her show for the Whitney (*Sky Above Clouds IV, 1965*). Miss O'Keeffe was very animated while she described the whole affair. Her long fingers were bending and unbending. She was rubbing her hands palm-to-palm as she described the anxiety, smoothing her napkin to illustrate a stretching technique with the canvas. She said she had a huge roll of canvas that she could barely lift. When I asked how she could stretch so huge a canvas, she laughed and said "Ask Frank." Frank is an Abiquiu man who was a sheepherder for a good many years. He stands about 6′5″. Sometimes he has a drinking problem. He is a real hard worker who understands how to take care of many little household problems.

When Miss O'Keeffe unrolled the canvas, she discovered it was a coarser weave than she had wanted. However, she knew it would be months before she could get a new shipment, so she

proceeded. After spreading paper on the floor in the garage at the ranch, she spread out the quantity of canvas to "let it rest." Miss O'Keeffe said she didn't know why a canvas needs to rest before stretching, but it does. It does better that way when you let it lie awhile. The canvas was like that for two to three days. A man from Texas had visited her and said he would return in a couple of months to help her with the problem in stretching. Miss O'Keeffe said she thought about him and decided she was as smart as he was, and could figure out how to do it as well as he could. She called her framer in New York and got some ideas. She and Frank set grommets (brass rings) around the edges and built a frame reinforced with steel edges. They laced the canvas onto the frame, and Frank tightened, strained, then tacked the canvas. Miss O'Keeffe said she had it arranged so she could stand on a table. She had two ten-foot long tables, then one six-foot plank to stand on. She sat on the table, then stood on a chair, then sat on a chair then on the floor in order to reach all parts of the canvas. Miss O'Keeffe brushed water over the whole canvas, then let it dry. The next morning the canvas sagged like a wash rag, she said. Frank rushed out and bought more supports and braces, and they set it right. Then she brushed on a glue base. The material was so coarse that sometimes she would brush, then find that the glue didn't stick. She brushed on another coat of glue, then white paint and another coat of white paint. Any coat of color that she put on had to cover the whole canvas in one day because there would be a line where she stopped otherwise. Frank would come to the ranch and mix huge amounts of paint for her in the mornings. She rose at six and painted all day. A girl from Abiquiu cooked for her. She found herself usually cleaning brushes at 9:00 p.m.

Two months it took her. Miss O'Keeffe said that in the initial stages, she lost the small two-inch sketch she had made so the painting was much simpler finally than her original ideas, which had something more happening in the center. Miss O'Keeffe said she hadn't begun to describe the difficulties she

had with that painting, wrapping it around a drum to ship to Texas. There were hassles at the Whitney trying to find a good enough place to hang it.

Over breakfast I learned about the Lake George house and the faithful maid Margaret who had worked for many members of the Stieglitz clan. Margaret was very quiet and didn't seem to see things, "but she didn't miss a dot." When Miss O'Keeffe went away for summer, she was confident that Margaret would look after little details so it would seem Miss O'Keeffe was not away. On the table where Alfred wrote, Miss O'Keeffe had the habit of arranging a dish with mosses, leaves, and little plants from the forest. Margaret did the same for him when Georgia was away. Miss O'Keeffe said Margaret was always referred to as "Miss O'Keeffe." (*As I recall, she may have said, "Little Miss O'Keeffe" since Margaret tried to make it seem a little like Miss O'Keeffe was still there for Stieglitz.*)

When I showed her the cover of *Knowing Woman*, which is dedicated to her, she responded, "Someone else noticed the beauty of the plant, and they felt they just had to give me credit." Miss O'Keeffe said she felt that her older brother was always preferred over her, and this was something that helped her in the long run. Miss O'Keeffe measured herself against him and decided she could do better than that and proceeded. "He died a gambler and I didn't."

At 3:00 a.m., we will go to the Christ in the Desert Monastery for Easter services, so I should sleep now. I will watch the crackling fire and let imagination drifts carry me.

We walked to the graveyard and back before dinner. I saw the morada (*a church for the Penitentes*). There was a half-broken horse on which a man rode up to us. Miss O'Keeffe said later to expect to roll beneath a fence if an animal charged.

(*I remember jumping and standing between Miss O'Keeffe and the rearing white horse. She said she was checking out the fence. I felt a little foolish to have made such a gallant gesture while she was being so practical. I had stood there with arms outstretched as if I could stop a horse.*)

On Easter morning I remember we got up at 2:00 a.m. and dressed warmly. I remember she insisted that I wear a long, heavy black wool cloak that was itchy but extremely warm. We ate buttered toast and coffee in the kitchen then rode in the back of a Volkswagen bus, driven by one of the men from the village. The way was smooth until we turned onto the dirt road just beyond the entrance to Ghost Ranch and just before the entrance to Echo Amphitheater. There was no sign to mark the road. Then we proceeded down twelve miles of a deeply rutted road that had been washed out by spring snow melt in places. In the darkness I could see the water of the Chama River below the cliffs we drove along. I was hanging on to handholds in the bus sitting next to Miss O'Keeffe. She simply sat there with hands folded in her lap. She said to me, "Sometimes you must just sit like a sack of potatoes." Inside the sanctuary at the Christ in the Desert Monastery, we were seated over to the right, apart from the small crowd. We sat quietly on benches leaning against the adobe wall, listening to Mass sung in Latin and Spanish for hours in candlelight. Finally, the sun began to illuminate the red cliffs I could see through the high windows behind the altar. It was awe-inspiring. After Mass we went to the front door of the Sanctuary and shook hands with the priest who had guided the Mass. He looked at me and said, "You must be Miss O'Keeffe's daughter." I replied that I was one of her helpers, and we went on to the delicious Easter breakfast spread out for everyone who had denied themselves sugar, chocolate, meat, or other pleasures for Lent. It was a very joyful occasion with lots of laughter. Miss O'Keeffe was surrounded by people who wanted a word or a handshake from her. I will never forget the beautiful moment of Easter sunrise on the cliffs after hours of chanting in the Sanctuary full of incense. It was highly inspiring.)

April 17, 1974

After immersing myself in Georgia O'Keeffe's world for a weekend, I find myself walking taller and feeling quite free inside. I speak a little louder. I have a very strong passion related to that woman in Abiquiu. It is very difficult for me to understand my strong feeling for her.

April 27, 1974, Saturday, Abiquiu

Early. Just finished Tai Chi Ch'uan. Then breakfast. We had fruit, toast, tea, eggs, and chile with garlic. Yesterday, I left work early to ride with Virginia Robertson, Miss O'Keeffe's former secretary who will work with Miss O'Keeffe this weekend. (*Breakfast always had a special fragrance. There was often jasmine tea or a very fine coffee. Then there was hot green chile with oil and raw garlic which had marinated in the refrigerator overnight. The bread was a meal in itself, containing whole wheat flour, probably soy flour, some wheat germ, freshly ground flax seeds, sunflower seeds. The butter was sometimes mixed with safflower oil. Eggs were cooked for the individual's taste, and there was often some savory jam like ginger and green tomato or sweet raspberry. The meal always began with fresh-sliced fruit and a small glass of very fresh orange juice. Sometimes I ate three slices of bread. It was so tasty.*)

Virginia is the widow of a past Dean of Oberlin Conservatory of Music, supposed to be one of the important music schools. We talked about acid rock music during the drive. Virginia believes that acid rock carries negative rhythms that are very harmful to the systems of the youth. I would like to hear a conversation between D. J. (a lawyer friend of mine) and Virginia. Last weekend at dinner at Nancy Tomasson's house, he told me that he thinks the classic music of the future will be acid and hard rock of today. D. J. is not inexperienced in music matters.

This has been a quiet afternoon of typing. Juan came by in the morning. He has had the stomach flu, and it left him weak. Virginia and Miss O'Keeffe sit in her bedroom and talk. At lunch we talked of Machu Picchu where Miss O'Keeffe spent three days. She said orchids grew within a few yards of the door of the place where she stayed. Being cautious of snakes she let the blooms alone, "so they just sat out there and looked at you."

Yesterday evening when we arrived, Miss O'Keeffe looked sad and tired. We negotiated the dogs, the lock, and the gate, then proceeded to settle in for the evening. Before bed we sat from

8:00 p.m. until 9:00 p.m. in the studio and talked. Miss O'Keeffe said that last weekend when Virginia left, she felt so tired she didn't care if she lived or died. We laughed and carried on with morbidity jokes. Miss O'Keeffe said Juan measured her to see if she fit in the long black box that holds sheets and towels in the studio. "He said it would do, but what a waste of a fine box."

Miss O'Keeffe wanted to go to New York this past week to see the Ansel Adams show, but she decided to avoid exposure to the stomach flu. (*She was very careful about exposure to illness. If someone who worked for her had a sore throat or a cold, that person was not allowed around Miss O'Keeffe until fully recovered.*)

Night, I am sitting by a fire.

Mrs. Robertson and Miss O'Keeffe are talking about musicians, true connoisseurs. Casals playing Bach, Suite #51 for Unaccompanied Cello, in D Minor, is beautiful, expert. They listen to Wanda Landowska singing selections from Monteverdi. Miss O'Keeffe said she knew the record well enough to fairly sing it herself. At dinner Miss O'Keeffe said Ernest Bloch and Stieglitz were close friends. Miss O'Keeffe knows Suzanne Bloch very well. Suzanne talks a mile a minute. Miss O'Keeffe does not know much about Beaumont Newhall. She does not care for Nancy, but didn't go into it. She was told by her dentist she had sprained a tooth and to take care eating on the opposite side of her face for a few weeks. Dressed in white today, she had a robe-like dress which went to her calves, cinched with a thick white elastic belt. She is wearing her usual black flat shoes. Last night I remember Miss O'Keeffe talking about how carefully Ida trims toenails. There is no pain, no tenderness. She cannot see well enough to trim toenails. The fire is so crackly, beautiful.

We picked Lilies of the Valley. Bleeding Heart is one of her favorite flowers. She mourns her sight when she can't make out the flowers. I would offer her an eye as an open flower if I could. (*I remember Miss O'Keeffe urged me to pick as many little lilies as I could carry under a cool shady tree. It was blissful to be picking so many*

with such a fragrance. I felt a little bit intoxicated. I carried them back to Albuquerque and kept them fresh as long as I could.)

May 18, 1974

Today is a warm day at Abiquiu. I was summoned here this weekend with the news that I would not, after all, be staying two weeks in June with Miss O'Keeffe. Just a while ago Juan asked me if I was still coming up here June 1–15. I told him I thought he wasn't going east after all. He said he wants to be relieved of the paperwork so as to work on his pots and the garden, and also get some rest.

Today I read short letters to Miss O'Keeffe and typed brief answers and polite replies as she dictated them to me.

One heart-rending letter from Anita Pollitzer's nephew entreated Miss O'Keeffe to release Pollitzer's biography for publication. He claimed that Anita had become emotionally withdrawn and should have her creative work freed for the public eye. While I read, the sensation in the atmosphere of the studio was one of intense care from Miss O'Keeffe with great sternness. I felt chills. Miss O'Keeffe raised her eyebrows after I finished reading and folded her hands in front of her on the plywood table. She explained that the answer would have to be a long one. She said that Anita had written a book about her, but Miss O'Keeffe refused to release quotations to be published. Miss O'Keeffe said that she was no judge, of course, but Anita's book was just not well written. She repeats things and quotes Miss O'Keeffe as if she had never heard a word she said. Even though many people have told Anita that it is a good piece of writing, Doris Bry agrees with Miss O'Keeffe that it is badly written.

Last night when I arrived at 9:00, for an hour Miss O'Keeffe and I shared news. We laughed heartily about Juan planting forty cabbages in the less-than-an-acre garden. Juan came in to dinner one evening and said, "I just planted forty cabbages. We will make sauerkraut."

Miss O'Keeffe replied that she had never made sauerkraut and Juan said, "Well, we'll just have to learn." Miss O'Keeffe put both hands over her face sometimes in this story laughing and talking in a high-pitched tone as if she could barely get the words out. This morning I certainly read some gushy letters about how people enjoy her paintings. Norma Moore of Santa Fe is washing and grooming the chows Inca and Jingo. They look fluffy and feel clean now. Norma with a braid over her lightly groomed head really loves to talk.

About two weeks ago, Mrs. Robertson, Miss O'Keeffe's former secretary, had a mild heart attack. She has been confined to bed and is rather uncomfortable. This weekend Mrs. Robertson didn't feel like coming to Abiquiu yet. She and Miss O'Keeffe are working on Miss O'Keeffe's autobiography together when they can. It is a great relief to me to know that she is writing this autobiography in her own words. Then the historical perspective may not be distorted by other eyes than her own.

May 19, 1974

It is a warm windless morning. At 2:45 a.m., the dogs woke me with their barking. Looking out the window of the door, I saw red, bushy, bear-like Jingo standing at attention, barking fiercely at the gate. I crossed my dark room and peered between thin slats of venetian blinds. There, lowering his horns and snorting, stood a bull. I carried a light out and his eyes shone green in the darkness. This was enough to make me superstitious if I had not been numb with sleepiness. I shouted, "It's Carol. Come look at the bull!" The creature moved to the far end of the drive and was no more than glowing eyes and a dark form.

Scrambled eggs, mushrooms, fresh radishes, orange juice, jasmine tea, muffins, whole wheat bread, butter, and honey were for breakfast. Little salt cellars were at each plate. A glass vase filled with purple and white irises made a heavy scent. A fire in the corner was crackling away with doors open for fresh air, and the sun was streaming through curtains. White saris have

been made into curtains. There is talk about the art auction next week. Doris will bid on her paintings if people do not bid high enough. Parke-Bernet is the big important auction house.

Claudia, Miss O'Keeffe's sister, is attending the horse races this season in L.A. Last night I talked with a sweet lady named Irene who has cooked this weekend. The description needs time.

May 28, 1974, Wednesday night

Miss O'Keeffe called this evening at eight o'clock to say, "I think you misunderstood. I don't need you to come for two weeks in June. Juan is not leaving. But if you will come with Mrs. Robertson on Friday afternoon, you can catch a ride to work on the weekend." (*Juan and Miss O'Keeffe disagreed about what my job should be at this time.*)

"OK," I said. "That is fine." In my heart I had halfway expected Juan to leave or talk her into having me there for awhile. But she has an obdurate will when determined. My afterthought was to call back and say that I could not go for some lame reason, then I decided that was foolish. I don't need to act so proud. I am simply a clerk with skills of a repetitive nature to share. My modest insights on the world are of little use to her except as a diversion from her cares. Last Sunday morning after breakfast, I showed her how to do the self-massage technique from Professor Huang's book. We laughed and enjoyed the experiment. Then this week I sent her a copy of the book.

May 31, 1974, Friday

Today Virginia Robertson and I drove from Albuquerque to Abiquiu together. She told me that George Miller, my boss at the University of New Mexico Library, had quite a breakdown at St. John's College in Santa Fe before he left. We stopped at Conscious Cookery in Santa Fe for a very refreshing meal. Then we drove on through cloudy and dramatically lit country with a dim rainbow. She told me how she and Miss O'Keeffe work on

the autobiography together. It is not for anyone's eyes yet, but it is good, says Virginia. Virginia takes what is written and helps to proof and edit. She says Miss O'Keeffe is a great writer.

Virginia is maybe six inches shorter than I am. She walks stiff-legged sometimes because she fights injuries incurred from a car wreck. Four weeks ago she had a mild heart attack from pinched nerves. I am concerned for her health. Sometimes her voice is higher than it should be. She seems to have an intensified feeling for beauty today, gasping over the dramatic lighting on the land through clouds.

Miss O'Keeffe was wearing a blue and white kimono over her nightgown when we arrived at 8:00 p.m. I gave her a loaf of bread with walnuts and apricots in it. She sat on the white sofa in the kitchen eating bread and butter and told Virginia and me how the flowers and flowing lines on her kimono gave her the feeling water flowed over her. Groups of blue flowers on white with three parallel lines flowing around and between the groups give the feel of water. I called Miss O'Keeffe's kimono a "flower fall."

I have bathed and laid reading for an hour between fresh sheets. When I arrived with Virginia Robertson, Miss O'Keeffe immediately took me to Claudia's room for me to sleep there, and she pulled back my covers. It was such a warm gesture. Tonight after dinner in Santa Fe, Virginia and I explored a shop in Santa Fe Village with jewelry and rugs in it. I found a beautiful necklace of amber beads. I just now remembered the end of a dream where I was in a bazaar where I heard another language and saw a beautiful and meaningful necklace. It was the dream that started where Professor Beaumont Newhall told me by the Chama River that he would show me how to understand the river. Then he disappeared in mist. I fell in the river then miraculously climbed out of the swift flow after giving up. Then a woman took me to the place and gestured to a necklace. Then she walked to a necklace. Then she walked away. Tonight in the shop, a very lively

family was discussing jewelry in French. My dreams are sometimes echoes of future events. What does this mean? Sleep now.

Friday, Abiquiu, June 15, 1974

Six hours I was in the book room listing books. At last I have time to sit before dinner. I found the book called *Ceylon* that Miss O'Keeffe wanted to see for the sculpture garden.

This week has been a very strong time for me. New poems are growing.

Here I sit in this white room with the brown door in a black chair. Brown cork tile floor. There is a tan comforter for a white bed, a tan telephone, white stool, and a brown and black fireplace carved in mud in the corner. There is a simply designed wooden desk with a basket waste can, a hand-carved wooden trough holding wood with a basket holding small sticks for kindling. White curtains cover an east wall full of windows. One huge canvas, maybe 5' by 4' with grey and white blending on lower two thirds with yellow to green to blue on top, like a horizon just after or before the sun. (*It looked very much like* Sky Above Clouds / Yellow Horizon and Clouds, 1976/1977.) There is a gas heater in the wall. I sit quietly.

Sage growing in the courtyard has an antiseptic odor, very pure, very clean. Jingo, the rust-colored chow, and Inca, the black-and-grey chow, pace the courtyard outside. I sit here simply waiting for the cowbell to summon me to dinner, my weight pressing into this soft chair, and sandaled feet flat on the ground. I am still for a while, and myself. There is a guest for dinner. He is a classical music collector and a very cultured man. Dinner should be fascinating because Miss O'Keeffe spoke of him with great favor. This was a large man who arrived with a lovely basket of wild mushrooms from the Santa Fe Ski Basin and a new record of classical music for Miss O'Keeffe to hear as well as stories of his recent travels. I was just very quiet. While listening to the music, I felt transported.

June 17, 1974

Miss O'Keeffe said last Saturday at lunch that she had read a good many articles about how much women were accomplishing in sports, beating records and going faster and longer. She thought it was a mistake for women to tip their hand. We can act weak and sick and female all the while knowing secretly that we are very strong.

June 21, 1974, Friday

My life is full of interruptions. Last Saturday, home from Abiquiu, tired, disappointed with Miss O'Keeffe's grouchy temper, I found my brother camped on my doorstep.

August 6, 1974

Several days before I had decided that I definitely wanted to go work for Miss O'Keeffe again, I remembered crying on the way to Santa Fe a year ago with Ida driving when I realized I had lost the secretarial job to Juan. I was offered the job, but when I hesitated, Juan was offered the job, and he took it.

Sunday morning Miss O'Keeffe called me to type a chronological list of her paintings for her book. OK, I will. Mrs. Robertson called today and explained about the list. She said that she would leave it in my door and thanked me for taking some of the typing load off her shoulders. Miss O'Keeffe invited me to bring it to her on Saturday when my parents and I are in the area. Mrs. Robertson said Viking Press will publish it in their Studio Books Series. Miss O'Keeffe had asked Mrs. Robertson if she ought to find an agent to take the manuscript around to various publishers. Mrs. Robertson in her own words, "Isn't that kind of grand?" Mrs. Robertson then told her she could probably pick a publisher then phone the president and tell him she might let them publish her autobiography. There will be many color plates. Viking is sending work to Japan, Switzerland, and around the U.S. to

find the right printers for the plates. Mrs. Robertson had post-poned her marriage to a wealthy Texan until December to fin-ish the manuscript. The publication date will be a year from September. I am excited to contribute even in a small way to this historic event, Georgia O'Keeffe's autobiography!

August 10, 1974

—Christ in the Desert Monastery

My parents arrived late yesterday. Today I drove them through Madrid to Santa Fe where we had bowls of soup. Then we drove through Española to Ojo Caliente through El Rito. We stopped in Abiquiu at Miss O'Keeffe's. I took in some un-yeasted bread and Castellos cheese. She was delighted like a little girl. When I walked to the gate, both dogs, red Jingo and black Inca, barked at me. Criselda came to the door to see what the fuss was about. I shouted that I was Carol with a gift for Miss O'Keeffe. She motioned me to the garden gate where I could be let in without letting the dogs go. She said as we walked along the flat stones in the patio, "What brings you to this part of the country?" I explained that my parents and I were on our way to the monastery. She asked me to say hello to the fathers for her, Criselda Dominguez. I was allowed to go into the studio where Miss O'Keeffe was on the phone with someone talking about welding. Then she came over to me and asked if I was on my way to be a holy girl. I explained that was later, that my parents and I were to stay at the monastery for one night, and I brought her a fun gift. She said she was so excited. I opened the sack on her plywood desk and showed her the cheese. She asked how I knew they were out of cheese. I said she must have told me by telegraph. Then I showed her the bread and she was beside herself with delight and insisted that we both go to the kitchen and try them both together. She asked if she should invite my parents then said she disliked to share even a few slices of her special bread. We laughed in the kitchen with Criselda about how heavy it was.

We sat down on the white sofa together with buttered bread and cheese. She said to me, "Put up your feet like you were going to stay awhile." Then Miss O'Keeffe told me about a houseguest who had been there four days when she finally said she liked Richard Nixon and didn't understand why we were making such a fuss. Miss O'Keeffe said she almost threw the woman out. (*I saw Miss O'Keeffe watch television twice: once to follow the Watergate scandal and another to watch fireworks in New York during the 200th anniversary of the United States.*)

Miss O'Keeffe said she had looked for a Thomas Merton book and had trouble locating it, also a Tamayo book, and finally found it on the floor shelf. She said she didn't know how she would ever find books in her room. I said I could make little cards for her with title/author/publisher/place, and she said what would she do if someone misplaced a book. She said she must sell them. Criselda said Abiquiu needed a library. Miss O'Keeffe asked me to mail her the list of paintings as soon as I could. Then she mentioned the *Secret of the Golden Flower*. I have my work cut out for me. We discussed food and triticale flour. I promised to make something from triticale flour.

Whew! What a day. There were hours of driving. Then there were the delights of meeting Miss O'Keeffe again. Then we went along twelve miles of hard road with my mother hugging the dashboard. We settled in at this rustic place and had a light salad together. I am writing by kerosene. The bread was a little doughy so I told Miss O'Keeffe I would try again. She seemed pleased. What a cosmic lady she is.

August 11, 1974

Miss O'Keeffe told me that an old boyfriend of 16 or 17 came to visit her a few days before as he did every year or so. I commented, "That was devotion." (*What I remember is her story of a little boy hiking on trails and roads at Ghost Ranch who became her friend one day when he happened to find her house. Then he visited her annually*

whenever his family returned to Ghost Ranch. He liked to call himself her boyfriend.)

August 12, 1974, Monday night

Miss O'Keeffe said Saturday that it was difficult to find the books she wanted in her book room. She said she really must sell them. I spoke to George Miller today and asked him what to say to her about the UNM library possibly buying them. I told him that I remain silent because, in all honesty, I do not feel good about the way the library warehouses books, and her collection should be cared for. He said I could always suggest that she give the books to the University of New Mexico Library.

August 15, 1974, 10:30 a.m.

For Miss O'Keeffe I have many things to do: Get Castello cheese from Portugal; make triticale bread; read the *Secret of the Golden Flower* onto cassette tapes; type the list of paintings for her autobiography. I feel it is a reverent duty to serve her, a very "high" lady to be sure.

(Around this time, I visited the Christ in the Desert Monastery for a week of silence, meditation, reading, cooking, working.)

September 15, 1974

Last night as I was building blueberry tarts to go with miso soup, waiting for my dear friend John (*hereinafter referred to as JLH*) to pick me up, there was a surprise. At my door was Juan Hamilton and a friend of his, Susan. He had come to tell my neighbor Meridel Rubenstein that Miss O'Keeffe liked her article very much. He asked me if I could take some weeks off to take his place in Abiquiu while he took a vacation. I said three weeks maximum, two weeks comfortably. He said that last week someone had left a decapitated dog's head on his porch. He moved out of his house and is now living at the ranch,

but doesn't have a sense of home there because it is all Miss O'Keeffe's. He called Peggy Kiskadden (sixty years old) to come and stay because Miss O'Keeffe needed someone to help her dress, help groom her, and help her use the bathroom. Peggy Kiskadden had said to Juan (among other insults) that he was acting like a sixty-year-old capitalist. He had accused her of calling Miss O'Keeffe a spiritual murderer for causing Rebecca Strand to commit suicide. Juan said Rebecca had some identity crisis by dressing like O'Keeffe and acting like her. (That's all he said.) He said also that Doris Bry is giving him trouble periodically. He was worried about his owing me a paycheck. He said that he had received two letters from me, and I had never mentioned whether or not they owed me money after he had asked twice. Doris had warned him about people suing for past wages. I reassured him that no money was owed, and now I should write him to firm it up. He said that Chicanos from Santa Fe had asked Miss O'Keeffe for money, and she flatly refused. Several days later, jewelry was stolen. Then he spotted some men from the group examining the area where the thief escaped. Juan said these men saw him carry a shotgun inside the house, and the men left quickly.

September 27, 1974

This is the start of a three-week adventure. I am going to stay with O'Keeffe at the Ghost Ranch. JLH brought me to the Continental Bus station and helped me get myself together making sure my bag was on, carrying things. I am going to stay while Juan goes to Vermont to get his things from his parents who are leaving for Puerto Rico. I will be paid $150 per week.

—Santa Fe bus station

I rode next to a very large, grey-haired, Anglo-looking woman who spoke Spanish. She had with her a large basket as huge as her stomach filled with things for her grandchild sleeping in

the seat across the aisle on her mother's lap. There are candy wrapper crackle sounds and sometimes a baby squeals. I will be riding into Española to be picked up. The day is sunny, chilly, and windy in Santa Fe.

—Española

I am waiting for someone to pick me up from this motel bus stop. There is a large, very loud clock in this living room waiting room. A buxom dyed-blonde in the next room is rattling keys watching traffic go by.

—Ghost Ranch

This was a busy evening. Juan picked me up in the Mercedes and showed me how to work all the gears, buttons, and dials. We drove laughing to Ghost Ranch. Peggy Kiskadden over the phone chided me for not telling them yesterday to pick me up. I replied after silence that I couldn't do anything about that now but was willing to wait.

Peggy Kiskadden, Miss O'Keeffe, Juan, and I had a simple dinner prepared by Ida from the village. Peggy was raised in Philadelphia. She has a polite, matter-of-fact manner. She has raised seven children. Four of them are hers. During and after dinner there were numerous jokes from Juan. He is very excited about returning to his Vermont home to see his old possessions from high school. Juan laughed at Miss O'Keeffe for drinking Ajax which is what her crushed up calcium pill in water looks like. Peggy has showed me Miss O'Keeffe's exercises for her arm.

Miss O'Keeffe fell three weeks ago and dislocated her left shoulder. Luckily, she is right-handed. She wears a sling and a shawl which covers and warms the shoulder and arm. Here I am sitting next to a fireplace in the studio beside my bed, and I just spotted a huge round brassy pot with wood boxes and a basket on top. The pot I am sure was in Stieglitz's gallery, *An American Place*. I saw photographs of it.

Miss O'Keeffe needs lots of attention while she regains flexibility. She is a perfectionist for arranging things around her. I shall try to describe the studio over these next days. Now I hear her heavy breathing in the other room. Peggy tells me to get used to irregular sleeping. I will learn the medicines and exercise her arm like a physical therapist.

Peggy knew Bertrand Russell and his last wife, Edith, who devoted her whole life to him unequivocally. Peggy said, "Bertie didn't know about love until Edith. He had been rather adolescent in his emotions until he received her utter devotion." She has several stories about that grand old man.

Peggy says, "Georgia has always been brave as a lion until recently when she is all tensed up in pain in her shoulder." Peggy seems to think it is shock and fear which make her so whimpery. For myself, I feel shock and fear are another form of pain. Peggy said she would like Georgia to go quickly (die?) in the night instead of being reduced to a quivering bunch of pain. I suggested that Miss O'Keeffe had always had an awareness of her mortality with so many skulls around. Peggy said in all their conversations she had never heard Miss O'Keeffe refer to the fact that they were once living, now dead. Rather, they are beautiful forms to her. I'm sleepy now.

September 28, 1974, Ghost Ranch

Evening is here with a nearly full moon and pale sky in the west, deep blue sky in the east. Just a moment ago the land was bathed in reddish luminescence.

This afternoon I sunbathed while Peggy Kiskadden did her needlepoint work of a New England snow scene. Criselda, the Spanish-American cook, came out and showed us photos of her precocious children, all ten of them. We ate some excellent bread. *Divine, celestial* are adjectives Peggy used to describe it. Peggy said Georgia particularly enjoyed the saying, "Old age is not for sissies." The saying came from an old friend of Miss Kiskadden's, she said.

—9:10 p.m.

The household is settling down for the night. The curtains are open for Miss O'Keeffe to enjoy the stars and the moonlight. Medicine is given. Doors are locked. Jingo is on guard in the patio. We listened to Ashkenazy playing the Beethoven piano sonata *Appassionata*. Miss O'Keeffe apparently has a collection of about five records of different artists playing that sonata. She and Miss Kiskadden had one evening played them all and decided that a late Richter was the best. Then tonight the record came up to standard, so now they will have to discuss the skill of both and listen more to compare and decide. This morning after breakfast we all three walked toward the cliffs and watched a flock of blue birds eat juniper berries. When we came upon some horses, Miss O'Keeffe immediately turned back, afraid. I had a long stick and tapped one on the front, and they ran off. Miss Kiskadden later said Miss O'Keeffe had never before exhibited such a fear of horses and had probably repressed it. I think anyone who grows feeble fears things that were not threatening when they were stronger.

Tonight, after supper on our walk, Miss O'Keeffe described Ida Rolf, who used to come twice a week at 9:00 a.m., massage her, and leave her feeling like she was walking on air around New York City. She said she used to call Rolf "the big horse" because she was a rather large, strong woman. Miss O'Keeffe said Ida Rolf used to pick up her pelvis with just her fingertips. She had a very special talent in her hands that most people do not have. Once Ida Rolf put her (O'Keeffe's) arm out of commission, and Miss O'Keeffe couldn't even pull up a blanket over her. She quit seeing her, but recently started going for rolfing to Jan Sultan of Santa Fe.

I fix her clothes and help with things that take two hands. I am learning about the little things, like closing the curtains to keep the rising sun out of her eyes. This morning while I did Tai Chi Ch'uan, Peggy and Georgia wrote letters, one to Bram

Dijkstra to compliment him on his book, *Hieroglyphics of a New Speech*, particularly favorable about the chapter on Stieglitz.

September 29, 1974

A full day. I rose at six to fix breakfast with Peggy, learning where the vitamins and orange juicer are, learning how to set the table. Peggy busied around and left for her plane at 9:30 a.m. She even left instructions about how to brush Georgia's shoes. She fussed over Georgia, who got uptight about her making beds and doing the breakfast dishes, and told me that Peggy should pour some of that energy into her needlework.

I made a roaring fire to toast Miss O'Keeffe's chilly feet. Then we went to the sunny kitchen and scrubbed her head. Her hair is really fine and silky, but it TANGLES! We were there until 11:00 a.m., untangling. Even so, I continued re-combing it through the day. Juan came and made his usual jokes. I left them alone to talk in the sun, drying Miss O'Keeffe's hair. Criselda brought Juan a bowl of melon, a banana, and an apple. Miss O'Keeffe went on about how he ate up all the fruit. Juan put on his mocking voice, mimicking her shrill tone, and she laughed and laughed as she does with Juan. Miss O'Keeffe's cheeks get very pink when she laughs. I took time out for showering and scrubbing my hair. What a glorious time to be alone and not on-call. I stood for moments under icy water. How invigorating!

The three of us had lunch together. Around Juan I find myself not too relaxed, pretentious even. I am not sure why, except perhaps I remember in the back of my mind last year when we competed to be Miss O'Keeffe's secretary. Apparently, Juan has been talking me up. Peggy commented on how fine and dependable I was reported to be. Today Juan said to Miss O'Keeffe that I was the only person he felt secure about leaving her with. He thought we would get along fine. She agreed. For the afternoon Miss O'Keeffe slept, and I did Tai Chi on the patio. Juan sunbathed and talked to Criselda in Spanish. Then

I bathed Miss O'Keeffe, a memorable occasion. I soaped the places she couldn't reach. That lady has dignity even without her clothes! I am practicing with great care to look away and give her privacy when she doesn't need my assistance. When we did exercises together, I practiced with her so she didn't feel that I was just ogling. She has to lean over swinging arms front and back, then in a circle to loosen her shoulder. Then I lift her left arm as high as she will let me to the side. Her arm trembles and has great resistance to movement. (*I had been taking classes in foot reflexology, and she appreciated foot massages to help her get better.*)

We had a fine dinner after I read to her on the patio in the sun from a catalog of the St. Petersburg Museum with a red poppy on front. She listened with head propped by her hand and elbow. Then she said, "Very interesting." She had me read one sentence twice about intellectualism in the West vs. the emotional-intuitive East. At dinner, we chatted about old friends, starting with Mary Hamlyn of Taos, who met Miss O'Keeffe at an Indian dance and invited her to a wedding meal. Mary will come for dinner next Sunday. I got the impression they had met only twice. Mary's husband chased, killed, dressed, then roasted a goat for their wedding meal. Miss O'Keeffe told me about Mary having a party and locking Brett into the bathroom.

Then she described a man named Charles Collier who taught her to drive and showed her Ghost Ranch for the first time. His first wife died just this year of bone cancer three days after their divorce, and they had been married forty years with five children. He has a new wife who had been living in Mexico and came to live across the street from him at his invitation. His first wife rigged up some legal gimmick where he could not speak to the lady. Miss O'Keeffe said she had seldom known of anyone who performed as badly as he did in this affair. He wrote letters to many people who didn't even know him well enough to care about the affair. Once his first wife said to Charles that Miss O'Keeffe would never speak to him again just as many of his friends would no longer do. He immediately called Miss

O'Keeffe and she talked to him. "Of course," she said to me when I asked her if she talked to him. "He was an old friend."

For her walk Miss O'Keeffe wears a headdress of a black scarf pulled back like an Arab or a nun with a shawl over a short black silk kimono and fragile bluish-white blouse. It is the blouse with little knots for buttons. She has long flannel black pants that fit very loosely. Off we walked to a tree one-half mile away with a folding chair. Then we walked further. I had a staff in my hand. Jingo was prancing proudly around the countryside. Miss O'Keeffe described happy times with Georgia Engelhard (Alfred's niece) with whom she explored the Gaspé in Canada. There they found thick forests, and in one place a sign that said, "Seals and all kinds of birds." There was a little cottage on the beach with two huge waterfalls, one that fell into a spray on a mossy place. There was beauty everywhere. At a place with hot pebbles they would paint awhile then walk. At Lake George they used to take out into the woods and walk for miles without clothes. Georgia Engelhard lives in Switzerland with a mountain-climber husband. Not long ago someone found a painting that looked like an O'Keeffe and wrote asking. Miss O'Keeffe sent the photo to Engelhard who confirmed it was her own. So their styles were quite similar. Tonight we went through the pill routine and foot and back massage. I am very careful of Miss O'Keeffe's fragility.

Miss O'Keeffe liked a book by William Carlos Williams. The correct title is *In the American Grain*.

This evening at the end of our walk, I stopped and said, "Listen, you can hear the electricity going through the wire." She grinned. I had that one spontaneous moment in the day. Otherwise, I am pretty stiff yet, silent before speaking, a listener. I particularly enjoyed her story of hiking in the Virginia woods in college days with a blanket tied around her hips, at night pinning it round her like a light sleeping bag.

She said about her teaching in Texas that she first showed the students how to fill a square space in a beautiful way, then a

round space. She taught them how to address an envelope with a special touch. When she was art supervisor for a large area, she made boards of grade-level examples of art to show distraught teachers who couldn't seem to get their students to work. Then they could see what she could get out of the students.

Juan said when Miss O'Keeffe is really mad she doesn't say a word.

Monday, September 30, 1974

Tactful reserve is my motto. Eyes and ears are open, but I am quietly reserved.

I am very tired tonight and will no doubt sleep well. When Juan and Miss O'Keeffe are together, I like to leave them alone, partly because Juan says she gets jealous, partly because they have their own form of communication.

Miss O'Keeffe's arm is more flexible. The pills made her dopey all day so Juan talked her out of sedatives. He said, "Wake up; feel the pain; go back to sleep." I am learning about kimonos, shawls, scarves, blankets, etc. Putting a stool under feet before requested. There is a secret, remembering what she liked before. Today the cook was ill, and a lady could come for lunch, but I fixed her breakfast and dinner. Whew. Juan showed me about correspondence and a temporary file.

I lay in the sun and read while Miss O'Keeffe napped. I am working more on the Summerhill paper for my bachelor's degree.

Before lunch we took a short walk. She said she had lived through two wars and Stieglitz. She first went to 291 to see what modern art was being done in America instead of museum examples of what we seemed to be through with. She lived with Stieglitz for thirty years. He had a hearty constitution, but he was inconsistent. He could get up saying one thing, change it around by 10 a.m., and change three or four times before evening. That is why it would be impossible for anyone to do a definitive biography of Stieglitz, she said. He was different things to different

people. He never forgave her for coming out to New Mexico in the summer to get away. She stayed longer and longer and had a friend keep an eye on Stieglitz and report to her. His doctor roared his disapproval when she left. She said he had it in his mind that America should have original artists, so Stieglitz encouraged them and found money when little was spent to support the arts. He could find artists and keep them alive. He also had an idea in his head that a woman must do something. She said they inspired each other. They were assets to each other, not competitors, because each was in another field.

She spoke of her profound depression when young men were sent away to the First World War without even knowing where they were being sent. I must go to sleep now.

October 1, 1974, Tuesday

A busy day, but I am not as awfully tired as I was yesterday. The chows are barking at horses or the moon outside. Miss O'Keeffe's heavy breathing is coming from the next room. She sleeps now without sleeping pills and rings for me a few times in the night to move shawls and covers around, get water, tell the time, etc. It takes a few minutes for me to get back to sleep, so I read *Hieroglyphics of a New Speech* until I doze.

When I am with Miss O'Keeffe, I reflect on old age quite often. With all her fame and money and talent and famous acquaintances, influence, and power, she cannot regain her youth and original vigor.

Tonight, I am sitting on the ground near a piñon tree beside the trail to the cliffs, leaning on a walking stick facing her seated on a wooden folding chair, as a pupil at the foot of a sage. We watched the sun set, and she said, "Imagine, having someone help me with every little step when I used to run up and down here all the time."

She gestured to different parts of the cliffs as her favorite places. She didn't like to go where there were rocks and most

likely snakes, but stuck to the "good earth." I told her the cliffs looked like curtains, and she said she could show me where there were some white rocks that really looked like curtains. She wandered and wandered, trying to find the base of those pillars and finally, by accident, decided to go up an arroyo and found herself at the base of the pillars.

At dinner tonight I commented, "Juan asked me if I was going to be bored here. He was concerned that I might be bored. I told him certainly not bored, awestruck maybe, but not bored." She seemed to particularly enjoy *awestruck*, saying, "That's a good word: *awestruck*." The land here is so vast and dominating; that is the word for it.

This morning and afternoon, Miss O'Keeffe slept and slept. She said to me that there wasn't really much worth doing except to sleep. I felt sad over that statement and several others like, "I'm just a remnant," or "I'm in little pieces," or "My left arm doesn't even belong to me anymore."

While she napped, I took an excursion to Abiquiu to pick up mail. On the way I had time to think. What makes her happiest? Juan makes her laugh. She seems fond of talking about teaching in Texas. She is very proud of her pot. She likes to feel better than anyone else. So I have asked her to teach me to paint or draw in three weeks (chuckle). When I said I would start with something easy like her small black rock, she said sternly, "Try it." When I said I would trace it she said I would still have a lot to do. I pointed to the sunset and said one certainly couldn't paint that light. She replied that a palette is quite limited, white to black, compared to what you can find in nature. We will try pots in two days.

I got uptight about Juan not even asking about me but wanting only to talk to Miss O'Keeffe. She was delighted, really cute. She enjoys someone being jealous over her, being envied. I revealed one of my dreaded vices which is chocolate ice cream, and we had a decadent feast of chocolate ice cream and cookies laughing like schoolgirls when she said, "All I want to do

is sleep." I told her she had a lot of wisdom to impart to me, simple and otherwise. I asked if painting would help me write poems better. She said painting starts you seeing things in a different way. This morning when we took our walk, across the achingly blue sky was a long fluffed-out ribbed jet vapor trail. She said, enthused, that she would like to make a pot with that feeling. I have looked at more today, with feeling. She explained how to shell and crush cardamom seeds. She asked why it seems many members of her entourage seem to hate one another. I replied that they vie for her attention and compete because she is a very powerful, influential lady. That was simplistic but, to some degree, true. She said the only person who was not like the others was Betty with whom she traveled all over the place to Peru and the Orient. I'm getting sleepy.

October 3, 1974

Yesterday evening Miss O'Keeffe and I walked to the cliff and back. She said she had a dream of being a white bird with huge wings, gliding in the air or floating still in the sky. She said she had never seen the kind of bird she wanted to be.

This noon she talked of a lunch with Ettie, Carrie, and Florine Stettheimer. Florine commented she had never seen a fly before when one buzzed across the table. Miss O'Keeffe asked how she knew it was a fly. Florine said she had read about them. Seems a petty thing to mention, but her face was so lighted up that I decided she had a good time with the Stettheimers.

I must remember to read Kandinsky's *Concerning the Spiritual in Art*.

This evening at 4:00, I drove Miss O'Keeffe to Echo Amphitheater and she pointed out a huge Modigliani in the cliffs. That amused her because it was so enormous. As we walked up close to the cliff, we came to a Douglas fir growing at a slant from the trail. Miss O'Keeffe said, "Look at that tree!" in a commanding tone, and I looked. I shouted, "Hello," and "O'Keeffe," to hear

echoes. She told me yesterday that she had taught a number of young people to see the red hills here.

I asked her how, when looking at a thing I was reminded of many other things, how could I get all those other things out of my mind to just see. She replied, "Why should you?" We listened to Beethoven's piano sonatas: *Moonlight, Pathétique*, and *Appassionata* played by Serkin. I found myself alternately crying and looking at many beautiful forms in diffused light with racing clouds. This morning I woke up crying because of little sleep. I was up with O'Keeffe several times because she was in pain from her shoulder. I just want to smooth her face like sand, make her young and hand her back her brushes. But I can only hold her clothes for her and hold onto her while walking and tell her about flowers and colors in the sky and cliff forms and birds and spread blankets and shawls and watch her sleep. That is the most I can do.

October 4, 1974

On our walk this morning, we saw a cloud shadow on part of the cliff that is usually bright, and that made the whiter stones below crisply stand out. Miss O'Keeffe said, "Oh, look at that. Isn't that beautiful." We were very busy moving paraphernalia from the ranch to Abiquiu.

Today Miss O'Keeffe told me about Jackie Suazo, a young boy whose mother drank when her welfare check came, and Jackie attached himself to Miss O'Keeffe who gave him all the milk and fruit he would eat. He would ask for money for one thing and another, then work it off for her.

One day she saw the young man slouching across the town square as if he was a ruffian looking for someone to beat up. This was Jackie Suazo. Yet he was a perfect gentleman at Miss O'Keeffe's home. She let him use a room and have a phonograph. Jackie would come there after school instead of going home. The young boys of the village were jealous that he had

better things than most of them. Furthermore, he was illegitimate. Jackie Suazo is now very fat, and he has studied for two years to be a policeman. Miss O'Keeffe said he would be perfect because he knows all the tricks. He was always being arrested for something. Once he knocked over a sheriff and hopped in the sheriff's car saying, "Ok, now, arrest me." The sheriff was afraid to get into the car.

Years back there was an ornate roof over a telephone in Abiquiu. You had to take your own bulb to the place, screw it in, make your call, and carry it home.

Then she told me about Eduardo whose grandfather was a Penitente and had straight up and down ears with no slant to them. He would wake up Eduardo to see the morning star. He started teaching him Penitente songs, then quit, saying they were too difficult. Her arm is more flexible now.

October 6, 1974

Over this weekend I remembered looking out the studio window toward the cliffs in early evening and noticed the reflection of a cow skull on the wall behind me, dramatically lit from the bottom with white light so that the skull appeared to float above the cliffs. It reminded me of Miss O'Keeffe's painting of red hills, skull, and a flower (*Ram's Head, White Hollyhock—Hills, 1935*).

Miss O'Keeffe has been difficult lately. We were wearing on each other's nerves. She was criticizing me for not doing things that she had not told me to do. Miss O'Keeffe told me she had a studio in Taos for years and went to Abiquiu a few times a week to stay with a friend who was a good cook and made any visitor feel it was his or her house.

October 8, 1974

Morning. Miss O'Keeffe's talking book is mumbling in the other room. She is listening to Adelle Davis's nutrition book called *Let's Eat Right to Keep Fit*. There is mist and fog in the valley.

Yesterday was a good day. Sunday I got back at 6:30 p.m. We greeted each other as friends. Emilia was glad to go home. She is a little short, fat Spanish lady, impatient to beat the dark.

Miss O'Keeffe and I laughed and laughed over the news from the *Christian Science Monitor* and the *Albuquerque Journal*. She was eager to hear about the crowd at the Girard Foundation fabric display at the Folk Art Museum in Santa Fe. We are eagerly awaiting news about the opening of the Hirshhorn Museum in Washington. One of the most humorous moments of this whole stay was yesterday afternoon after our walk around the driveway twelve times. We came in the back door of the studio and sat by the glass door having a feast of salted dry roasted peanuts, Norwegian goat cheese that tasted like caramel, and tart apples. The air full of yellow cottonwoods in the valley, I told Miss O'Keeffe I could hardly wait until her book came out so I could read it over and over. She was interested in my reaction. I thought five pages on dolls was a bit much and maybe could be tightened up, but other than that, I thought it would be an inspiration to a lot of creative people. She said "they" (meaning Peggy, Doris, and Juan) are trying to stop publication. I asked why. Miss O'Keeffe said they were afraid she would fail. Then she added that was nothing new to her. In her years in New York whenever she would try something new, the men around her would predict failure. For example, when she painted the first huge Jimson weed, Stieglitz bent over it with a handkerchief hanging from his lip. "He had a very well-formed mouth." He bent over the painting and said, "What do you intend to do with this?" She replied, "I will just paint it."

We have been listening to Schnabel play Schubert's Impromptu in f-moll this afternoon back at Ghost Ranch. There is a festive feeling here from returning to this quiet place all outdoors. There is a lunch of vegetables and liver for Miss O'Keeffe. Bryan Holme called from Viking to see how she felt. She mentioned that Skira people might be consulted about printing the reproductions. She told him that Doris Bry would

be best because Stieglitz trained O'Keeffe, and she trained Doris. I asked how one was trained to judge reproductions. She explained that you look to have the feeling reproduced and not each color precisely the same as the original. She added that someone learning from another was apt to try too hard and miss the mark. She added that a number of young men tried to do what Stieglitz did and tried too hard.

Then she discussed Joe Hirshhorn and Olga, his third or fourth wife. They had 7,000 objects of art collected over the years and needed a museum, so they had made this one in Washington which just opened. Olga ran an employment agency and they met and she swam in his pool. Then to show her charms, she let down her masses of hair, but he was too clever to be caught by that. Miss O'Keeffe was laughing while telling this the whole time. They got along very fast after that. She laughed saying Geri (who used to work here) called last night all excited about seeing the Hirshhorn opening on television, recalling Joe going to the kitchen calling people when he was seventy-six years old saying, "You thought I was dead, but I'm not, so there!"

—*Night.*

Miss O'Keeffe said to me many young lonely people would come to her to find out how to make it, what method to use, and for the most part they were bores. What she could offer was just the knowledge that you just have to work very hard, in the right direction. There is no secret method.

When she spoke of Stieglitz teaching her to judge prints and reproductions, she commented that the same process of reproducing the feeling, not the exact original, was useful also in writing. She didn't elaborate anymore.

I am concerned about Claudia O'Keeffe's arrival. She is not a happy lady and not easily pleased. So it could mean several troublesome days just as I am feeling at ease with Miss O'Keeffe. Tomorrow is my twenty-eighth birthday. I will make a cake and celebrate. Juan called last night. His voice is strong and sure. He

is more at home now. Miss O'Keeffe is stronger, and we will work on pots soon, I think. She wants to add a passage to her autobiography about the growth of her pot. I really like her a lot. We laugh and laugh about simple things and I feel myself getting lost in doing for her, not really lost, just immersed. I don't pump her for information, just let flow whatever we end up talking about.

October 9, 1974, 2:00 a.m.

Sometime I must write about what Miss O'Keeffe said of Tony, Mabel Dodge Luhan, and Rebecca James when she was working out of Taos. There are about four good stories. Mabel Dodge Luhan knew Isadora Duncan and wore chiffons sometimes covering her ugly hands. She would invite people over then sit in such a way that no one dared say a word. SILENCE. Miss O'Keeffe delighted to come into the party at that time asking how everyone was, sharing news, and making noise. Soon everyone relaxed and carried on. So Mabel Dodge Luhan could not say how stupid the Taos crowd was. Miss O'Keeffe said that Mabel Dodge Luhan enjoyed showing people a good time then taking it away.

Mabel Dodge Luhan and Tony had met their match in each other. Both were strong. When Mabel Dodge Luhan left for her health, Tony lay across her bed like a log. When she angered him, Tony would say, "I go pueblo," with his braids and riding britches.

Tony, Georgia, and Rebecca were in Navajo country, lost on some logging trails. They built a huge bonfire for the night. Rebecca and Georgia couldn't sleep so they cleaned themselves with cold cream. Tony was enchanted with the cold cream, and there they sat in the dark morning before sunrise smearing themselves with this cream. Miss O'Keeffe was surprised that Mabel Dodge Luhan hadn't shown him cold cream. Tony was always very silent. That was one of his charms, she said. Once they were all driving through the valley when plum trees were in bloom, and Miss O'Keeffe was making a lot of awed noises

about the color and said to Tony he did not appreciate the color and the valley the way she did. Much later, after much silence, Miss O'Keeffe forgot what she had said, then Tony uttered, "That's why I here." Meaning, he stayed because he appreciated it. He implied that Miss O'Keeffe would leave New Mexico no matter what she said about the beauty of the place.

Tony would come to New York and not wanting to trail after Mabel would bring his drum, spend an afternoon singing with Miss O'Keeffe there. She said Tony was something special. Mabel Dodge Luhan was sometimes jealous, but Miss O'Keeffe never had any designs on Tony. Mabel Dodge Luhan had told Georgia to come over anytime in the evening. Once when Georgia wasn't too tired after working all day, she called. Mabel Dodge Luhan said some Penitentes were coming, and she didn't want Georgia to come. A little later up the stairs of the hotel where Miss O'Keeffe was staying in a room on the top with many windows, there came Tony inviting her to see the Penitentes. Georgia explained Mabel had told her not to come. Tony was angry, saying he had much trouble getting the Penitentes, and if she didn't want his friends to come, then he wouldn't go either. So he sat and rocked all evening right there.

October 10, 1974

I called my brother James, yesterday, to see how he was. When I moaned to him about getting up at 2:00 a.m. to give Miss O'Keeffe water, he said, "You ought to run a hose to her room." We howled at that. He is staying in my apartment while he and his friend look for a place, a house to work on jewelry.

Miss O'Keeffe's tantrums came to a head today, this morning at bath time. Because I had left her feet too long in a basin of hot water, she nearly slapped me. I told her I would leave this afternoon if she wanted. She said I could leave if I wanted.

I said, "What will you do when I am gone?"

She replied, "Manage as I always have, perhaps better than when you are here."

I said, "I hope so, and I wouldn't doubt it." I was trembling with anger released. Then I slowly rubbed oil on her back, gently. She began saying, "Please," for this and that plus, "Thank you." I said I would take hours off this afternoon because I felt cooped up. Fine.

We took a hot walk at noon. I told her I liked her spirit.

She said, "You like someone who spits nails?"

I replied that a lot of people would be reduced to a sniveling mass of tears at such a painful arm like her dislocated shoulder and such a discomfort with the exercises. She said that with tears she would just be in a worse place. I agreed.

She said, "So you want to write poetry?"

I told her I already did, but didn't really have the time. She said of course I had the time. I replied, "When? I work eight hours, sleep eight hours, spend eight hours going to work and coming home from work."

> I can say about how I felt today
> Washing Georgia O'Keeffe's white stockings
> In the basin . . .
> I can talk about hatred between
> Her friends and employees
> I can talk of history
> Of the Taos art scene
> Of New York in the 1920s
> I can talk about her clothes
> Ranging like Mandarins
> Conspiring in the closet.
> I can talk a lot.
> But I cannot speak of
> Cloud shadow slowing crossing cliffs
> Or the look on her face when
> She turns her unseeing eye to sky
> And remembers blue.

She said that writing is easier than painting. I agreed that one couldn't carry an easel in the back pocket, but still it takes

time to come around to an idea. She asked why I hadn't written more than one poem here when it is all more beautiful than real. I said I can usually write about people but places like Ghost Ranch leave me speechless. They are for looking.

She said, "Write that. There is always something to be made of everything."

There were heavy white clouds in a blue sky, moving slowly behind the cliff. Hot, we can walk from shady spot to shady spot.

October 11, 1974, Friday

Last night we read an article by Derek Bok on women at Radcliffe and Harvard. Miss O'Keeffe was swathed in shawls and light blankets. We discussed women. It seems she was something of a "slave" to the clan at Lake George since she had to oversee the kitchen and grounds. When she began making noises about it, life wasn't worth living. So, because she didn't have time for her work, she began traveling around to find a place where she could be alone. She ended up out here. This morning on my walk with her, she said that Stieglitz wrote her often and would take several days to complete a letter. He had kept a diary for twenty-five years accounting for whoever had done what each day. His mother insisted he burn the volumes, leather-bound ones, because one day he might die, and no one could live down what was written there. So he went to the basement for three days in a row. He took off his shirt and burned all that history in the furnace.

Miss O'Keeffe stayed five years in Alcalde with Mary Garland, the good cook. Mary Wheelwright who owned Los Luceros brought Maria Chabot to this area. Miss O'Keeffe described Maria as an impossible person who yelled too much at the workers. She would leave sacks of groceries without putting the things up, and would peel off clothes on her way to the bedroom dropping various layers onto the floor. Miss O'Keeffe said Maria drank too much.

I asked Miss O'Keeffe how it felt to come up onto the plain where Ghost Ranch is and know it was your place. She replied it was just a place where she had to be. One could put up with all kinds of inconveniences just to get a little work done. There was no gas, no electricity, no telephone. It was seventy miles to food.

I said I still felt like a visitor. She looked startled. I felt like I didn't really belong. I thought I needed a body of water near me to be comfortable. Today when we were walking, I told her I felt most at home when I had my journal with me. She said, "Maybe that is your place."

This evening we were laughing and carrying on like friends. Juan will be dragging a lead weight behind him with the prospect of Claudia's arrival. Read *New Republic, Common Cause,* Jacques Cousteau in *Saturday Review World,* then "Kafir, fisherman of Baghdad" from *Arabian Nights.* I have breakfast, dressing, and bathing down to a concise routine. The cliff walks are refreshing. I am telling her a lot about the library.

Monday, October 14, 1974

Next Sunday afternoon JLH will pick me up to go home. I arrived in Abiquiu last night to a crabby scorpion. When she tosses off her little abuses, I find myself keeping empty by repeating a mantra. I shall be glad to return to the library routine at the university, plus my routines at home because I won't feel so sucked dry by the end of a day. I will have more than an hour and a half to myself. I get a half hour for a shower, one hour off in the afternoon after lunch during naptime. With Miss O'Keeffe, the *I Ching* advises sociability without intimacy.

Miss O'Keeffe said C. Demuth was one of her good friends in the twenties. He was one of those people you don't want anything from, but you are good friends. He was diabetic, and she could tell when he was about to pass out. She would tell someone to go to the drug store for a glass of orange juice with lots of sugar, and no one ever asked her why. When he was asked to a party, she was asked as well to help him handle his liquor. She

said she was always taking a drink from Demuth and hiding it behind a lamp or a vase. He got so he would take a drink from a tray and not even sip from it, just hand it on to Georgia. In his portrait of her, he put a gourd similar to a gourd she had used for a darning egg for twenty-five years. It amused her that he included the gourd even though she had never mentioned it to him before. He used to eat lunch with them whenever he was in town and often dinner as well. He would stay a couple of weeks until he was sick again, then return home where his food was weighed. In the city he did what he wanted, and it always made him sick. One of his girlfriends gave Georgia a seashell she knew Demuth had wanted. The girlfriend wanted him to notice she had given it to Georgia instead. Demuth lived in a house his family had owned for 145 years.

October 15, 1974, Tuesday

So tired today I ran into a wall in the kitchen and dropped a tray full of lunch dishes with a big crash! I broke cups, plates, saucers, and more. I was up four times last night. I really need to go home to be alone and sleep for about three days.

I called Juan last night for a little moral support to try to deal with her negative energy. His advice was to stand aside when the shit flies. He has fallen in love with a Scorpio lady in Vermont with two children and a husband. He says they are all four very open with one another, and she may come out here in six months or so. He is worried that O'Keeffe may be jealous. I am sitting in a garden among drying sunflowers and corn. Last night Miss O'Keeffe said it seemed she had had no summer.

This morning on our walk it seemed she relaxed her angry temper and told little memories, let herself go as she does several times a day.

She said after she fell, she felt sturdy on her feet until her Dr. Ziegler shook his finger angrily and warned, "Now don't you do that again." She said she suddenly became frightened to get up in the night and felt all frazzled. In her words, "My edges

got blurry, for about three inches." I asked what she meant, and she changed the subject.

Mrs. Robertson called and asked me to encourage Miss O'Keeffe to write on the Whitney, Chicago, and the rock paintings as well as the pot she made. I told her I didn't think I was the one to do that, and Mrs. Robertson encouraged me. Then Miss O'Keeffe came in from the walk and talked, saying I was leaving Sunday, and Mrs. Robertson should come next week sometime. She is gone to see Dr. Ziegler, and I am letting the sun cook into my back for a while.

Claudia O'Keeffe is in Santa Fe at La Posada. She was coming this afternoon, but I called her and told her Miss O'Keeffe will be totally exhausted after the doctor's visit so she should only plan to come for a brief time. She will come tomorrow instead. She asked many questions as if she didn't know much about Georgia's injury. "Where did it happen? Is it stiff? How is she? Miss O'Keeffe will need someone to stay here nights for sure. I am concerned about that." Claudia thanked me for looking after her sister. I told her I just did what I could.

I walked to Bode's for ginger snaps and milk and there met Emilia, a wizened little Spanish woman as tall as my breasts. She asked if I was staying. I said no, and she was surprised, and asked why. I explained I had a full time job in Albuquerque.

Emilia said, "She's really a good woman. You know that."

I replied, "Yes, but sometimes a little tough."

Emilia said she knew that because she had worked for her since she herself was sixteen. She was tired, couldn't be going over there every weekend, getting stuck into the job when her own children came to visit on weekends. There is great affection between the two women. Miss O'Keeffe prefers Emilia to all others. Emilia works there out of honor because she is tired and sixty herself.

I was thinking this afternoon as I rested on the studio bed that I was disappointed Miss O'Keeffe's temperament seems to me less than the quality of her art. I wonder how I will separate

her harsh words from the beauty of her paintings now. It seems to me a fine artist should lead an exemplary life in all facets and not just in the creative, productive facet. I am disappointed. I like to think of artistry as an expression of wholeness of life-style; as a running over from fullness.

Then I remember what Juan said that she was once an active free person reduced to a blind cripple, and that deeply affects her pride. She doesn't like anyone to see her this way. And her shoulder constantly pains her. So perhaps this person I am helping is the remains of the artist I would've loved as a friend. I will stay the rest of the week because I promised Juan I would. I will stay because no one else is lined up at the moment to do what must be done. But come Sunday, I will leave.

I am learning quite shockingly of the ravages of age and injury. I am learning of mortality. I am learning of the usefulness of beautiful forms to combat the basic realities of life. So what if I make beautiful poetry. I am still nothing in the face of all that flows through time and space and makes me sick and well, be born and die. I want to reach the still center place I feel in Tai Chi and live from there and write from there if it suits the flow.

Much needs to be written which I have not yet written. I don't know where to start. Except it is more that I must continue. Here I sit waiting for Miss O'Keeffe to return so I can thread her legs and arms into pajamas and shawls for her to rest. Poor old body. Such a strong spirit bewildered by its crumbling adobe and no more clay sand, straw, and water to keep it standing. It must be terrifying.

October 17, 1974, Thursday

Last night before bed, I read to Miss O'Keeffe from Livingstone's biography by Elspeth Huxley. When we found our Dr. David Livingstone was associated with the Congregationalist Church, Miss O'Keeffe laughed and told me about her auntie who was a Congregationalist. At sixty she was thought too old to go to

church alone, so one of the children of the household had to go with her. Miss O'Keeffe said she hated to go because it was so boring. Miss O'Keeffe said there were three religions to choose from in her household. There was the Episcopalian religion which attracted only the wealthy of the community. She thought that Congregationalist religion was boring because there was no incense smell, no good music, no beautiful windows like in the Catholic Church, and the priest didn't wear beautiful clothes either. The Catholic religion contained all classes of people and it was beautiful as well.

—9 p.m.

I am so tired tonight that I can barely write. There has been no stopping since 6:00 a.m. We were up early for O'Keeffe's bath, dressing, taking brewer's yeast and molasses, making tea, my bath, typing, getting mail, reading mail, answering mail, straightening the table. Claudia O'Keeffe arrived. We talked to her. I looked after her Yorkshire Terrier so she wouldn't be eaten by chows and sat by waiting while the sisters talked. I was reading *Time* magazine and attending to little things. I helped steer talking to non-competitive congenial chat and helped Miss O'Keeffe to settle for a nap. I talked for an hour and a half with Claudia. Then Georgia woke up. They talked. I sat with my eyes closed hoping for a mini-nap. I was asked to do a couple of things. Then I tried to weave a string belt, but got it tangled from getting up and down. I saw Claudia off and Feta, a Cuban lady who tends to Claudia's needs, and Susie the dog. I was carrying the Santa Fe Chamber Music poster out to the car, reminding her of this and that. Miss O'Keeffe was inside ready to go through papers on shelves. Sister Bernarrita arrived and agreed to work on Sunday. I drove Miss O'Keeffe to the ranch. We walked a mile and then drove back. I fussed over dinner, fixed her for bed. It was a half-hour or forty-five minutes of preparation. It is slow dressing for the shoulder. I fixed myself for bed. Whew!

(I remember Feta as a short, strong woman from Cuba who was Claudia's maid and helper in all things. She usually spoke Spanish with some English mixed in. She told me a marvelous story of always having boiling water on a stove in case a violent man barged in, in which case you poured it on him to make him leave. She was very hard-working, always moving to fix something, clean something, prepare something to eat, never still. She had laughing eyes.)

Tomorrow there is no cook, so I get to take over that little chore for a couple of meals. Will I survive until Sunday?

Richard of Las Vegas called Miss O'Keeffe and told her the head of the Vienna Riding School just died of a stroke after a performance. Miss O'Keeffe seemed greatly moved. He had arranged special seats for her both times she went.

(I remember her expressing appreciation for the precision and the art of her dead friend.)

She told me a tale from around 1944, one fall when she and Stieglitz were walking around a corner at Lake George when a car struck the grocery wagon spilling the milk and eggs all over the place. The out-of-town car drove on.

She showed me a spot up into the Ghost Ranch red hills where I could find a charred, petrified tree and gather good stones. She showed me an arroyo where I can gather smooth black shiny rocks. It is across the river from Abiquiu.

—*Saturday*

Juan will arrive today if all goes well. There is a large T-bone steak waiting for his dinner. Here is an amusing story and repartee between Miss O'Keeffe and me concerning Juan's pottery. She said one day someone whose opinion mattered to her noticed Juan's big pot. This person said at first it looked like an oriental pot, then as he picked it up and looked at it all over, he said whoever made this is a very sensitive person. Miss O'Keeffe said she replied it was just somebody in the valley. I asked who was the person who made such a do over Juan's pots. She asked why I always asked such things. I replied that she herself knew what

a curious lady I am. She responded tartly that she was never so curious, and she was tired of it by now. I added that she only had to put up with it one more day. Then I asked if she never tolerated any characteristics other than her own. She answered of course she did.

Then she said, "How do I know who you'll tell?"

I said, "Who do I know?"

She responded, "You'll go back to that library and talk."

I said, "Oh sure. It's the intellectual center of the United States. What a big difference it'll make."

Then I said after suitable pause and quite low and seriously, "Miss O'Keeffe, I never say much of anything about you to anyone. I even make people angry about that."

Then she appeared to abruptly change the subject, but she wasn't really. "I knew Hirshhorn was coming one day. I knew exactly where he would sit. So, I put Juan's pot just out of reach. When Hirshhorn arrived, he sat just where I knew he would and he glanced around. When he looked at Juan's pot, he jumped back like it had stung him. But he acted like nothing had happened, and I didn't say anything. After awhile, he reached over and pulled it to him and looked at it, and asked who made it. I said someone in the valley whose name I don't remember. After a little while he bought it. He came not wanting to buy anything, but he bought it. Some people you have to fool."

I feel very high that she had shared a small confidence with me.

The whole subject arose when we were answering Tom Armstrong's letter. He is the director of the Whitney. He will visit November 11. Miss O'Keeffe wanted to mention Juan in a humorous way to start them thinking about this man and why he is here. Maybe they would look around a bit and discover his pots. Of course they are nothing to show yet, but they will be in time.

She said she hadn't been in the art world fifty to sixty years for nothing. Last night she told me that Stieglitz used to take a

mild sleeping pill that she knew didn't do anything for him. He had taken it so long that she didn't say anything.

She told me that when Stieglitz was two weeks old, he was dropped as a baby, and they didn't notice the broken nose. He could only breathe out of one nostril. So to get more air he would fit the very corner of a handkerchief in between his teeth, and it would hang from his mouth. He would talk that way.

I drove her to Ghost Ranch for a morning walk. On the way she told me about working in Amarillo. She stayed in a hotel so she wouldn't have to be in contact with the other teachers who lived with people. She said she certainly didn't want other people about. She soon found that the first and second grade people knew a lot, and she didn't want them to find out how little she knew so she stayed a little apart.

In Amarillo on the second day, she went walking around and entered a little church full of people. The wind made the little building creak so that she said she would have left if the people hadn't appeared unconcerned.

When she taught at the normal school, it was windy. To go a mile to the school, they would sometimes call a taxi. The taxi people would say they couldn't send a covered taxi because the wind would overturn it.

Laura Gilpin doing a portrait of O'Keeffe
Laura 85 and O'Keeffe 89
O'Keeffe in the window at Abiquiu studio
holding her pot in various poses
asked Gilpin not to photograph her grinning
"All those grinning Americans.
You would think all we had was funny."
Miss Gilpin works quietly, takes a little time
with each pose, said after you do a shot,
funny how people will just drop
into the more natural pose
Laura had thickened ankles and teetered on her feet
occasionally used a cane—Nikon 35mm
Kodak 2¼, said her work at Canyon de Chelly
got her started with 35mm, she would shoot
whatever she would come back to later,
that won her over, said time was she would never
have thought of doing such a job on anything
other than her box camera. But with her disability
she had to be prudent.

June 1975
C. S. Merrill
O'Keeffe, Days in a Life

[1975] 3

February 3, 1975

I have gone a long time without writing anything significant. Now I am back to the old yellow pad about O'Keeffe. In the semi-arid desert, we walked the road by the red hills. The earth breathed. The earth was fluid beneath my feet. I walked on a gently rocking boat, amazed in orange air at sunset.

I said, "The land is alive."

Breathless, I looked to her eroded face for surprise. She did not pause, did not glance, did not stumble, stepped through the swells of breath upon rocking soil, sure of her old feet, holding tight my arm for guidance.

She said, "Yes. Men have not been here to ruin it."

Monday, April 7, 1975

Last night I dreamed a very strong dream with vivid images. My parents took me to a very old, dusty house. They led me to a dark room filled to the ceiling with books. I was reading little volumes and suddenly, superimposed over them were changing forms like the writing I see in dreams on my wall. Four quadrants with little crouched figures and lines raised as if sculpted in stone. Then, even when I looked away, I saw these stone carving figures changing urgently before my eyes like there was an important message, but

I didn't understand the code. I began screaming and bumping into furniture because I couldn't see properly with these patterns changing before my eyes. The spell was broken, and the sky was full of stars, more stars than ever possible in the sky at once.

April 23, 1975

(*I was writing about visiting a Jungian about my dream projections or eidetic dreams on the wall, but late for my appointment.*) Virginia Robertson said O'Keeffe had experienced such projections since she was in her teens. That information made the urgency a little less intense. Sunday I gave easy birth to a torrent of poems about O'Keeffe and the land around Ghost Ranch.

May 16, 1975, Friday

O'Keeffe show in the Governor's reception room in Santa Fe, from left to right:

> *Cliffs Beyond Abiquiu, Dry Waterfall*, 1943, oil on canvas.
> *Cloud Painting No. II* (was in Claudia's bedroom), 1962, oil on canvas
> *Pedernal*, 1945, pastel
> *Black Cross, New Mexico*, 1929, oil on canvas (Art Institute of Chicago)
> *Ladder to the Moon*, 1958, oil on canvas
> *Gerald's Tree*, 1937, oil on canvas
> *Black Place III*, 1944, oil on canvas
> *White Rose with Larkspur*, 1927, oil on canvas
> *Blue Black and Grey*, 1960, oil on canvas
> *Black and White*, 1930, oil on canvas
> *Spring*, 1948, oil on canvas
> *Black Rock with Blue III*, 1970, oil on canvas

May 17, 1975, Saturday

Yesterday, JLH and I went to Santa Fe to see the show of a dozen O'Keeffe's. His favorite was *White Rose with Larkspur II*, 1927. For me, I prefer *Cliffs Beyond Abiquiu, Dry Waterfall*, 1943, and *Blue Black*

and Grey, 1960. We looked at the white wall with paintings hung zig-zag fashion for a half hour to forty-five minutes, then off to The Shed for lunch. Back to the O'Keeffe show for a while, looking carefully, memorizing. How do her paintings work their magic? Common, even trite, subjects are made sublime again. My theory is that she reaches mystic levels of spatial "understanding" when not sleeping well, rather resting in a deep trance. Peggy Kiskadden told me last October that Miss O'Keeffe never slept very well. I get into drowsing states where I see things on the walls: forms, faces, movements. Virginia Robertson said O'Keeffe had been seeing things in this way since she was very young.

May 30, 1975

JLH left me a gift at my place: a Laura Gilpin portrait of O'Keeffe. There is a plant behind and above her with leaves perfectly formed and a curled snake in clay in the window. There is light on half of her face. Her eyes have different shapes, and there is her smirking wisdom. She wears a simple white garment with the silver O'K pin by Calder. (*Miss O'Keeffe often wore a sculpted pin made for her by Alexander Calder. It was a silver spiral that had a long extension which formed a "K" so that it looked like her initials. When looked at from another angle, it appeared to be a flower with a stem and two leaves. She often wore it to secure the wide collars of her dresses.*)

September 12, 1975

Virginia Robertson called today and said I should call O'Keeffe. A bookshelf fell over, and she needs someone to come and put books back in order. I am to call next week after the publisher finishes discussing the prints. So I will. I feel happy, though reserved. My affection is still strong for her even though she worked me to a shred last October.

September 29, 1975

Last Friday Meridel Rubenstein visited O'Keeffe. Juan called her and arranged it. They talked for several hours over the

reproductions to be used for the autobiography. Meridel said Miss O'Keeffe mostly wanted to tell about Stieglitz, and Meridel had to keep redirecting the conversation. Meridel will get to look into the notebooks of photos of Miss O'Keeffe's paintings in order to draw some conclusions for her M.F.A. thesis. She wants to explore the interaction between Miss O'Keeffe and Stieglitz with subsequent effects on his photos and her painting. Meridel has been at the National Gallery in Washington to see *The Portrait* (300 photos) and the Yale Library at New Haven to see what was there. There was an important fall, perhaps 1924, when Stieglitz stayed over at the lake, and they worked together. Miss O'Keeffe has forgotten.

October 10, 1975

JLH and I drove to Abiquiu. The trees high in the mountains were yellow in the distance. Along the Chama, they are partly green. When we arrived at Abiquiu, a young boy met us and said to go to Ghost Ranch. As we drove along the road past the red hills, there was Miss O'Keeffe walking with her two dogs, managing a cane with her right hand, not really favoring her left hand, but not using it either.

We stopped, and I shouted to her that it was Carol. She said she wasn't sure I would arrive before dark so she took her walk with the dogs. She said to drive on to the house, and she would follow. She was dressed in white, her white dress that fits like a coat, pulled across her chest and pinned with her silver O'K pin, brown heavy hose and navy blue tennis shoes, much sturdier shoes than those she had last year which were black flats more suitable for concrete. Her face is softer this time because she is not in so much pain. We drove on to the house and got out, loaded the suitcase and coat and cheese into the kitchen. JLH had to attend a meeting north of Taos. He took the road from Tierra Amarilla to Taos, then north. I walked out to meet Miss O'Keeffe. We walked toward the cliffs together while she enumerated the names of the chows in her past: Chia

and Bobo, then Chia and Bobo II, then Jingo and Inca, the red and black chows she has now. We walked to the first tree by the road then back, maybe one-half mile in all. She is very steady and sure of her feet. They have had only one snake this year, one morning by the breakfast window.

(*The following passage is not in the journal, but what I remember. Aside: At Abiquiu I remember one encounter with Jingo, the red chow, one cold early morning right at sunrise outside the bedroom door when I was walking toward the studio to take Miss O'Keeffe something. Jingo gave one woof. I stopped, and she gripped my right ankle, and held on for about five minutes gently growling. Inca, the black chow, sniffed around me. I remember being frightened and cold but not moving, just talking softly to Jingo about what a good watchdog she was. Finally, with no struggle Jingo let go and went on about her business. We never had another unpleasant encounter, and I was always careful to give them both little treats from the kitchen to stay on their good sides.*)

We fixed a dinner of *quelite* soup, cheese, rice crackers, and salad. Miss O'Keeffe showed me the secret of the salad dressing: garlic chopped into a large spoon, salt sprinkled over with the garlic crushed into it, olive oil poured over, then lemon juice or vinegar. Then you pour it drippingly over the greens and toss with the same spoon. There were white, wide plates, white bowls, white cloth, simple brown straw mats, salt in white salt cellars (shaped like little hour glasses) with tiny mother of pearl spoons. On the stove for the soup spoon, a there was a little ashtray-like dish, very gaudy purple, green, yellow, from O'Keeffe's favorite restaurant in Madrid, so she said.

While we ate, we watched the sun finish itself against the cliffs. One high place in the distant east of her house held the sun a good long time. She reminisced about Stieglitz and how he merely ate zwieback toast and hot chocolate for breakfast and never another meal until a large dinner because of his nervous stomach. She said she tried for ten years to eat the way he did and got very ill. Then she decided she didn't want to die. So there were two meals, one for him and another for her.

The woman who kept the Stieglitz house was named Margaret. He sat for hours remembering old guests with her. His sisters were angry that he didn't seem to have a word for them. Miss O'Keeffe said he was just punishing them for existing. She said a mutual man friend, Harvan, advised her on whether Stieglitz was ill enough for her to return. Stieglitz's brother was his doctor, and they would often send for her, but she would wait for a call from Harvan.

Miss O'Keeffe cleaned the dishes, and I straightened up the table, the pantry, and the dishwasher. Tomorrow, I will list books.

O'Keeffe promised to show me her pot. She listened to Schumann as we got ready for bed. The Concerto in A Minor for Cello and Orchestra was performed by Casals.

O'Keeffe is reading the life of Columbus now. He was in chains and lost all of his property after he had discovered much of the New World. She asked if the people in my class like my poetry. I said "Yes, well some do, some don't." She said that's the way it always is. I brushed and braided her hair for bed. She usually has a Thai girl stay with her, Mary. Mary has a craze to cook in the night. Mary would sometimes get up and make granola at 2 a.m. (*Miss O'Keeffe told me that they would eat the warm granola and cold milk in the dark early in the morning.*)

The moon is half a rice cracker. The sky is clear and silent. One blue bird hopped and squawked.

"I am a good age, twenty-nine," Miss O'Keeffe said about me, "Just beginning." She said she gave her manuscript to a woman who writes for the *New York Times*. She made some suggestions that would please the common reader. Her husband is an editor who said to completely leave the manuscript alone. Viking will come out with it next fall. Juan just spent a couple of weeks in New York at her storage area supervising the photographing of some of her work for the book I assume. Juan is making additions to his house now.

October 11, 1975

Today we got up around about 7:00. Breakfast was granola, boiled eggs, chile with garlic, toast, coffee, and apple juice. Brenda came from the village, and we listed shelves and shelves of books. There was Chinese art, *Arabian Nights, America and Alfred Stieglitz,* Japanese and Chinese prints from the collection of Ledoux. Lunch was turnips, greens, bread, cheese, with raspberries for dessert.

October 12, 1975

11:00 p.m. Very ready for sleep. Suffice it to say, I have worked very hard listing books. Killed a rattler on the patio at Ghost Ranch yesterday.

(The following is what I remember, but it is not in the journal. Hard to believe that's all I wrote about the event in my journal, since I may have saved Miss O'Keeffe's life. She was in the little bedroom south of the room she slept in, separated by the bathroom and an opening through the back of the closet. She was talking to Brenda, and I was bringing something for us to drink. On the mat just in front of the bedroom screen door that opened onto the patio, I saw a small snake, maybe two feet long, rattling for all it was worth, and Miss O'Keeffe was talking and starting for the screen door. I shouted, "Stop! Snake! Stop! Don't come out the door!" Miss O'Keeffe couldn't hear what I was saying, and she started for the door even faster to come out and hear what I was shouting about. Brenda understood and held her and yelled to her what the problem was. Miss O'Keeffe headed back through the closet, then the bathroom and out into the studio area calling the chows to come from the patio through the big old studio door that also opened to the patio. Brenda without a word raced outside to her car and sped away. Miss O'Keeffe came out with me on the patio portal and told me to kill the snake. I asked her with what? Then I reminded her that I was a non-violent vegetarian and didn't believe in killing animals for any reason. She said if I didn't kill it that she would. I said I would do it then to save her from getting bitten. By this time, the little creature had gone behind the woodpile, and Miss O'Keeffe

handed me a shovel. I began banging around on the woodpile knocking the logs, and hitting pieces off the woodpile. This was afternoon, so the sun was a little low, and it was dark on the west side of the patio. Finally, it crawled out to get away under the sage bushes, but I crashed down on it with the shovel again and again, feeling awful, with Miss O'Keeffe cheering me on from inside the studio. Finally the little creature didn't move anymore, and Miss O'Keeffe told me to dig a hole outside the kitchen door toward the arroyo and burn the snake in the hole and cover it with dirt. Otherwise, the fangs might still poison the dogs if they dug it up. So I did that out to the east of the house feeling just miserable about the whole thing and entirely weak and trembling. When I came back inside, Miss O'Keeffe was in the kitchen and gave me a small amount of whiskey to drink. We went into the studio after awhile and sat quietly listening to some splendid classical music. I believe it may have been Casals playing Bach on his cello. Slowly I calmed down, and the sunset was really especially rich. She told me about the many, many snakes she had killed around Ghost Ranch. It was a regular occurrence, but she never got used to it. After that she and I read her two-volume set of books by an authority on rattlesnakes that described how to walk with a heavy foot and a pole or a cane to vibrate the earth so the snakes would feel you coming and move away. We discussed the habits of rattlesnakes and read many details about their lives. That evening we discovered one of the gates had been left open just a little, enough for that small snake to slither through. She had her fences at Ghost Ranch two feet deep into the ground and her gates constructed with L-shaped sides so they closed very snugly to keep the snakes out. She called them her snake gates. There had been a theft of her buffalo skull, and we guessed that the robbers had left the gate open carelessly, because no one else had a reason to go through the gate. I found myself in quite an altered state of awareness for hours after killing that snake. Miss O'Keeffe said it was not unusual for someone from the village to flee when some crisis occurred.

I remember another time Miss O'Keeffe shared with me that the villagers believed that there were many ghosts up by Ghost Ranch and in the canyon where Christ in the Desert Monastery was located. She asked me if I had seen the lady ghost in her house, and I said I had seen someone

writing at her desk by the window, then looked away, then back and she
was gone. And Miss O'Keeffe just smiled.)

Today we walked to the cliff and listened to a Caedmon record-
ing of Noh plays. After warm milk and roughly sixteen hours
of O'Keeffe, I am ready to sleep. Cane chairs, blue plates, Noh
music, Union Jacks, lamp stands . . . all things Miss O'Keeffe
seems to want.

October 13, 1975

This morning early we drove to Abiquiu from the ranch. It
was windy and chilly, dark with blue clouds. Here and there
the sunrise was showing through with bright colors. The top
of Pedernal was covered with a flat white fog cloud. We had
breakfast. I typed a few lists left over from the ranch book
room. Miss O'Keeffe called Santa Fe for a vet to take care of
Jingo's right foot. It may be a splinter, goat's head (*a kind of*
sticker that has two sharp prongs like a goat's horns), or a rock bruise.
Maybe it could be arthritis. We went to the book room after I
read a list of books considered valuable to a rare book curator
from Los Angeles. Miss O'Keeffe said that after two shelves of
books toppled over, she had a wonderful several days going
through them, remembering people and places connected with
them. So I think she is no longer very interested in unloading
the books soon. At any rate, I am bringing a list back at her
bidding to show George Miller at the University of New Mexico
General Library to get more advice about the collection. She
showed me an article about Henry McBride, who was a critic
they waited for after an opening. It was in *ARTnews* written by
Daniel Catton Rich. O'Keeffe said there is a book by Rich about
McBride coming out this fall. He seemed like an impressive man,
a Quaker into leading public taste, not directing or bullying.

Lunch with Juan was hilarious as usual. He makes a con-
tinuous stream of humorous remarks like how many people

leave O'Keeffe at a run holding up their pants as they go, the former secretaries. We discussed the Ghost Ranch promotional film which has a sneaky fifteen seconds of O'Keeffe and another thirty seconds of her paintings, one of the skull, and another one with a large pink flower.

October 14, 1975, 12:05 a.m.

Last night Miss O'Keeffe played a Caedmon record of Noh plays for me. There were those highly symbolic moans in Japanese. While sitting at lunch she asked me if I had heard of the legal problems with people very critically ill being taken off medication and let die. I said my grandfather had that happen to him last week. I wrote a poem about the problem.

She said, "How will they tell when people are just tired of taking care of you?"

I walked to the cliffs with her last night. Turned around and she was gone. She had walked nearly all the way back to the house. There I was in all the immense tonnage of those colorful cliffs, holy ground, unspeakable memories of power.

Today while we prepared to move to Abiquiu, I kept hearing the "Grand March" from *Aida* in my head.

Today before I left she held my hand. I felt the blood pumping through her fragile hand. She looked so small in the bed covered with her black comforter. She wished me good luck, mentioned my poems to Juan, and told him how busy I am. So frail! I cry. Why is she so frail? She has so much. I do not understand the pattern of being. I can only record at this point. There are many mysteries beyond my knowledge, and I am barely a speck under Pedernal. Beauty so moves me at times that I am in a timeless space beyond separation. My blood called out to O'Keeffe, a recognition beyond words. Her quick looks, her plants, rocks, her erect body, her voice early in the morning, her methodical napkin folding are all so characteristic, so memorable. I braided her hair for bed.

October 16, 1975

Today I delivered copies of O'Keeffe's library list to Phyllis Cohen, librarian at the University of New Mexico Fine Arts Library, and also to George Miller at the Zimmerman General Library. It is out of my hands. If they pursue the collection, it is their business. (*What I recall is that at some point in negotiations, the administrators at the University of New Mexico General Library decided that if she donated her library, the books would be dispersed throughout the library. When I told her that, she decided to look elsewhere for a place that would keep her collection intact as a rare collection.*)

Sunday, October 19, 1975

Perry Miller is the woman making O'Keeffe's film. Juan is working with the film makers collecting old photos and things that reflect the past. We were in the book room looking at old photos. There was one with O'Keeffe young and sensuous in a white lace dress on a boat. There was one with her in a plaid skirt. She looked very "country" between two women relatives in a poorly composed photo. There was another with her dressed in a black coat on a boat. Stieglitz was kneeling, kissing her lap, and she was looking to the sky laughing. It was a beautiful comic moment.

October 22, 1975

This morning Miss O'Keeffe called to see what was happening with her book list. I explained all since apparently Juan didn't read her my letter. She inquired about how it goes with me. I told her that yesterday I delivered a talk on feminist criticism, and it was well received, even though the professor said it was not professional. I asked if there had been any more snakes.

She said, "No, we're still alive here."

She said again to me that painters who are women have it harder than writers who are women because you can leave writing and come back to it; whereas, you have to stay right with

paintings. I told her that the brown lamp stand should arrive in a month.

"Won't that be nice," she said, "since the lamps are useless without them." She said she hoped I would come up again sometime soon. I said I hope so too.

November 25, 1975

JLH and I drove up to Abiquiu to stay with Juan in his house on top of Barranco. He has four rooms and a bathroom. Onto the back, he added two small and one very large room. Upstairs there are two large loft rooms. He has views of mesas, ridges, and snow out every window. Over the fireplace in the front room, he hung a poster of O'Keeffe's painting of clouds. Over the sofa in the other front room, there is a poster of red hills, grey clouds, skull with antlers, desert flower, white with yellow center. Pots, large pregnant black forms are here and there. He has acorn squash and pumpkins. O'Keeffe's black hat is there plus a photo color negative, a huge one, in the front window of an 8" x 10" rock on tree stump. There is a Brancusi watercolor and an O'Keeffe watercolor on the walls. There is an O'Keeffe oil, a blue curve on white.

This afternoon we found
One unconscious hummingbird
Had battered itself against
The studio window, took it
To the kitchen, made sugar water
Carried it to the garden
It sipped and perked up alive
Iridescent blue green chin
Whirred off suddenly up.

<div align="right">

May 1976
C. S. Merrill
O'Keeffe, Days in a Life

</div>

[1976] 4

January 6, 1976, Tuesday

Juan called to say he and Miss O'Keeffe are going to the Caribbean, as soon as they get over their colds. In another week JLH and I are invited to stay at Juan's house in Barranco and cook on his wood stove in the beauty and fresh air. Juan's Maine woman wrote him to say she would not come to live with him after all. He is pretending to be glad for his freedom from entanglements, but he wasn't fixing up that house just to rattle about in all that space.

Monday, March 5, 1976, early a.m.

Yesterday afternoon at 3:30, Miss O'Keeffe called to ask if I had recorded the McCurdy books. I said I had not since she asked me to cover them with a cloth and regard them as a gift for the McCurdy School. Then she asked if the library was at all interested in her collection. The Smithsonian is going to make her house a museum, and she doesn't know if they will be interested in keeping her books. She said probably they will show her paintings on the walls in various places. I said I would check with George Miller (my boss at UNM General Library) and answer her by mail.

I asked her how her autobiography was coming along, and she answered that it isn't a biography, but a picture book which is really a kind of biography. She said they had just received the color prints which they would compare to the transparencies. She asked if I had seen her white volume of Noh plays translated by the Japan Society. There is one play in that book, she says actually says the unspeakable, which is very difficult to put into words. I suggested it might be at the ranch or in the studio at Abiquiu. Upon my telling her I was looking for a summer job, she replied that she might need someone and would keep me in mind. She said there might be some work with this Smithsonian project. I told her that I am reading Henry James and thoroughly enjoying him as she said I would.

May 27, 1976, Thursday night

Here I am again at the Ghost Ranch in Georgia O'Keeffe's house. JLH and I drove up here today. We wandered around Santa Fe, lunching at The Shed, wandering through a bookstore and a gallery then the museum. I was impressed by the portrait of Rebecca James. Then we drove slowly to Abiquiu where we found an empty house, then to Ghost Ranch.

Juan met us at the kitchen door. He looked pale and didn't show his usual liveliness. He reached out to shake my hand rather gravely. JLH said later he seemed not as full of energy. Juan had called me two weeks ago to say he had been beaten up, and that his life had been threatened. He carries a gun now. I thought the threat would blow over, but it has not.

Miss O'Keeffe showed me to the southeast bedroom off the dining room. It has a private bath, a view of Pedernal, and a beautiful painting. A tree moves in luminous swatches of spring green with a rusty peach tone that brings it to motion. Branches and wind—beautiful. Her comment was, "It is very old." Our dinner was delicious as usual: tomato soup, salad, asparagus, cheeses, crackers, banana bread, and hot tea. Juan

had left. A couple of old Spanish men interrupted dinner, and Miss O'Keeffe left JLH and me with Mary who was cooking. We found out later they came to discuss Juan's problem. There appears to be nothing that can be done. I have been brought here to help catch up on the old correspondence.

—Friday

This morning I had breakfast with Miss O'Keeffe and Mary. By 9:00, I was working with Juan on filing. Lunch was with Claudia and Juan. More filing. I got Juan a date with Theresa Sánchez. He seemed very pleased and rode back to Abiquiu with Mary. Dinner was with Miss O'Keeffe and Mary. That is the basic structure of the day. Now I will fill it out.

Our breakfast consisted of Jewish eggs: onions scrambled with eggs in small skillets, English muffins, orange juice, and tea. Afterwards we collaborated upon the composition for the blurb on the jacket of the Viking book. Great humor about an underground version saying: "There has been so much nonsense written about Georgia O'Keeffe. With all due respect to critics and historians, it's about time she told her own story. This has been the result of collaboration between publisher, artist, and a number of hangers-on and groupies." We wrote several possible paragraphs for the blurb for her book.

Miss O'Keeffe stayed at Ghost Ranch to look after the plumbing which had overflowed several times in the last weeks. Frank was driving out to check the cesspool and the flow.

When we arrived at Abiquiu, Juan started me on filing. He tried to act secretive about some files until I asked him what would I do with the information. Who would I tell?

At lunch I heard a detailed account of a troublesome O'Keeffe nephew who begs from his rich relatives. Feta, Claudia's maid, mothered him as a child, and at thirty-five, he still asked her for a large part of her salary. He can't hold a job even though he is somewhat educated. Then there was a horrid

story about Anita, sister to O'Keeffe, living in Florida in an extremely sumptuous house, yet it is like a prison for the help.

In the afternoon, Juan and I found a hummingbird in the studio that had battered itself against the window. It was unconscious. We took it to the kitchen and concocted sugar water, took it to the garden, and it sucked and perked up, then whirred off suddenly with an iridescent blue green chin.

I remember O'Keeffe talking about having original ideas to paint when no one cared whether she painted or not. At dinner she said she wore black a good deal because she feels invisible in black. Her first dress she bought herself was wool with black and burgundy checks.

She stroked Inca, the black chow, from his head to the length of his tail. She had a very satisfied look about her. I look at a fireplace with an antelope head on the mantle along with a large pine cone, twelve inches long, and a piece of driftwood and a candle.

Monday night, June 28, 1976

I remember Miss O'Keeffe after Sunday lunch of Cointreau on carob soufflé telling me about Brett who was seldom very clean. When O'Keeffe first went to visit Brett, a huge roll of dirty clothes rolled onto the kitchen floor when O'Keeffe opened a closet door. After that, she always did Brett's laundry when Miss O'Keeffe came to visit her.

I remember our Sunday morning walk to the cliffs with the sky blue and a few clouds. Miss O'Keeffe said she has a difficult time visualizing eternity. For example, how can the sky go on and on? She said she wanted to be buried, then she decided she didn't want anyone to think of her buried up at Abiquiu by the house. She would rather have her ashes spread out by the cliffs where she can become part of the grass and the trees. That is another kind of eternity, a kind of immortality.

Several times Miss O'Keeffe spoke of Laura Gilpin as one of the good old girls.

June 25, 1976, Friday night

I am very happy tonight. I am right where I want to be under the silent stars at Ghost Ranch, in the southeast bedroom at Miss O'Keeffe's house. I can glance up at a painting of a spring tree painted with lots of spring green. I am here to help Miss O'Keeffe determine what paintings will be available for the museum the Smithsonian is planning for her work.

We have stacks of lists and prints from the book. There has been an offer from John Crosby at the Santa Fe Opera to have land around the opera to build the museum with lots of land bought up around it so there will be no encroaching. The people who will work in the museum would not be able to live in the Abiquiu house, so a museum will be established in Santa Fe. People will be able to visit the Abiquiu house by appointment. It will be kept as it is.

Last weekend at Abiquiu, I remember Miss O'Keeffe was reflecting on how a long showroom in the museum should have the door on the long side of the room in the middle. That way a show is easy to hang, and someone entering could take in the whole show, where if you enter at one end, it is not possible.

June 26, 1976

What a day! After breakfast, it started with a trip to Abiquiu to wait for Laura Gilpin who was to do a portrait of Miss O'Keeffe. Miss Gilpin works quietly and takes a little time with each pose. She said after you do a shot, funny how people will just drop into the more natural pose. Miss O'Keeffe asked for her not to catch her grinning, "All those grinning Americans. You would think all we had was funny."

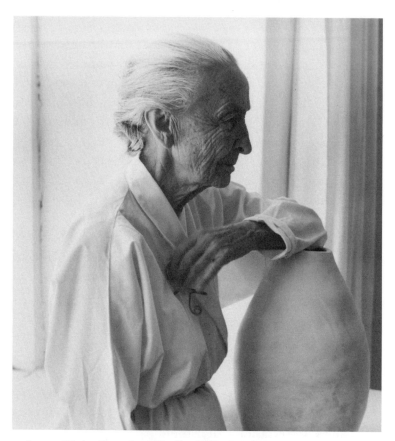

Laura Gilpin, Georgia O'Keeffe, 1976, Gelatin silver print, 6⁵/₈ x 6³/₁₆ inches. ©1979 Amon Carter Museum, Fort Worth, Texas, Bequest of the artist, P1979.130.1237.

Laura has thickened ankles, and she teeters on her feet. She occasionally used a cane, worked with a Nikon 35 mm and a Kodak 2¼. She said her work at Canyon de Chelly got her started with 35 mm. She would shoot whatever she would come back to later. That won her over. She said time was when she would never have thought of doing such a job on anything other than her big camera. But with her disability, she has to be prudent.

Miss O'Keeffe was in the window of the studio holding her pot in various poses. Laura and Georgia, one 85 and the

other 89. Two great ladies have immense respect for each other. How I wanted a camera to snap the two working together.

Early this morning, Miss O'Keeffe and I read an old letter of hers to Edna St. Vincent Millay which had been sent by Millay's biographer. It was a beautiful letter comparing Millay to a bird, quick and fluttery. Miss O'Keeffe said she only met her a couple of times. She was introduced to her by one of Stieglitz's friends who traveled with Georgia through Maine.

Cliffs are a floating immensity tonight at dusk. They are glowing and dominating.

Tuesday night, August 10, 1976

Here I am cozy under a white spread between blue sheets at Ghost Ranch. I arrived to work for Miss O'Keeffe for a week before I begin teaching at the English Tutorial program on the 18th. I have just completed an extraordinary weekend at the Lama Foundation. This evening JLH drove me to Abiquiu where I called Miss O'Keeffe, and she said to wait for Anna at 5:00 to ride up to the ranch with her, and to go sleep in the sitting room. There I saw her new painting with delicate shading: Red door, pink sky, and shades of pink tiles and below a white wall.

I slept after a light dream of many complications and a balloon popped making everything simple and easy to sleep.

When we drove to the ranch, Anna and I began to get acquainted. Anna is taking Mary's place as breakfast and dinner cook and night sleeper. She is an excellent and inventive cook, aware of healthy foods.

At dinner tonight, Miss O'Keeffe said many interesting things. First when I walked in, she showed me the first run of part of her book. There were about two dozen prints, and the type on the pages opposite. WOW! It is going to be super! The special edition of 1,000 will come out with a black cover. The others will have white covers. About *Starlight Night, 1917* (little squares of light on blue field), she said it was done on very cheap paper that you used for drawing class. It was so cheap you started fires with

it and wrapped packages with it. She said she could paint freely on such paper where one had to be very careful on watercolor paper that was $2.00 a sheet. She is very funny in her attitude about the book, how absurd that a blind person would make a book of color plates.

At the Santa Fe Opera, she saw *Mother of Us All* by Virgil Thompson with sets designed by Robert Indiana and Bill Katz. She said she would have made Susan B. Anthony quite differently, in black and white, with a dark background so she would stand out. She said it was amusing how a person on quiet roller skates represented unspoken thoughts quietly gliding between people.

More to write about: picnic, Orraca, Crosby, Smithsonian, Juan, Anna, and the cookbook.

—Wednesday

Anna is from Indiana and lived in California for ten years. She is thirty, and she is very eager to please Miss O'Keeffe. However, she is afraid she will miss teaching craft classes where she made a difference in a great many lives. At dinner, we had great fun planning a cookbook using Miss O'Keeffe's good recipes and Anna's ability to make unique creations out of whatever is in the kitchen. (*Written by Miss O'Keeffe in the front of her cooking notebook on red paper there was a long poetic statement about the importance of onions and garlic along with a personal touch in the art of cooking.*)

—Wednesday, still

Last night Miss O'Keeffe said that José Orraca arrived at the door a couple of weeks ago carrying a large basket of mushrooms covered with a blue paper. She said he was so full of energy, she had to send him away for the second day he was here so she could go to bed. She sent him to Taos. Then he came back to Ghost Ranch for his third day. Miss O'Keeffe and Mr. Orraca worked together on preservation problems for the Stieglitz archive. Mr. Orraca is a very large man, and she said she had expected a small, dried-up little fellow.

Today John Poling came to paint the house. He helps around doing odd chores and now, at 3:30 this afternoon, he is helping Miss O'Keeffe with a large rectangular canvas, approximately 4 feet by 8 feet. He draws lines for her and talks (I presume) about how it looks.

This morning I typed replies to a dozen or so letters. John read them to her and had her sign them. He has been at the University of New Mexico and would like to get more into archaeology. He has been working with digs at the School of American Research. Like so many young people who find their way to Miss O'Keeffe, he is very ambitious and jealous of anyone who attracts her attention. Anna seems similar, but Quaker gentle. John was using some of Juan's type of humor that puts me in the worst sort of light and leaves me a bit speechless. He is tall, thin, has a mustache and black wavy hair and careful blue eyes. I could have hit him when he said, "So, you brought your dirty laundry up here to Miss O'Keeffe's." He shut up when I said I had been in Taos for four days. He rested easier when I talked about my nine-month job that starts this September.

Thursday, August 12, 1976

At lunch Miss O'Keeffe mentioned that Stieglitz used to rub bee's wax over his photographs to bring out the color of the paper. He bought thin sheets of it, melted it down into a bucket container, kept a shaving brush in it, and heated it just a little before applying it to photographs.

Yesterday, while we worked on the mail in her studio, Miss O'Keeffe said her brother went away to Episcopal military school. He came back with the news that there was something gravely wrong with Jews but wouldn't say what. He would only say, "You'll find out." She said she married one just to find out, and she never did. We laughed and laughed about that.

When talking about a picnic held by Crosby, John Poling and Miss O'Keeffe both agreed that Crosby has a mysterious, quiet feeling about him. Miss O'Keeffe said the first time she

met him they sat together at the first Santa Fe Chamber Music Festival. She said now he has gained a little weight, appears quite a solid man and has this very quiet quality about him. John said when Crosby walked up, it was as if a spirit had descended.

There was a picnic near the opera on a hill with Robert Indiana, who designed the set for *Mother of Us All*, Katz who had a special Chimayo rug made for Miss O'Keeffe, and a number of other men were there too. Several tables were set up. Miss O'Keeffe was surprised at the extent of the arrangements. There was a man there named Tobin along with his mother. Miss O'Keeffe said they have a secure income from a grandfather who made maps that the army is still using. Tobin has twenty to forty Shetland ponies grazing on the lawn of his San Antonio home. He used to be a little bit drunk all the time, then he had a serious car accident, and that sobered him up. Miss O'Keeffe said he used to be quite well-groomed, but he has become frowsy. Her chows are perfectly combed compared to the way his hair looks now, she said. "Tobin's mother was there, wearing an inappropriate fur that made her look as wide as that." To illustrate, Miss O'Keeffe's hands extended about three feet apart. Miss O'Keeffe remembered that once Tobin's mother appeared in a beautiful dark taffeta with flowers (about four inches long) printed here and there on the dress, not too many. Miss O'Keeffe said Tobin was pleased that she remembered his mother's dress and agreed that it was truly fine.

Miss O'Keeffe commented about how the Tobins carefully live in separate houses so they won't fight. That's what she says families should do. She said Diego Rivera and his wife lived in separate places. Andrew Dasburg arranged to have a separate room added onto the house so his wife and child stayed separate from him.

The following was written by Miss O'Keeffe, planning a letter to John Crosby who manages the Santa Fe Opera. They are planning a museum with the Smithsonian. It may be on the hills by the opera north of Santa Fe:

When you came out and spoke to me that afternoon before we went upon the hill to where the museum might be, I was astonished at the quiet feeling you gave me. Most of the time one is rushing and misses quiet. As you stood before me, moved away, and returned several times right along into the evening. When I stood up on that hill top the world so free as one turned about, wide and free, it is a good place if one can create something on the hill top feeling as wide and free as the place. I was very surprised with you and the hilltop and the trees, and the picnic among the trees, all so near to Santa Fe.

I don't know how I happen to be so fortunate. I feel fortunate to live in Abiquiu with the wide Chama Valley out beyond, and here at the Ghost Ranch with the cliffs and the red hills, to add your hilltop as a place for my work seems rather special. May I thank you for thinking of it.

Sincerely,

Friday, August 13, 1976

Last night I dreamed of cavorting with a spider monkey that Miss O'Keeffe introduced me to. It was a friendly little light brown very limber creature with sweet eyes.

Today at lunch we talked about how many items Miss O'Keeffe has sold or given away. She used to own a Lachaise sculpture of a woman with large buttocks and breasts and a small waist. She stood with her arms at her sides, her hands out. Miss O'Keeffe said she used to hang bunches of very large grapes on the woman's hands. She seemed very delighted when she spoke of it. Then she had another white alabaster woman bent back from her knees until her head touched behind her. Miss O'Keeffe said she was really special. Sometimes she would put the statue in front of a bunch of flowers. But it got so that since Lachaise was such a disagreeable character, Miss O'Keeffe didn't want to have any of his things around. She said that's the way she got her Calder mobile. She was walking out of a museum once and saw the Calder mobile. She asked Cort if he

would trade the mobile for her Lachaise. He said he hadn't seen her Lachaise. She replied that if he wanted to, he should have a woman go up to her room where the Lachaise was in her closet down among her shoes. She was going out of town. A little later the Calder arrived in the mail. I asked why Lachaise was so disagreeable. Miss O'Keeffe said that he kept asking Stieglitz for money, and Stieglitz didn't have any money. Miss O'Keeffe said Stieglitz had been very ill in the spring, and she had labored very hard to keep him alive. They didn't need Lachaise to come in every day begging for money with nothing to offer.

Earlier in the meal Miss O'Keeffe said during the year of her Whitney show, she got ninety-three percent of the publicity for artists, men and women included. The women had a tiny, tiny piece and the men more, but she had the most. She said a woman called her from Los Angeles with Peggy Kiskadden as a friend and asked Miss O'Keeffe if she would lend a painting to go all around the country in a women's show. Miss O'Keeffe sounded indignant because there are not any women doing anything these days.

I asked why, in her opinion. She said that we have lots of good women writers because you can do it at the table after a meal, over by the stove waiting for the bread to bake, or wherever. I asked her how she happened to do so well because she had many of the same problems. She said she took care of two houses for a while, but for twelve years she lived in a hotel in New York where all she had to do was get up and have breakfast. It was run by a military man who had some men do all the work.

"A man would come in and clean up," she said. "You didn't have to talk to him, and he wouldn't speak. He would just go about his business."

Once Ansel Adams sent her a barrel of greenery from California. Miss O'Keeffe put it all around her apartment, and it was really very beautiful in the fireplace. The Eliot Porters were coming over for dinner, and she had to think of what to do with the greenery. She decided to burn it all at once. When she did, what a fire! It burned high hot inside and outside the chimney. The wall

got very hot. A woman who helped her had a damp dishtowel, but wherever she touched it to the wall it left an awful spot.

Where she painted Miss O'Keeffe said she had a large south window. When she went to the house at Lake George, she would arrive early in spring when it was too cold for anyone else to want to be there. She said Stieglitz's cousin would spread out a bedspread on the floor to do her painting, and she could be as sloppy as she pleased. Miss O'Keeffe made a face. She said it was very wonderful to wake up and find it had snowed. Sometimes water froze in a glass by her bed. She loved to sit up in bed and look out on the chicken house with a chimney and see how the snow had balanced on the chimney and the roof. She held her hands up about six inches apart. She looked pleased remembering.

She said when she couldn't stand the company in the house any more, she worked at a shed which was a five-minute walk away. It was a neat little building built for dances. The women donated money, and the men their time to build the structure. In the fall, Miss O'Keeffe would stay later than anyone else and close the house. During the summers, she came to New Mexico. She returned in time to secure everything for winter so it wouldn't freeze. She could get a little work done then, too. Yesterday, I went into the studio, and there was John Poling on a stool in front of a large canvas painting a yellow-brown over white, like this:

CR 1263, *My Last Door*, 1952/1954, Georgia O'Keeffe, © Georgia O'Keeffe Museum, Image courtesy of the Georgia O'Keeffe Museum.

The painting I sketched in my journal had a yellow-brown wall, 8 white stepping stones, a rectangular white door, and a white sky.

On the backside of another large canvas in another room is a large piece of paper the same size with these forms sketched out in charcoal. Miss O'Keeffe was in a chair with her feet propped up studying the work. Playing on the stereo was a Caedmon recording of Noh plays which she loves. Today she had me check her brushes to make sure they were clean, four of them, different sizes and shapes.

Last night before bed, I took letters into her studio to be signed, and we did checks for various materials from *Public Citizen*. Then she played a record of Wanda Landowska, playing Bach with a very aggressive and almost passionate style. Miss O'Keeffe described one of the performances. A man came on stage and carefully dusted the piano keys. Then a tiny woman with a little waist entered in dark taffeta that looked as if she had slept in it. She had little pointed slippers like bedroom shoes. Then this little lady took out a handkerchief and meticulously dusted each key. Miss O'Keeffe said it brought down the house. "Be sure the piano keys are clean!" Then Miss O'Keeffe and I listened to this very loud Bach which was very fast, very passionate.

Miss O'Keeffe said something about making the most of your appearance, making it a real performance. Little Wanda Landowska carried herself like she was *the* authority on Bach.

August 23, 1976

When I was sitting in the freshman English class that I was teaching, I was troubled by a huge spider bite on my right thigh, really ten bites in ten places. There was swelling, soreness, and

worry. I imagined everything from bubonic plague to rabies. I had gone to Dr. Ziegler in Española with Miss O'Keeffe. He looked at the red swollen spot and said it was just a matter of time. There wasn't anything he could do for it since I didn't know exactly what kind of spider bit me.

(From the painful nature of the bite that simply would not heal with normal treatment, I found out from a friend who was a medical student that it was most likely a nasty bite from the deadly brown recluse spider. We consulted his textbooks. As a result of learning about herbs and nutrition from Miss O'Keeffe, I went to work to heal the wound from the spider bite with continuous treatments of comfrey leaf poultices. Within a month my painful spider wound was healed. Possibly, I owe Miss O'Keeffe my right leg.)

August 25, 1976

I called Miss O'Keeffe today, and she has a hoarse throat. It made her sound younger. I told her that I finally got my schedule squared away and could come to work for her on the weekend. I could catch the 5:30 p.m. bus to Española, arrive at 7:45 p.m., and stay through Sunday afternoon. She will let me know. She let me take the list of things in the Lawrence box on a handwritten list to George Miller at Zimmerman Library at UNM.

October 25, 1976

Yesterday I called Miss O'Keeffe to tell her I have some jasmine tea for her if she is still lacking. She said that Mary had sent three boxes of tea all securely wrapped, and she has received the jasmine from the Chinese man at Taliesin West.

She just got back and was pretty frail. Claudia answered the phone. Miss O'Keeffe said Juan will need help filing soon. I suggested Thanksgiving. She said that's very far away isn't it? She asked about my work, and I told her I had nine students who think nothing of English. I said they challenge my every teaching technique. She said sometimes those are the best students to have, those who want nothing to do with what you have.

Looking at photo print
of pelvis bone floating in sky
O'Keeffe said
she was seldom pleased
by what she painted
never reached what
she saw
what she intended.
She was amazed
people seemed to like
what she did
always felt
she must work on
try again.
If she ever reached
what she saw
she would
stop painting.

March 1977
C. S. Merrill
O'Keeffe, Days in a Life

[1977]

January 27, 1977

Monday night Juan called from the airport and said he would be over in fifteen minutes and invited me to a Chinese dinner. Of course I accepted. We walked to New Chinatown, a rebuilt restaurant about a mile up the main neon Albuquerque Central drag. Juan told me about a car wreck he had last month. He rolled off the side of a road three times over and over and messed up his right shoulder. He has been to Jan Sultan, the Rolfer, and the pain is gone. The flexibility is back. His BMW was a total loss, so he will probably try to get a four-wheel-drive truck from the insurance money. He said he made a good income last year and was taxed a great deal, and he has only $1,000 left. He said he took a lot of people to dinner in New York and lived pretty high. He had a $100 dollar bill in his wallet. We ate Chinese vegetables on rice, egg rolls, and some lobster mixture. It was not bad.

We lingered over tea, and he gave me advice about my boyfriend in Albuquerque. Juan is still pretty lost about his loneliness. He carries a gun in his purse-like satchel. He wants a good friend to come live with him. I wonder if he really does. He asked if I thought he should go to the Lama Foundation. I told him some of the people there seemed pretentious, but there are some real ones there.

He wanted to meet some of my friends, particularly women, so I called up Barbara since she needs advice on what to do with her art, and Juan likes thin women for girlfriends.

Then JLH came over. Juan, JLH, and I went to a light-weight movie called *The Seven-Per-Cent Solution*.

Juan stayed at my apartment, and I left him soap and clean towels while I stayed overnight at a friend's house. On the next morning, I came back to fix breakfast with him. He still has a way of going right to the most embarrassing heart of the matter.

His basic advice about my boyfriend in Albuquerque was, "No one owns another person."

For lunch, I introduced Juan to GM, another slim lady with a very positive soul and sense of humor. I was not comfortable having both of them at the same table since each of them had snagged a job that I would have really liked to have. I still harbor a little suppressed anger there.

Earlier in the morning, I introduced him to PW, who just told me she has some grant money to document Abiquiu. Juan thought she would be fun.

February 6, 1977

This has really been an extraordinary week. Tuesday JLH and I had a leisurely afternoon in Santa Fe. We ate lunch at The Shed then drove to Laura Gilpin's studio on Camino del Monte Sol. A year ago, I spilled water on a chair next to my bed where the Laura Gilpin portrait of O'Keeffe at the window was leaning against the chair back. The water soaked into the mat and discolored it for about an inch from the bottom. Sena Brush-Morales, Laura's helper, will cut a new mat and we will go back awhile later. Laura Gilpin is shorter than I am with a head full of fluffy 2-inch white hair with a pink scalp, a blue shift, a cord with a magnifier around her neck and such a laugh, wide-mouthed, tooth-showing, eye-closing hoots and guffaws, when I established that I had been moving furniture while she did a portrait of O'Keeffe in her studio with a pot last summer. The photographs were all

calculated to conceal her difficulty in seeing. Laura particularly preferred a profile without much detail. She told us that Eleanor Caponigro suggested a series of portraits of O'Keeffe's hands around openings in pots, because she has such beautiful hands, and Miss O'Keeffe painted so many portraits.

March 19, 1977, Saturday

Today I am very happy. I was trying to arrange with Juan a way to be around beauty. I was going up to visit him, but a family arrived from Maine so there would be little peace and quiet. I called this morning. Juan had stayed in town. He called back later to say Miss O'Keeffe would give me a room, then Sunday I could drive her up to the ranch for us to walk. I am happiest driving and being there.

—Late night, Saturday still

Sitting on a reclining chair in "Claudia's room" (*this was the room just to the left of the gate for cars*) covered with a warm tan comforter gazing up at one of Miss O'Keeffe's huge jade plants. Sat in a warm bath reading Barbara Rose's comments on Miss O'Keeffe's book in the March 31 issue of *The New York Review of Books*. I arrived here at 4:30 p.m., just before dinner as Juan suggested. A woman named Nancy Prince stood at the gate to welcome. She is middle-aged, clear-faced with very short hair. She seems to be not especially class conscious with a calm appearance, turtleneck sweater, and dark trousers. Miss O'Keeffe was on the phone chatting with someone. She was trying to hang up. When she did, she turned to me and said, "Do you ever talk to someone who just won't let go of you, and you try and try to hang up?"

She was dressed in a black suit with her Calder pin and a white scarf at her neck. Her hair was in a French roll at the back. She felt like riding up to the ranch. She seemed pleased that I handed her a record of Baroque pieces with Pachelbel (Canon in D) and Corelli, and more. She was interested in the *Time* magazine article I brought on Madame Mao Tse-tung. We will read it tomorrow. I commented about the headline on the cover of the *New York Review of Books*, and she said, "Yes, I got a headline. It is a long article." We got her warm things, a velvet hood, a quilted Chinese coat, gloves, and fresh Kleenex tissues for her watering eyes. We rode in my friend's Volkswagen. There were some village men digging at some plumbing by her fence with water everywhere. We hit the road to the ranch. Miss O'Keeffe said that Barbara Rose stated she was deeply influenced by Thoreau and Emerson. Miss O'Keeffe followed with, "I'm supposed to have read Thoreau as a child. Well, I don't remember that. I suppose I have him now, but I don't remember anything about him." She proceeded with, "I have found that when something is written which is untrue, it is best not to comment on it because that only draws attention to it. Otherwise, it just disappears, and fewer people notice it."

She said she has received much mail in response to the book, and that astonished her. About the energy crisis, several times she said we will just have to learn to be colder.

We walked most of the way out to the cliffs talking about this and that. Peggy Kiskadden is well. Geri was out last week, and she wants to work for Miss O'Keeffe again. When we walked, she held my hand for a cane, and she insisted again and again I must relax my hand. Next week they get the dummy for the second edition of the O'Keeffe book.

We don't discuss Doris Bry. "Who's she?"

Mr. Hall (*who used to own Ghost Ranch*) is thinking of building a house close to Miss O'Keeffe's walk to the cliffs. She said she would not be pleased unless they built it underground.

We drove home to a dinner of cottage cheese, onions and oranges and sesame seeds on lettuce. There was cheese, wheat bread, gingerbread, and raspberries, delicious without sugar. She was in a mood to chat.

I almost forgot. In the car I described my "crazy" student Lisa who will not write in my class. She sees ghosts and hears music and voices. She has had eleven psychiatrists in three years and spent time in a mental hospital. Miss O'Keeffe suggested that if she could write something of what she experiences, it might be thought that she made it up and was quite clever.

She described being invited to the Calder dinner and refusing. Then she had to go to New York to talk to her three lawyers who have located three stolen paintings of hers. They were stolen years ago. A dealer friend of hers had mentioned that he wished he had bought one of them when offered, and she remembered that it had been stolen thirty years before. She went to the Calder dinner, which occurred three days from her lawyer's appointment. So she went to the dinner. Everyone was there, and it was very noisy. The show wasn't much. She remembered a pile of crockery where you could toss things, and they would bounce among these items and produce sounds. John Cage was serving bread around her table. She remembered dining at Cage's house once. A plant grew in through a window, and along the wall a ways. She likes e. e. cummings's poetry. She had cummings's chair at the Academy. She said she doesn't go much for Hart Crane.

There was a photo of her and Calder, printed nationally, and everyone thought she had come to New York for his dinner, but she really came for her lawyer's appointment. She said Calder enjoyed himself. He danced very slowly, but three days later, he died. It was like the party was for a big good-bye.

Aaron Copland will be in the Santa Fe Chamber Music Concerts this year. She used to sit next to him at meetings of the Academy because he could tell her who all those old fellows

were. She was surprised to see Lewis Mumford's head, bald and shiny as an egg, like he had polished it. When she knew him, he had had a head of thick brown hair. She voted for John Cage, because if all those old men were arguing over him, he must be good. Alan Priest gave her the wooden Buddha in the *nicho* (*Spanish word for niche*) in the dining room wall.

Our centerpiece consisted of two polished brown rocks on a piece of lace on the wood table. It was nice to watch her hands rearrange the stones.

When I told her about my judo classes, she said that was something I ought to continue.

She enjoyed my pride over being published in the Gallimaufry poetry book and said she would order one. It was pleasing to be appreciated.

When I commented that the photograph was not totally flattering, she said, "When you have been photographed as much as I have, you forget what you look like."

March 20, 1977, Sunday night

This morning Miss O'Keeffe and I flew a yellow triangle kite at the Ghost Ranch. Once it got away and was caught by an electric wire. It flew there a few minutes, then dove into a small tree. We gathered the string that we could, tied on new string and flew it again on the driveway. Once again, it got away, and I chased it hard and caught the string. The kite was about 120 yards up. It was fun. Miss O'Keeffe said when I chased it, all she saw were the soles of my feet.

I got six gallons of the soft spring water from the Abiquiu house and brought it home.

We had breakfast, both in black coats. Miss O'Keeffe seemed interested in the books and articles I had read lately. This evening before I left, I took JLH's copy of her book and mine into the studio for Miss O'Keeffe to sign. She made a big deal about my friend's book not having been opened. He told me to tell her he had looked at the paintings again and was distracted from the

text, though that is not to say the text is poor. Miss O'Keeffe had made jokes with me about learning to make quilts.

She signed mine and then talked about a poem of mine that I had read to her from *The Face of Poetry*. She said it was interesting, but she didn't remember much. It wasn't good enough. She said that I was writing about a pitiful part of the world that didn't amount to much, and there is so much that matters in the world. She advised me to keep writing and perhaps eventually I would be able to say something important. She said she once saw a photograph of the edge of a house, and it was quite good, but it wasn't enough. She said it might as well be thrown out the door. It was good, but it wasn't enough.

She described a jade knife with a curve of the blade handle that was something one remembered. It mattered. She described a large room in the Victoria and Albert Museum with a red tapestry with a yellow central seal. The colors were worn, looked once vibrant and weren't faded or dirty, just lessened. She said about this room that it was air surrounded by a wall. This special life to things Miss O'Keeffe likened to wind.

She liked Diane Wakoski's title about getting used to her face. Miss O'Keeffe said she used to have a mirror on a bureau when she grew up. It had pink pansies painted around the top frame. In that mirror her face seemed round. It was not until Stieglitz began photographing her when she realized that her face was long.

At breakfast Miss O'Keeffe said that she tried to read *The Brothers Karamazov*, but it was just too bloody. It was too much to take in the middle of the night when she likes to do her reading. She stopped at the point where a four-year-old child was nailed to a wall by the ears. She says when she reads, whatever she reads becomes almost real for her in the night.

March 22, 1977

Miss O'Keeffe is working on a piece of writing that she began ten years after she took care of Stieglitz's prints in 1949. She began this in about 1960. She said it is about the husband she

was with thirty years, and it is rather sharp. I asked what she meant by "sharp," angry or smart? She replied rather stiffly but with something of a smile, "If you live with a husband for thirty years, and you left, and you are talking about why you leave, and you are telling the truth, it is sharp."

Yesterday, I told Joy Harjo that Miss O'Keeffe had said on the occasion of another visit that she was seldom pleased with what she had done. Her work never reached what she saw, what she intended. So she was amazed that people seemed to like what she did. Miss O'Keeffe always felt she must work on, try again. That seemed to help Joy's discontent about not being pleased with her work.

July 4, 1977

A close friend said to me, "Why are you sad?" and I replied, "I may never see Georgia O'Keeffe again."

Friday I rode the bus to Española where Juan picked me up. We shopped for groceries and drove to his house at Barranco. He was very funny and candid, talking of the lawsuit with Doris Bry. He appeared lighthearted, but I didn't realize how deeply this legal battle was affecting him.

After dinner when I asked to go down to Abiquiu with Miss O'Keeffe, he completely lost his temper. I asked him to take me back to Española to catch the bus. Then he became truly rude and argumentative. I hope I never say to another human being what Juan said to me. He drove me to Española where I met the bus.

I may never see O'Keeffe again since Juan influences her. I have written too much about his meanness. This is just a record to re-stimulate in my mind what I promised Juan I would never tell. He seems to be getting a strong feeling for art history and his place in history. Enough!

There was Joy Harjo, just in from Flagstaff, as I arrived at the bus station, and me without money for a cab. How lucky! Joy's friend Pat Jojola gave me a ride home.

July 10, 1977, Sunday

Last week was a great effort. I wasn't paid my full paycheck for July 1. July 2 was when Juan blew up. My ride back on the bus was relieved by what I exchanged with two yogi women. I was able to call Miss O'Keeffe and say I would like to come back next fall and work for her. There was a long depressed alone time the rest of the weekend.

August 10, 1977, Lama Foundation, San Cristóbal, New Mexico.

Standing in dim light in the kitchen waiting for my milk to heat at 10:00 p.m. This was a long day which began at 5:30 a.m. Joy picked me up at 7:00 and we started the drive to Taos. Joy and I talked to Santa Fe about our love lives. There we stopped at her friend's house. Her friend's name is Nancy. Then I went to a house on Camino de Las Animas to be interviewed by Laurie Lisle of Norton Press who is doing a biography on O'Keeffe. We had a nice talk for an hour. She was interested about how I first met Miss O'Keeffe and how she had influenced my work as a poet. She wanted ideas about how to meet the woman, whether Juan would help or not. I told her about our trip for the Easter service at Christ in the Desert Monastery. I told her that I doubted whether Miss O'Keeffe would be interested in someone writing a biography of her. Laurie said she should appreciate what it would do for other women. I said Miss O'Keeffe told me that she thought women were giving up a good deal of privilege by wanting equal rights. Laurie told me that Miss O'Keeffe once belonged to a "votes for women" party when it was unfashionable, while she was working hardest at her art. In the twenties, she allied herself with "the boys" and not with the women. She has always been pragmatic where her art is concerned. Laurie seems intrigued by complicated contradictions and inconsistencies in Miss O'Keeffe's life. What I saw was a young woman in a hurry, and I advised her to slow down a bit if she expects to learn from Miss O'Keeffe.

Laurie was surprised that Miss O'Keeffe had been rolfed. She had been going on about how Miss O'Keeffe's brother, older brother, provided explanation for much of her life. I advised her to avoid psychological interpretations with Miss O'Keeffe because she dislikes analysts. She thinks people come out perfect little patients. Laurie will probably persist. She has a rather good eye. Here and there in the small house she has rented for the summer, there were lovely touches. There was a white cloth tacked and drooping over the skylight. There was a feather here and there, red peppers on a white wall. She had white directors' chairs. Her table was set up much like Miss O'Keeffe's with a typewriter on one end and notes and paper on the other so that she moves herself when she changes her tasks.

I carefully avoided talking too harshly of Juan, but I did, indirectly, I think, warn her of his bad temper.

It felt odd to be talking about Miss O'Keeffe to a stranger. She said she would like to see more of my poetry, and her editor is Adrienne Rich's editor. Who knows what might come of it? I am sleepy. It is very dark here at the Lama Foundation. Ruth welcomed me warmly this afternoon. Now I go down to the guest tent. There is much to write. I am working here for $3.00 room and board.

Reading Philip Whalen's *On Bear's Head*.

Tomorrow I begin two days of silence. As I walked to the tent in the blackness, I remembered I told Laurie Lisle one of the most important things about Miss O'Keeffe is her attention. She gives complete attention to all details. In her house one is surrounded by thoughtful beauty. Another important thing is her love for music.

December 20, 1977

Juan called last week to apologize for the difficulty last July, referring to our horrendous argument.

There is a good article on Miss O'Keeffe in the latest *ARTnews*. The article about her reminded me of many important

memories I have of her. She says her success isn't due to talent so much as nerve and hard, hard work plus a sort of simplifying, deciding, limiting, giving up some things in favor of painting. If she was up all night dancing, she wouldn't paint for three days at a time. I remember her saying to JLH when they talked about painting, "Isn't it fun?"

When she works, she works for a whole day at a time. She walks, does rolfing exercises, stays informed, and creates and eats carefully. She goes into a rage if anyone pampers her. It is as if she fights such conditioning to make her dependent or weak or less than she is. I want to take her a present: Jasmine tea, cheese, candied ginger, maybe next week.

The long room
on north white wall an African mask
oval and black with protruding mouth
and slitty eyes; long braid
extending up from the head.
O'Keeffe said there were two,
but the other one was not so fine.
She used to take it with her summers
hang a painting next to it—
if it held its own
the painting was good,
next to the mask.

January 1978
C. S. Merrill
O'Keeffe, Days in a Life

[1978]

6

January 7, 1978, Saturday night, Abiquiu

Here I am at Georgia O'Keeffe's house again after all this time. It must have been last spring when I saw her. Juan called last night asking me to come up for the weekend.

I drove up in my Volvo, stopping at the Safeway in Santa Fe for salad makings, and arrived at eleven. I was welcomed at the gate by two barking chows, rusty Jingo and dark, ashy Inca. A woman was at the gate asking if I was Juan's friend from Albuquerque before she let me in. Margaret from Norman, Oklahoma, seems very eager to please and very energetic. Out came Juan with a handshake. He seemed eager to see me, not overdone, but not unfriendly. He explained that a girl at Ghost Ranch had been interviewed to stay with Miss O'Keeffe, then another one arrived to stay in her place. They were furious at the switch without warning, and Miss O'Keeffe chose to stay alone. Then they called me. My work for the weekend will be to cook Miss O'Keeffe's meals Saturday and Sunday, keep her company, read the manuscript for the book for the Stieglitz show of O'Keeffe photos at the Metropolitan this spring, and read to her selections from letters between her and Stieglitz to caption the photographs. What a treat! What a chance!

Miss O'Keeffe was off in her bedroom, and Juan and Margaret were busy over at the IBM Selectric typewriter getting the last bit of the manuscript typed. Miss O'Keeffe walked out dressed in black with a white shirt, her grey hair done back. She walked very strongly and steadily with one of her dark wooden canes. She extended her firm handshake. The palm of her hand always feels a little bit hollow. She accepted the large rock I gave her, the smooth pink and gray one from the Maine Coast. She rubbed her hands on the top and bottom of it and asked where it came from, then placed it on her desk. She said the bedroom across the way was to be mine to stay in, and she would be over in a while to make sure the sheets were clean. In the meantime, she wanted to see what Juan and Margaret were finishing. I went into the sunny warm plaza and reacquainted the dogs with my scent and voice while I "wooled" them around a bit, playing roughly with them.

Miss O'Keeffe came over to the bedroom where I am now. She pulled a chair over by the desk and plumped up the pillows saying she had this chair here for the other girl. We looked at the sheets, and they were clean and pressed. In came Juan, and they bantered together over a problem with reaching the conclusion of this catalog book.

Juan had to rush off to cover a pot he had been working on this morning. He offered to drive Miss O'Keeffe over in his truck, but she insisted on not going since she would have to look at the pot.

Then Juan interrupted, "And if you said anything, I would smash it on the floor." I asked if that had ever happened, and Juan answered with a serious look. Miss O'Keeffe chuckled.

For lunch I fussed over steamed cauliflower with cheese sauce, salad with the O'Keeffe dressing (crushed garlic mashed with salt, 2 tablespoons salad oil, tablespoon of tarragon vinegar, and palms full of various herbs: lovage, summer savory, tarragon, parsley, etc.), some spiced-up Campbell's soup, and mint tea. Juan stayed for some salad, and he ribbed me about the deep

voice on the phone at my apartment. While I was cooking, he had Miss O'Keeffe believing that WO was a black man, the man who answered the phone. I just laughed with them but didn't let on, letting their curiosity build for a while. I was balancing everything to come out on time when Juan took Miss O'Keeffe to the studio to approve the last bit of work on the manuscript.

All of the dishes were warmed to the proper level. The cauliflower was tender, but not yet sulfurous and overcooked. The salad was dressed and marinating. The table was set with all in place, and there sat the two of them, Juan reading to Miss O'Keeffe at the desk. Of course that manuscript is far more important than my puny little lunch, so I waited patiently and let things cool down. Finally Juan and Miss O'Keeffe (Georgia to him) came over and I served her soup while he stayed in the kitchen to show me what had to be done with this manuscript. It seems they prefer a dash to a comma or a period and use it very liberally. It looks fine on a page as it did in her autobiography, but it is tedious to make rules for consistency. My assignment is to catch glaring errors and leave alone the individual style of the work. Luckily, the text is fascinating enough that the eccentric punctuation, except in maybe three cases, doesn't stand in the way.

When he came back from his place, I thought that Juan smelled a little bit like marijuana smoke, a great way to keep one's sense of humor, I suppose.

Old Estiben has worked for Miss O'Keeffe for years and years. He is the one who builds perfect fires in the fireplaces here. His wife died of the flu. Many of the people who work for Miss O'Keeffe here are in mourning for her, and that made it difficult to get help around here.

Ida, who washed Miss O'Keeffe's hair a day ago, arrived with a serious cold. She was sent home. Miss O'Keeffe won't go into public places in order to avoid cold germs and will turn away anyone with a cold.

Juan left for Santa Fe with the Volvo to have a knob replaced on the carburetor, to do some grocery shopping and to pick up

from the bus station, something to do with the new book. He planned to spend the night down there somewhere.

Miss O'Keeffe and I had a fine chat after lunch. She warmed her back by the gas wall heater. She told me about her Aunt Ollie who lived to be 103. She is one of the first people Miss O'Keeffe remembers visiting as a child. Her sister went over to fix up Aunt Ollie with a housekeeper and a nurse. Before she got back home, Aunt Ollie had fired the both of them. Whenever anyone gave Aunt Ollie vitamins, she threw them under the bed. Miss O'Keeffe said that is the way she herself was when she was a little girl. If the horrible foul-tasting medicine didn't suit her, she would chuck it under the bed.

I told Miss O'Keeffe I was interviewed by a woman last summer who said she was doing her biography. Laurie Lisle with Norton Press had called me. This released a storm of indignation from Miss O'Keeffe who said when that woman came to her gate with a gift, she said for her to go away or she would sic the furiously barking chows after her. Miss O'Keeffe said that woman called to say she wanted to write something on Miss O'Keeffe. When Miss O'Keeffe said, "Get busy," that woman took it as a signal to interview and question friends and relatives. Miss O'Keeffe said she and Claudia went to lunch, but Claudia said that woman never asked her any questions. I assured Miss O'Keeffe that I didn't reveal anything personal, just facts which could be found in most of the books or articles about her. The only misguided questions she asked concerned Miss O'Keeffe's early motivation which no one can ever know anyway. Miss O'Keeffe said the worst thing that woman did was to call on a very old friend of hers named Dave and ask some probing and very personal questions. She said he was one of the few people she could stand with in a beautiful place and feel completely alone. "Those people are pretty rare," she said. She once stood with him on the rim of the Grand Canyon and felt alone.

As I cleared the table, I mentioned that I had read the latest Carlos Castaneda book called *The Second Ring of Power*. She

reminisced about her brief visit with him. She said he was very energetic and so enthused that he hugged and kissed her as he left. I mentioned the furor over whether the books are true or fiction. She wants to know more as I find out. She said he told her he was going further south to work with someone other than Don Juan. She has read only one of his early books because Juan wanted her to.

I'm not sure where it came into the conversation, but I remember her profile against the light and shade of the patio as she sat at the table, telling me she wished she had thought to tape-record Stieglitz's voice before it was too late. His voice took on a very special quality, especially when he got excited about something, rather high-pitched and intense.

After a warm bath, here I sit cozy under a black comforter covered with roses in one of my favorite rooms in the whole world, in front of a blazing fire. One of Miss O'Keeffe's canes is leaning against the desk over there. Her long early light sky-scape is over the desk. Estiben's one-match fire is all waves and licks of flames. The air and flames are going up the chimney in wind gulps making fire thunder. An antler, a white one, is simply placed on the narrow mantle. The manuscript is over there on the. . . . (*One page is missing from the journal. It was torn out.*)

Earlier in the other room, I overheard Jackie Suazo say to Miss O'Keeffe he had opened the door for a woman last week, and she (the woman) had scolded him for it.

Miss O'Keeffe responded to Jackie, "Have they gone that far now? Well, did she open one for you?"

Later in the kitchen, Jackie was discussing his job, which is to deal with discrimination cases. He talked of a woman denied an office job at Las Cruces because it was given to a man. Miss O'Keeffe joined in with, "Well, the woman should get an equal chance at it, don't you think?" He politely assented. I think that Jackie Suazo must be very complex. He served five years or so in the Marines only after Miss O'Keeffe convinced them to take him even though he was in jail.

Tonight for dinner we have beans with cardamom, rice, salad, cauliflower, and herb tea. We talked awhile. I entertained her with a light synopsis of the movie *Close Encounters of the Third Kind*. She was favorably impressed, raised eyebrows and a nodding hum with closed eyes, "With communication by music."

Sometimes there seems to be an extra dimension to our talking, rather like meditating.

She showed me copies of the photos to be in the Stieglitz show with a comment that she doesn't like to look too much into the past. The next project is a book on abstract art and perhaps a show somewhere.

Then she described the exercises Ida Rolf gave her. Two knees to the chest, one knee to the chest then the other while lying down. Move the head back and forth. Stretch the neck with hands and bend both knees then lift. Get off the floor using only legs, first one way, then the other. Some stretches with arms and hands facing one way, then another. Sounds very enterprising for a ninety year old. She asked me what I thought if she lived to be one hundred. I said it would be grand. What a celebration! She said sadly about Estiben's family that they must feel very sad to have left the old grandmother out in the cold graveyard. I do not like to think of a world without Miss O'Keeffe.

Of course much more occurred than I can write. I'll try more tomorrow. Sleepy now. Got to get up at 6:00 a.m. to rustle up her eggs, toast, coffee, and fruit.

Juan may get a brindled Great Dane from James Stieglitz, Alfred's nephew.

January 8, 1978, Sunday

A good day, but how can I ever write down what occurred when I am so tired I can barely creep around this bedroom?

At seven this morning, the phone rang, and Miss O'Keeffe's voice greeted me with, "Are you awake? I'll dress and meet you in the kitchen."

—9:15 p.m.

I have just taken a bath, listened to some music on the education channel, laid out my clothes for tomorrow early. I agreed to read from old Stieglitz letters at 6:30 a.m. I built a two-match fire in the fireplace which is crackling away now.

This morning I, barely awake, fumbled on my clothes and dashed for the kitchen where I coordinated our breakfast of grapefruit, coffee, hardboiled eggs, hot toast, butter, and apricot-mint jam. That meant trying to time things just right. In came Miss O'Keeffe at about 7:30, surprised the table was all set, and I was ready for her. We had a good long talk about various topics until around 9:30.

She told me how angry her sisters will be when they find that she hasn't willed them anything. She doesn't believe in inheritance. She said she believes you go out and struggle and make your own way in the world. Her sisters are quite well off anyway and don't need her to support them. She doesn't care all that much for any of them anyway. Take Claudia, for instance. Claudia set up a school in Beverly Hills with a woman named Hilda, a woman with a stomach Miss O'Keeffe said. Miss O'Keeffe said the shape of a person shows the kind of food one prefers, and Claudia and Hilda both preferred rich food. Miss O'Keeffe said she could eat anything rich once, even twice, but after three times she would balk and feel bad.

When Hilda died, Claudia closed the school and came out to stay with Miss O'Keeffe. She stayed in bed and just crept around slowly. She would insist on Estiben coming in to fix her fire every half hour. She could have gotten acquainted with the books and Miss O'Keeffe's affairs but didn't. Then, when Juan came along, Claudia got upset at what he was doing. Now they are in the middle of this lawsuit, Juan and Miss O'Keeffe vs. Doris Bry. Claudia wants to know what is going on, but there is just too much to explain, and Miss O'Keeffe doesn't want to do it.

There is a nephew who is shiftless and dangerous. He refuses to get his needs taken care of by welfare, but takes from Feta, Claudia's maid, practically all the money she earns. He has been known to threaten members of the family. His father, Miss O'Keeffe's older brother, went to Cuba, made money in sugar then gambled it away. The sister in Florida sent money, but his wife wrote her not to since he would drink it up. Miss O'Keeffe said he just sank into the land.

She talked about her travels and how she would like to go up the Yangtze. She remembered Abu Simbel. There was a party on a boat where everyone was seasick so no one came. There was a place in Egypt where she slept high up in a cliff. There was a narrow canyon she rode down to see some marauders' caves and a temple front. Two years later, some French women were drowned there during a flash flood. Miss O'Keeffe said that there would be no way out with water tearing down on you. At least on a horse, maybe you could swim out, assuming the horse knew how to swim.

A couple came from Washington to view some paintings at 10 a.m. Juan came over to show some old nude watercolors, some recent abstract ones, and a couple of oils. There was a lot of small talk. I was asked to leave when money was discussed. In the meantime, I read the manuscript again and again, the third and fourth times for commas, meaning, and sentence structure.

Lunch was with Juan and Miss O'Keeffe. Juan came into the kitchen while I was cooking and asked me to go to the studio to see a painting get started. I dried my hands, despaired privately at the already steaming vegetables, and ran after him. On the south wall of the studio, three of the *Day with Juan* paintings in series were lined against each other something like:

(In the journal is a sketch of two vertical paintings from the Day with Juan *series, both on their sides with the wider part of the monolithic forms touching in the middle. These two sideways paintings are leaning against another vertical painting, right side up, with the two in front obscuring the one in back so that a portion of the top of the monolith is showing as a square portion of the painting. Miss O'Keeffe mused about painting a fourth canvas to exhibit in an arrangement suggesting a cross. She was experimenting with the appearance of the upper shape of a cross.)*

Juan said there might be another on the bottom for the suggestion of a cross. Miss O'Keeffe wanted to see one alone like:

CR 1623, *Untitled (From a Day with Juan)*, 1976/1977, Georgia O'Keeffe, © Georgia O'Keeffe, Image courtesy of the Georgia O'Keeffe Museum.

Here in the journal is located a sketch of one of the vertical Day with Juan *paintings turned upside down (pictured above right side up) to experiment with the form with the wide portion of the monolith at the top, and the narrow portion at the bottom.*

They put them together like this, with me on the shelf behind holding them:

(On this page I made two sketches of arrangements of two vertical paintings from the Day with Juan *series to remember the vitality and creativity in the room where Miss O'Keeffe was experimenting with forms. She had me stand on a book case holding these canvases from behind in these arrangements. On the left side was one sketch of a painting right side up on the bottom, with the other one upside down on top for a modified hourglass effect. On the right was the opposite arrangement of the two paintings with the bottom one upside down and the top one right side up with the wider parts touching in the middle, with a sense of fullness in the middle. At the time I wondered if that experiment in form was reflecting the nature of her vision with macular degeneration.)*

Juan said they were getting ready for the abstract show in a couple of years. I felt very energized by all this, so much so that I was scheming about big canvases full of poetry in calligraphy out on the mesa. What could I say worth a signboard canvas feeling? What? There I was building a salad with my hands with my mind jumping to schemes of this and that with poetry.

The lunch conversation was very funny, full of Juan's clowning. He was even clowning at his own clowning. He works on his pots with an hour here, a couple of hours there.

They seemed somewhat interested in my opinion about the photos and the text of the book. The text on first reading was so interesting that I forgot to notice mistakes. I enjoy the understatements here and there. The photos are impressive. I was surprised by the ones with the car tire. I looked again later and noted a flow among them in the arrangement.

After lunch I read a stack of excerpts from Stieglitz's letters. One from June 1917 caught my eye as particularly touching about O'Keeffe discovering the Spirit Body of a woman which is her own, and trying to re-create the experience. I may get a photocopy of it tomorrow.

At 3:15 p.m., Judge Seth and Mrs. Seth arrived to chat and talk about the foundation. I typed the final draft of the manuscript. We barely took time off for dinner, and I finished at 7:00 p.m. Read some of the letter excerpts to Miss O'Keeffe. She said she wanted us to listen together to a tape of a friend of hers, Mortimer Clapp, who read his own poetry. She knew him from the Frick Gallery. He used to read Greek, and he kept a Greek book by his bed. Late in his years, he lost his mind. Miss O'Keeffe said it was very sad.

"He just wasn't there," she said.

I asked her if he realized he had lost his faculties. She said she didn't think so. (*I remember she said that what she feared most was losing her sanity or "going off her head." She said that when we were out at Ghost Ranch.*) Once again, tonight, I really didn't know what to say. We made some hearty jokes about getting up early and off to bed.

There is an Oklahoma woman here, Margaret, age twenty-four, whose awkwardness reminds me of myself six years ago. Our faces and body types are rather similar. She still has some of an "Okie" accent. She doesn't know quite what to say. I feel a little impatient with her. Her dad is a photographer.

I have worked well today. I feel good about myself. I'm going to watch this fire burn until I'm sleepy.

January 9, 1978, Monday

This was another long day. I got up at 6:30 a.m. expecting to leave at 9:00 a.m. and ended up staying the whole day. One woman has a cold and another two are in mourning. So I was cook and secretary. Juan drove the manuscript down to Santa Fe to send it by shuttle to Albuquerque and then TWA and off to the publisher. Miss O'Keeffe and I read excerpts from some of Stieglitz's letters, then I typed five pages of the ones we chose and read them to her again. Margaret made breakfast. I made lunch. Late in the afternoon, we looked for other quotes from exhibition catalogs and what not. There was time to talk from chore to chore. I will try to hit some of the high moments, but I despair of ever writing down every moment, every utterance, every insight. I enjoy listening to her reminisce about the eccentric Stieglitz family. I'm so sleepy I feel like I'm writing in a dream. I am nearly trembling with fatigue. I bathed and started a fire then stared into space awhile. Why do I feel such an urgency to write here as if the moving pen across space made things more real? I am such an inadequate tape recorder.

The following are excerpts from a very full day. I am constantly amazed when Miss O'Keeffe answers a direct question from me instead of meeting it with stony silence or changing the subject. There are names swimming in my head, along with many stories.

One of the Stieglitz women collected unusual friends. If she didn't like what someone said, she would throw his hat out the window, three stories up, and he would have to go after it. She had a dog that died on the same day a bird flew into her house and died. Shortly after, her husband died. She had them cremated and placed in urns on her mantelpiece. Miss O'Keeffe was very amused by this.

Miss O'Keeffe is in great shape. She gets down and up off the floor without assistance, without a cane, without grabbing

something. She said she feels that she will live for some time yet. I'm inclined to agree.

She told about two men who brought a buggy top into the Lake George house and pretended to be Ma and Mischka going to the opera. At one point, they even took off their underwear. Mrs. Stieglitz's favorite opera was *Tristan und Isolde*. When she went to hear a play by Shakespeare, she recited the lines several words ahead of time, annoying those around her. One of the men who did the impersonation (*of Ma and Mischka*) was Hugh Lofting who was successful writing children's books.

Stanton Macdonald-Wright, the painter, managed to be supported by various women he would be with. He had a big monkey. He had a friend who was a painter, and they stole tubes of paint from each other because they were so poor. Finally, Macdonald-Wright married a very wealthy woman.

My bedtime reading is out of Miss O'Keeffe's rare book case, *A Study of the Modern Evolution of Plastic Expression*, March 1, 1913, published by 291 5th Avenue, 4th floor, Marius De Zayas, Paul B. Haviland.

January 11, 1978, 12:30 a.m., Albuquerque

I worked seven hours for Miss O'Keeffe today, then drove all the way back to Albuquerque, stopping just briefly for tea in Santa Fe and to buy some herbs.

At lunch after Juan left to go back to the studio for phone calls, Miss O'Keeffe showed me a staple, an open staple that she found in her first bite of food. She was very mild about it and said it wasn't my duty to chew every bit of food I brought to her. She almost showed it to Juan to convince him to chew his food carefully, but she decided not to since he was talking with Estiben. Then she thought he would make a fuss about someone trying to poison him or some such nonsense, so she kept quiet. She was very confidential, like a great secret was going on.

There is so much to write, I barely know where to begin. I find myself staring at the plants on the table by the front window. I find myself wanting to write it all down at once, yet I

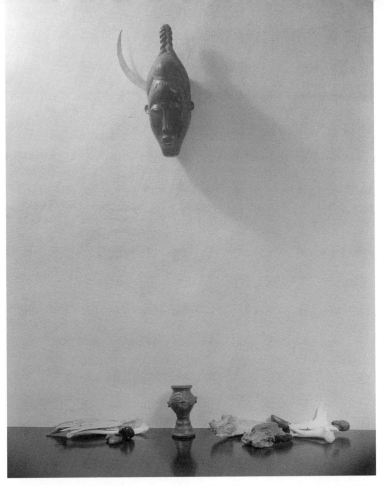

African Mask: Laura Gilpin, Georgia O'Keeffe Residence, Abiquiu, 1960, Negative, 8 x 10 inches. © 1979 Amon Carter Museum, Fort Worth, Texas, Bequest of the artist, P1979.208.2350.

have to remember and savor word by word because I am limited by time and space. There are numerous moments with Miss O'Keeffe that cannot be described. Today at lunch before I left, I was gazing toward the long sitting room. On the wall was an African mask. It was long and black with protruding lips and slitty eyes. There was a long braid extending up from the head. I asked some general question about it, and Miss O'Keeffe said there were two, but the other one was not so fine. She said she used to take it with her summers. She would hang a painting next to it, and if it held its own, she knew the painting was good if it looked all right next to the mask.

This morning, I drove Miss O'Keeffe to her Ghost Ranch house in heavy fog and blustery snow. Everywhere was unforgettable beauty. I'm going to have to get some sleep and write more tomorrow. I made notes.

Hamilton Easter Field was the first man to buy a Picasso from Stieglitz, she told me. It was the head of a woman.

January 23, 1978

A week or so ago while at Miss O'Keeffe's, I dreamed of going along a stream and being instructed on how to catch this little silver fish with a gold crown. Occasionally it would change form and become a segmented silver bar down among the rocks in the clear stream, and there would be a segmented gold piece stuck to the top of it. I could find it by the glint of the sun.

January 25, 1978

Here I am again in the middle of beauty. Miss O'Keeffe, dressed in black, met me at the gate. I squeezed in past the chows and helped her lift the gate to close it, latch it, and lock it. We went through the ceremony of making room for me. She showed me into the usual big bedroom where she had been painting. There were thick big pieces of paper on the bed, large brushes and dishes, sponges, aprons, cheesecloth, spatters on tissue, a thick mat board cut thin across leaning against the wall by the fireplace, presumably test swatches of black, grey, varying intensities and shades. One three-part porcelain dish with a beautiful blue in it, somewhat dried, some sumi-e brushes and pens with assorted tips. There was a big tube of black, Mars Black Liquitex.

I am very tempted to write huge words on a thick curling edged piece of white paper. She cleared things off it when we came in here and said if I felt like doing anything literary, I could use that part of the desk. I wouldn't hurt the paper. There is a good lamp there. I am sitting on a stool, drying my hair with my back to this fire.

On the bed, there are ironed sheets, two thin green wool blankets, two pillows, and a white thin ruffled-at-the-edge bedspread. When we went to the studio after supper, she handed me a bed-size wool blanket that had been handwoven in Albuquerque. It is very lightweight with all sorts of interestingly spaced earth tones and a blue and a grey. It is gracefully woven. That is on the bed, then a brown silk comforter.

We talked and talked over dinner. She had saved me a delicious enchilada from lunch, watercress, applesauce, bread, cheese, and a cookie. She had oatmeal, cheese, and bread. We shared a large pot of mint tea until the last log burned out in the fireplace. I may be imagining it, but there seems to be some sort of imperative coming out of these brushes. It is not quite a command, more like an urge.

Miss O'Keeffe is reading Bronowski's *The Ascent of Man.* (*She had her various helpers read to her.*) She seems interested in what he says is the difference between man and animal, that man wants to make the world better. She's also reading *U.S. News, Hawaii,* and something on the crusades.

February 17, 1978

This weekend I was going to work for Miss O'Keeffe but the roads are a bit treacherous. This time can be spent on writing in this book.

February 18, 1978, Abiquiu

This morning at 9:00 a.m., Miss O'Keeffe called and asked me to come up for a day because Pita Lopez had gotten ill and could not stay for the weekend after all. I am in the studio on the

white rug leaning against the white bed by the window where I will sleep. It seems to me that in the last twenty-four hours I have worked very hard on myself.

I will write while Miss O'Keeffe changes for bed. I just did the dishes after fixing a small meal of leftovers: cold lamb, brie cheese, buttered bread, warmed *quelites*, and crab soup. We had beer and mint tea. It is 7:00, and the cold wind outside moves the skim of clouds past the piece of moon out there.

She has the *Black Place III*, 1944, on the wall in the studio here where I can look at it over one of Juan's dramatic black pots on the marble table. That pot has a tiny opening in the top, and it reminds me of a rock painting by Miss O'Keeffe.

There on the long shelf sit two of the *Day With Juan* series and two even larger pots of his underneath.

(Sketched in the journal are two large black pots side by side. The one on the left has broad shoulders with a deep opening in the middle that would be saying "Ahhh," if it could speak.)

(The pot on the right is rounded with sloping shoulders and a lifted opening that would be saying "Ooooh," if it was singing.)

When I arrived around 3:30, Miss O'Keeffe in her black suit and vest with white scarf sat in the studio opposite a woman named Rosalia who had come across the road to visit. Rosalia is about forty with curly black hair. She is married to Johnny who drove Miss O'Keeffe and me for Easter to the monastery several years ago. She has a young son named Dicky that Miss O'Keeffe is partial to. At four years old last fall, he systematically arranged the good and bad apples under her best apple tree. She is very taken by his devotion to his "work."

They chatted about the news of the village. There was something about a man who died a couple of months ago. At a museum, an owl put out one of his eyes. He went to two hospitals to have a cornea transplant, but they didn't take. He got sadder and sadder and drank too much. The people of the village put together stories and decided that he was cursed by a witch.

March 25, 1978, Abiquiu, Miss O'Keeffe's studio

I arrived around 6:00 last night. A fashionable woman met me outside the gate. She carried in a basket of crackers, cheeses, honey, and tea, plus a large green bottle of Pellegrino mineral water. This is a woman named Diane who just moved into the house that a man named David used to own up the hill here. So her basket, along with some vegetables I brought, plus Bodhi Mandala tofu made our supper. When I came in, Miss O'Keeffe was waking up from a late nap. Barbara Rose and her two children had been here this week along with a young man from a foundry in Cambridge. On the big desk in the studio are two sculptures each about ten inches high.

(Above left): CR 1123, *Abstraction*, 1946, Georgia O'Keeffe; (above right): CR 73, *Abstraction*, 1916, Georgia O'Keeffe. Both images © Georgia O'Keeffe Museum, Images courtesy of the Georgia O'Keeffe Museum.

(Left): *The sketch in my journal was of the dark maquette for this sculpture.* (Right): *This is the same image I sketched in my journal; however, I sketched from the original plaster cast for this bronze sculpture.*

Here I am in the most beautiful place in the world.

I was sitting on the top of the patio well in the sun, facing the black door. Miss O'Keeffe came through the passage under the Japanese shell wind chimes. She has been in the garden supervising two young men from the village. After her morning yogurt and cookie, I manicured her fingernails and she oiled her hands and

put on light tan cotton gloves. She was walking into the patio in her black suit and sturdy brown leather shoes, rosewood cane and tan gloves, black hair twisted at the nape of the neck; she looked elegant, a certain grace and dignity of years, if slightly uncertain step, past the black door, up the steps, down the passage toward the studio. She stopped and mused over the dark damp patch of mud in the wall where a Mayan face had been stuck but fell out. She wondered where the household staff had put the face.

When I went through the bedroom into the bathroom, I stopped to see what she had been painting in the large bedroom. On the table in the oil-paint-redolent room was a white painted canvas, about 3 foot x 2 foot, with the patio door white on white and white stones along the bottom. On the bed were resting large pieces of paper with blue, black, and grey watercolor calligraphic paintings, one a bluish curl and stretch of paint, one a grey and black circle within a circle down to a center; another, a grey circle with a cross inside. I was tempted to take a closer look, but I felt too nosey and left to bask in the sun.

This morning over breakfast, Miss O'Keeffe said one of her favorite walks in New York was right along the river up to the Gracie Mansion.

Tonight before retiring, Miss O'Keeffe said, "I can't believe we will not survive. We will invent things no one has thought of yet." That was after a discussion of what the future may hold for humans such as satellites to live on and laser beams of solar energy sent to earth.

March 30, 1978

—*Late night*

I was remembering while editing the Edelberg manuscript on Creeley, last Saturday morning I drove Miss O'Keeffe to the Ghost Ranch. When we drove onto the land from the highway, I felt a calm, at-home feeling like when I have my hands on a

lawn mower and then turn it off. There is the silence and no more vibration. It was a kind of "Ahhh" feeling.

When we were driving, she said, "Are you going fifty-five?" I said I was going sixty, a little over the speed limit. She said she could tell that from the feel of the car. We picked up some watercolors, a small plywood platform for her sculpture, and we looked for some cotton gloves then walked to the cliffs. On the way back, she talked about her nephew who bugs Claudia all the time for money.

Miss O'Keeffe said, "It's time to make him go out and earn his own bread and butter." Feta nearly died of pneumonia, and this man along with another she helped raise came to stay a while, and they kept her alive. Feta, Claudia's maid, gives this nephew her whole check sometimes.

Miss O'Keeffe had been very feeble-acting on Friday, but Saturday after our good walk, she perked up. We checked the kiln to see if Juan was still firing his pots or if it was cooled off.

At one time in the weekend, Sunday I think, while I read to her from the Stieglitz-O'Keeffe letters, she said she could have done really much better if she had it to do all over again. Her work could have been more beautiful, she said, if she had known someone like Juan who makes such beautiful pots.

When I read to her from the manuscript, she was put off by words like *joy* and *express*. She said people might think her a part of the expressionists by her use of the word, and she never meant that. She and Barbara Rose were having a disagreement, she said, about the opening of the manuscript. Barbara wants to start with the very first letters, and Miss O'Keeffe thinks no reader will want to read into the book because those first ones are so uninteresting. She asked my opinion as I read them to her. I suggested that it depended upon who her audience would be. The scholar or artist interested in her and Stieglitz would read past the slow beginning. She said she wanted to know about the common reader. I suggested a rousing foreword with excerpts

from the more lively letters to grab the common reader. She listened to me, I think.

When I served dinner in the dining room on Friday night, Miss O'Keeffe came in and asked, "Shall we have a fire?" When I hesitated in order to save it for the morning chill, she said, "Ah, but we may not live until morning. Let's enjoy it tonight." I was surprised at the first time I remember having heard her refer to her own death.

She seemed interested in what Genro (*the abbot at Jemez Bodhi Mandala, Zen Buddhist monastery in Jemez Springs, NM*) and I had discussed at the Zen monastery. When I told her I had talked with him about solitude, she said, "That sounds pretty dismal. What did he say?" I said he thought it was a good idea. She agreed.

When we read the letters in the manuscript, we laughed over someone calling hers the "hands of a saint." We laughed long over her reactions to the people of Canyon, Texas, and also over the letter describing the day she awoke to horrid roses on the rug and terrible wallpaper. She said she ate some awful food there. She remembered people pitching a tent far out on the plains, then the man and woman slowly walked toward town with the woman carrying a shiny pail.

I cried over the passage where Stieglitz described himself alone in bed longing for the warmth, closeness, the sound of breathing close by. She suggested marking the passage by bending the page a tiny bit.

She told me a vignette about her older brother who got deathly sick once when he saw a plaster cast of her hand.

Sunday morning I made some horrid pancakes for Miss O'Keeffe. There was no flour and I tried to grind up bulgur wheat, which turned out to be gritty. Twice I tried—Yech!

She laughed and said, "How many times I have been in exactly your place. I remember having a time trying to make sour pancakes just right. It took months to get them just so." She was very patient, tolerant. Settled for a quick, spare breakfast of

orange juice, coffee, cheese, half a gritty pancake. Then I made a substantial lunch hours later.

That morning we discussed how to find your own voice, your own vision. I argued that a painter can get off alone and work in color, alone, but a writer must use words, which requires a community of minds. You have to write to a community of minds.

She spoke very harshly, very loudly, "Do you think that community of minds cares a moment for what you have to say?" I thought a moment without answering. "Of course they don't," she continued. She said this after I said I amassed ten years of poetry and there were several different voices, and I didn't feel any was mine, my very own. She said of course I was writing like others told me. She said it was a very difficult thing to listen to yourself and write from that.

She said the key is in free time. Give yourself an hour or two a day, all to yourself. Everyone has free time, but they don't use it. I said I have time when I am walking to school. She said that wasn't free; yes, I was walking, but I was walking *to*. That wasn't free time.

I said I wanted a year off from work to write. She asked if I would be tempted after that to go on welfare. No, I answered.

Saturday night she told me about Thomas Merton's exuberance when he met her. He had promised to find her a place in India where she could stay thirty of forty days in an area she wanted to return to in northern India. She was impressed with his attitude toward the church, very energetic.

When I told her I was applying to be a fire-watcher in a tower, Miss O'Keeffe thought it was a grand idea. She said when I go in for an interview, I must speak in my deepest, strongest voice and proclaim that I am a strong woman who can do the job right.

At the Sunday noon meal, she said I could stay for dinner before leaving and collect some of the goodies in the refrigerator. When I told her that I should leave earlier, around three,

to pick up the dog, she said "This is the last meal we will have together." I said, "Yes, for this trip." The possibility of imminent death seemed to outline everything distinctly from everything else and for some moments, I noticed many details about her gestures, her clothes, her jaw chewing. Saturday I watched her sleep in the warm sun. Sunday after lunch, we sat on a bench in the sun, back to back with a white down pillow between us. A honeybee buzzed my underarms and face. Our heads and upper backs were touching. She wore a floppy straw hat.

She is looking for someone to read her the entire three volumes of Murasaki's *Tale of Genji*. She also would like to listen to the *Christian Science Monitor*. The news magazines she gets now discuss "our riff raff," and it's difficult to listen to in the night. She wakes up feeling down and wonders why; it's the dismal stuff she has been listening to. She gave me the Mozart record to check on replacing. I gave the name to Jim Wright at the University of New Mexico Library. He found the troubadour songs for her already.

Saturday, April 27, 1978, Abiquiu

I am sitting in Miss O'Keeffe's studio. Eleanor Caponigro and Miss O'Keeffe are behind me at her desk working on a book for the Metropolitan. They are going over the writing and called Juan to talk to him about Weston Naef and different ideas. In front of me on the big round table are two of Juan's pots, a big one and a small one, both with tiny openings, about an inch apart; tension between the two.

This time I brought Miss O'Keeffe a pineapple and an Ikebana arrangement by a friend in Albuquerque, full of mums, eucalyptus, and some purple flowers I don't know the name for. She said it looked like it just grew there.

On the wall over the black linen box is the *Black Place III*, 1944, and a black charcoal of maybe an aerial view of a river. On the table, there is also the Museum of Modern Art book called *Steichen Master Prints 1895–1914*. At the head of the bed on the floor is a folded-up bear skin. Yesterday evening when I arrived,

Miss O'Keeffe was dressed in her light white summer dress. She said she was calling me to see if I had forgotten to come this time. She had called me earlier in the week, around Tuesday, to make sure that I would be here this weekend. I had stopped at the Piggly Wiggly grocery store at Fairview north of Santa Fe for Cream of Chicken soup, a honeydew melon, cottage cheese, endive, and strawberries. That was to avoid putting up with a nearly bare kitchen like I occasionally encounter there.

There in the left of the window looking north is the three-foot-high sprawling bent-over Blood of Christ plant. There are bright red drops, blooms on the branching tips. Behind me on the sink is a one-inch vase, a dark one, with the tips of two slim pointed green leaves, one tipped yellow, sticking out of the narrow top. It is almost humorous in its understated beauty.

Jingo, the red chow, has healed the eczema on her right rear hock. Her coat is smoother and less filled with dandruff because she has been getting a teaspoon of wheat germ oil every day in her food. Yesterday after dinner, Miss O'Keeffe came over to her bedroom where she sat in a comfortable chair that rocks back in the moonlight, a full moon night. She rested on her electric hot pad, very composed. A couple of weeks ago when she was in that pose, I laughed at Whistler's mother, and she said she hoped she wasn't that broken down yet.

She has been so involved in reading the Rothko book sent to her by Edith Asbury that she hasn't even taken the time to wash her hair in the last week.

She seemed pleased with the idea that I brought her some cotton gloves from Albuquerque that should match the size of the beige ones she sent with me. I brought back eight-inch-long beige ones and wrist-length dark brown ones.

On and on I could keep writing about the mundane things of life, to avoid what has been on my mind, in my body for two weeks. *How does one write about an ecstatic experience of absolute beauty in nature?* Two weeks ago on Sunday, Miss O'Keeffe arranged for Estiben to watch the Abiquiu house after he got home from Sunday Mass. She announced to me we were driving to the ranch. I drove the Mercedes up there. We talked occasionally about odds and ends. We drove into the gate, and I felt that odd peace I feel on that land with her. We drove slowly past the wheat field, then left, down through the shallow arroyo and on past those breathing red hills. We got out of the car, walked out onto the Ghost Ranch land. We didn't stop at the house, just began walking.

Miss O'Keeffe said to me, "You walk on ahead. Go as fast as you want to exercise. I'll follow along slowly. I'll be all right. I know the road well."

I walked on ahead with an odd feeling of expectation that was unexplainable. I was carrying my E-flat bamboo flute to play for her but walked ahead thinking she might want to be alone. Then I felt as though I was in a dream. How can I write this? How can it be put into words when there were no words but feelings?

I felt there were a number of people around me, but no one there really, maybe the trees. Who knows? Am I mad? Go on, I thought. I walked quietly into a grove of trees. I had done the five healing breaths someone had taught me at the Lama Foundation, walking a quarter mile breathing these elemental breaths. There by the trees, I began playing the flute, maybe a few notes. Suddenly while I was playing, everything was quiet as if everything around me was listening to the sound. There had been a brisk chill wind from the west. (*Later on, Miss O'Keeffe said*

she heard it from the east, the wind.) Then the wind was quiet, the birds were quiet, nothing moved, no sound. Then I was quiet after several simple tunes, and I walked a little bit further. A couple of weeks before, I had wanted to gently touch this land almost like a living person. How shall I write this?

As I walked forward, my body tingled like when I hear great music. I walked carefully, watching everything around me. Out of the quiet, there was a recognition, an assent, a yes. Then I had to respond. I stood still, feet firm, flute in hand. I felt tears in my eyes. There was an ecstatic moment of truly seeing the earth in reality, a kind of ecstatic union. I was transfixed by beauty. The giving up myself was essential.

My eyes saw everything as light, angles of light, absolute perfection. There were moments of being, of union. I can't write this using words. I can't say exactly the way it was. I blinked several times and became separate again, myself again walking on the earth, the two tracks of the road. There was a deep wonder about what just happened. What was that?

I turned around, and there was Miss O'Keeffe just walking into the grove of trees. Then she walked left to a log and sat down out of sight. I walked slowly, carefully to her. Kneeling beside the log, I played a few notes for Miss O'Keeffe. She said my playing reminded her of walking in the mountains of Peru, where boys would come out of nowhere playing their high flutes. It was beautiful. Then she reminisced how she drove a station wagon up to the cliffs just behind where we were sitting. She slept several nights in the back where she could get up early, make breakfast, and immediately start painting. When she wanted something from the house, she could take a walk down and back.

After sitting awhile, I calmed down, and we quietly walked back, discussing the direction the cool wind had been coming from. She needed a handkerchief but had left hers in a black jacket she had shed on the ground. I had three handkerchiefs and offered her two. She said I should not be so free with my Kleenex.

—Afternoon.

A couple of weeks ago, that last time I was here in Abiquiu, there was on the desk a photograph of a large building with huge smokestacks. At the bottom was written: Castle of Herend near Budapest, built in the XVI Century. Herend is in Hungary in the district of Veszprém. Miss O'Keeffe said she was learning about a relative who everyone said was Italian; she is certain he was Hungarian. His last name was Totto, maybe a grandfather.

On the table was also a little grey book, maybe 4" x 7", entitled *Julius Stieglitz May 26, 1867–Jan. 10, 1937 A Biographical Sketch* by Herbert N. McCoy. Julius was the professor in Chicago. Edward and Hedwig were the parents of Julius and Alfred. Leo, the other brother, was a doctor in New York. Miss O'Keeffe said he treated all of the important Jews. The book was a reprint from the *Journal of American Chemical Society* 60, 3 (1938).

I read to Miss O'Keeffe from a manuscript written by Sue Davidson Lowe (daughter of Elizabeth Davidson). It's called: *Everything is Relative, a Biographical Memoir of Alfred Stieglitz*. Her address: Wild Duck Road, Madison, Connecticut, 06443.

That time a couple of weeks ago Miss O'Keeffe told me about a recurring dream of hers. She is with a bunch of people much shorter than she is. They are in a narrow corridor looking high up to a track that looks like a dotted line. There is a white bundle, like a bundle of cloth that whizzes around on that track. Occasionally, it comes close enough that they almost catch it, but she never has been able to open the bundle and see what is inside. Occasionally, one of the short people will shout for everyone to rush down another corridor. They all do, but they don't get the bundle. Miss O'Keeffe said that she had never figured it out.

After we returned from the ranch, I made Miss O'Keeffe lunch and then she rested. As she woke up, I told her I had a horrible neck ache, and before I left she insisted on fiercely rubbing my neck with her hands, strong hands. I was really amazed at the

strength of her hands. She had me hold a hot pad to my neck for five minutes, then went at it again. At one point, I had my head against her belly, my eyes looking down at the floor as I sat on a stool. She was fiercely kneading those knotted cords in my neck. Then, in addition to the beautiful scarves she had given me, a batik, a Japanese silk, a sheer scarf with mums and irises printed on both ends, she lent me a fine piece of black wool to wear around my neck to keep it warm all the way back home, a lovely gesture. I remember the weather had turned very chill. She walked to the gate with a black hood over her head. She looked very medieval as she waved at the gate. Her cane, the black hood, the chows by her side, the wind, that look on her face as if looking into the infinite.

I am in the bedroom. On the wall by the fireplace, coming out of the dark brown wall is the very composed right hand of a Buddha. Richard gave it to Miss O'Keeffe. He is the man who lives up by Taos with his Arabian horses. Last night she told me it used to be broken so that one of the middle fingers would move back and forth. She sent it to be fixed, and when it returned, a special something it had was lost, gone. Now it's just a hand. It had a patina on black, looks like lacquer or enamel, slightly upturned fingers. It seems the hand of a blessing with palm outward. Long, long fingers like Miss O'Keeffe's.

Last night I heard her talking book, one on gerontology. This morning she said that she didn't understand many of the technical terms, but she did understand enough to see someday people may not have to grow old.

Here beside me on the banco, I just noticed a cassette entitled "G. O'Keeffe Will dated 6/11/77 Articles 1–15 G. O'Keeffe Will con't'd Arts 16–end and 6/11/77 amend't to 1971 Trust." On top is a paper about the will, I presume.

> Claudia—Abiquiu house
> Ranch—If Juan does not want Ranch House, it goes to
> Presbyterian Church
> Japanese Prints
> Seighans

Doors
Movies
Towlaur Track?
Mobiles
Juan—paintings
Article 5th
Other paper: Yale—my collections
Dogs—Juan
Exposures more than 20
Jack in Pulpit

What a nosey busy-body pack rat I am.

For some reason, I find it difficult to be around Eleanor Caponigro who is helping Miss O'Keeffe design that Met book on the Stieglitz photos. I suppose raw ambition is a bit much to put up with. I find little point in competition. Scarcity hypothesis rears its nasty jealous head. There was something in the way Eleanor Caponigro fingered her knife at lunch and patronizingly thanked me for serving her . . . little things, granted, but awkward to be around. I hope she gets what she wants. Usually, it is such an uncomplicated arrangement with Miss O'Keeffe and me for the weekend. I had forgotten what a medieval court of intrigue this place can be.

It frightens me to think of Miss O'Keeffe dying, such a light in the world she is. I just walked into the studio and sat in a white covered chair opposite the bed where she is lying. She is dressed in black, blue shoes, brown soft throw woven from her chow dog fur spread over her, grey hair blending with the white pillow. There is the deep window sill beyond her with those gracefully curved long horns, and beyond all that, the land, this emptiness.

Sunday, April 23, 1978, Abiquiu, 7 a.m.

Miss O'Keeffe is still in bed and apparently sleeping. She has felt so under the weather from time to time that Friday she went to the hospital at Los Alamos for tests to see about her low vitality.

Juan called about 6:45 a.m. to say good morning to her.

—*Evening at the Outside In Café, Santa Fe*

This morning while I did yoga on the white rug in the studio and looked up at the *Ladder to the Moon*, there was that golden ladder suspended in a greenish sky between a dark Pedernal and that white half moon. I thought of what Miss O'Keeffe had said to that Eleanor woman the day before, "If I had some ambition, this would be fun (talking about designing the Metropolitan book of Stieglitz's photos of O'Keeffe), but as it is, it is only a headache to me, only a headache."

Somehow the ladder appeared to me as the essence of ambition to get higher and higher, raw ambition. Against the sky, grounded by the dark earth, it seemed entirely absurd. This evening I told Miss O'Keeffe that I finally liked that painting. Before, I liked her flowers and wondered why she did that. She said she was at the ranch, outside waiting for someone. It was right after sunset when the sky is beautiful green. There was the moon and black Pedernal. She had been thinking about starting a ladder period, so the next morning she started her ladder period. There it is.

April 24, 1978, Monday

Last night on the way to Albuquerque, I watched the moon rise three times; once at La Bajada, once at the Santo Domingo turn-off, once again over the Sandias. First big and yellow, then shy behind clouds. Finally pearl-pure gem tracing the upper silhouette of the crest. I was weaving a bit on the road from fatigue and from intoxicated moon-watching.

April 25, 1978, Tuesday

Today I sent the registration money to Naropa Institute and my resume for a summer in Boulder.

April 26, 1978

We were sitting at lunch on Sunday last weekend when Miss O'Keeffe told me about when she was a child. She had some

dolls, and she chose a secluded spot a ways from the house where she could make them a park. There were tall weeds for trees and grass trimmed with scissors for a lawn. She had a walk for them down to an empty place. Then she said she made a pest of herself in the kitchen for a milk pan to make a lake. After several days of persisting at this, they finally gave her one. She filled it with water and called it a lake for her dolls.

April 28, 1978

When she built a little boat out of a shingle and put her dolls on it, they fell off into the water. One of the dolls had two of her arms drop off as a result. Anyone could easily have fixed the doll, but no one did.

She said once she had all her dolls down in the grass and something ripped on one of the dresses. She planned to bring her white thread and needle the next day when she went down to play. She brought all of her dolls and things but forgot the needle and thread. The same thing happened the next day. It wouldn't have taken more than a few minutes to go back to the house, get the thread and get back to her dolls to mend the torn piece. She rushed back to the house, dashed upstairs, grabbed her needle and thread, rushed downstairs so fast that she nearly fell. She hurried down to her dolls and easily repaired the torn dress. That was how she learned not to put off things that could be done so quickly and easily.

Last Friday evening when we sat down to dinner, Miss O'Keeffe said, "How would you describe this room?" she gestured to Juan's large white pot and to the huge paper lantern overhead. I asked her about the ceiling. She said the wood was from the original ceiling in the house. The rough pieces had been dipped into a disinfectant and placed across the large vigas. It was during the war when wood was difficult to get.

She remembered opening the window of her hotel room in Peru, and there below was a huge herd of llamas. She watched a

woman herd them and direct them with a leather strap that she snapped in the air producing a loud "crack" in the air.

She was eagerly reading the Rothko book that Edith Asbury had sent to her. It was a fascinating account of the legal case that surrounded his death. Apparently the author proposed that he might have been murdered instead of committing suicide because his glasses were off and his trousers were folded very neatly over a chair. That was not his habit. A number of people Miss O'Keeffe knows are in the book like Edith Asbury, her packer, and several others. She had to forego other chores in order to read on in this book. Juan had the book for the weekend.

May 1, 1978

I remember Miss O'Keeffe talked about a dog blind in one eye and missing a paw, a real gentleman dog that used to hang out by her back door and follow her around when he could. Once the dog followed her down across the highway to Bode's General Store. She started back up the hill and noticed he wasn't following. She looked down at the highway and saw his crushed body. A semi truck had passed so fast on the dog's blind side, he didn't see it. She said she went up to get Estiben, and they put the dog in a wheelbarrow and cried all the way up the hill.

Miss O'Keeffe said one of her outstanding memories from childhood was watching a nun come through a door carrying a large round tray over her head. On the tray were bread and butter, bread and molasses, bread and sugar, all for refreshment.

She tells me again and again how she disliked sweets as a kid. For punishment her mom would send the kids to bed early without their bread and sugar. Miss O'Keeffe thought that was fine. The other kids in the family thought she should be given bread and sugar as punishment, in which case she would do without.

She told me about her small tent that was orange and thin and lightweight. If you slept on a moonlit night, it seemed like

twilight all night or like sitting in a glowing fireplace. There was a flap she could open and watch the stars.

She had had stomach troubles for the week before and had gone to the hospital at Los Alamos for tests by a woman doctor. Her usual doctor may be preparing to run for the legislature. She pronounced that, "I'm going to start being a little more careful of my heart. I've always had a strong heart, but now it's time to be more careful." We read an Adelle Davis nutrition lecture delivered in Denver years ago which recommended yeast, lecithin, yogurt, and vitamin supplements plus unhydrogenated oils. Her diet is pretty secure for combating cholesterol build-up.

Miss O'Keeffe was surprised when I told her that Van Deren Coke had reported finding a book of oriental-looking photographs. He took it home and discovered upon peeling out some of the prints that they were by Arthur Wesley Dow. She said she didn't know that he photographed, but she could imagine the old man doing it on the side. She said she really preferred some of the teachers teaching under him to sitting through his classes. She remembered one of her school chums, Dorothy True, who used to drop money out of the window to keep an organ grinder playing below during one of Dow's lectures. She reminded me that she doesn't usually say what she truly thought of Dow. Then she talked about her other school chum at that same time, Anita Pollitzer. Anita had hair past her waist, and it was always coming undone, and it was often a mess. If Miss O'Keeffe and Dorothy were going someplace, usually Anita would want to come along, and they would tell her she could come if she would straighten herself up. She always carried a disordered array of miscellaneous papers on one arm. Whatever cause it was, Anita always had the latest information on politics, art, women, war, communism, or whatever.

She said the man who runs McCurdy School in Española would like to take her Abiquiu house when she dies. He would have Chicano students live there for six months to learn the traditional Spanish way. He would have a man and a woman

oversee the project and live there. Miss O'Keeffe doesn't believe it would work.

Once we walked into the space between the studio and the kitchen, and she looked up at a two-tracked jet trail and commented almost unconsciously, "Imagine what the Indians would have thought if they saw that."

She reminisced awhile about being in the Gaspé with Georgia Engelhard. Georgia was just learning to drive, and they were coming down a steep incline without properly changing gears. There was a sharp turn at the bottom of the grade, and they had an argument about her driving. At that place they got out of the car and started walking. They could have run into bears at any point on their walks. It was really very dangerous she said. Everyone in the area had their bearskin tacked to the wall. She and Georgia painted together during this time, and not too long ago someone had a Georgia Engelhard painting that had been called an O'Keeffe. Their styles were close at the time.

At any rate, they walked along that steep road. To one side was a wall of fir trees so thick you couldn't walk through them. They saw a sign just as they were about to turn back. It read: "Road to the sea, seals, and birds of all kinds." She said it was one of the most beautiful places she has ever seen in her whole life. There was a high waterfall. There was a shack with a small supply of food. They slept in bunk beds, though she never slept much because it was so beautiful. She would be out ranging around to see the place at night in the moonlight. There was a high flat rock where she could lie on her belly and view the seals swimming below. After three days, she told Georgia they would have to leave the place so she could get some sleep.

At one household where they stopped, food was kept under the staircase so you kicked dust into it as you climbed the stairs. That was where the chipmunk slept against the bread, but "you sliced and ate the bread and glad to have it," she said.

One especially poignant memory she relayed to me was the one about running away from home as a small girl. She had

forgotten why she was angry at the folks, but she decided to leave. She remembers walking down a road thick with trees on either side. At the end of the road was the bright red sun setting between the trees. She had a feeling that she was walking into the sun. She will never forget that feeling. I said to her that memory reminded me of the watercolor she has been working on in Claudia's big bedroom. She smiled and said, "Yes, but it doesn't come close to what I feel, to what I felt that day I was running away." I insisted that it was beautiful anyway, but she returned that it wasn't the same.

CR 1665, *Abstraction Dark Green Lines with Red and Pink*, 1970s, Georgia O'Keeffe, © Georgia O'Keeffe Museum, Image courtesy of the Georgia O'Keeffe Museum

This is similar to the painting I sketched in my journal. The only difference was a blue color instead of pink above the red orb.

After I left Miss O'Keeffe's, I went to Juan's house at his invitation to watch the photographers for the Yamaguchi Sheet Co. who were paying him $500 and a huge supply of sheets to photograph his lifestyle around their sheets. A very aggressive lady photographer asked to photograph me, and when I refused she got indignant and unjustifiably angry. She clicked her shutter a couple of times at me like a naughty child, and I soon left, telling her (surprised at my quick irony) I liked her inhibitions. There was enough time to see the newly finished second

floor of Juan's house that has the coziness of a roof room and the expansiveness of picture windows on northern New Mexican landscape.

I was tempted, very tempted to ask for the open job cooking for Miss O'Keeffe at the ranch this summer. Judging from Juan's enthused response, it would have been within my grasp.

Then in an aside about something else, Miss O'Keeffe talked about her talented sister Ida O'Keeffe, who could pick up a feather, a dried branch, and a stone and make an attractive arrangement of it. She used to say to Georgia that her talent was nothing because she just painted a huge single flower. On the contrary, Ida could make these lovely complex arrangements. Miss O'Keeffe said the difference between the two of them was that she took every opportunity that came her way, whereas Ida didn't grasp her opportunities.

I knew I had to grasp this opportunity to go work with Ginsberg in Boulder, Colorado, and possibly be his apprentice. (*He said I could come study at Naropa and apply to be his apprentice for the summer. He could not accept me as an apprentice unless I arrived intending to study there whether or not I would work directly with him.*)

That time three weeks ago, when I had that profound awakening with the beauty of Ghost Ranch land walking along with Miss O'Keeffe, I drove home in the evening and found in my mailbox a letter from Allen Ginsberg critiquing my poetry. I liked the tone and the generosity. He put stars by his favorites and re-ordered them into a preferred sequence. (*I wanted to take my poetry to another artistic level, and I thought that Allen Ginsberg and other writers teaching at Naropa Institute in Boulder, Colorado, would challenge me enough to improve my work.*)

May 21, 1978, Sunday a.m., Abiquiu

I arrived here Friday night, heated mushroom soup made by Margaret, then made salad and sliced melon for dinner. Miss O'Keeffe said she would like to see the Rothko Chapel in Houston.

The bells at the church just sounded at 7:30 a.m. I am listening to the chows bark loudly at the bells. It may hurt their ears.

Pita and Miss O'Keeffe are over in the studio making up last-minute questions for Juan before he leaves for Paris, Washington, New York, and Princeton. Juan's parents were here last night.

Juan most favors his tall father, Allen Hamilton. His father has blondish hair with grey and a mustache like Juan's too. He likes to tell humorous stories with punch lines that could almost be one-liners. The jokes are hardly uproarious, but he likes to entertain. Juan's mother enjoys eating. She spotted the quiches when they first walked into the kitchen. His dad has a sort of "preacher" tone to his voice sometimes. It's hard to place. He has a sort of resonance that some men put on to read scripture. Juan's dad said he was surprised at how Juan can talk to Miss O'Keeffe, but she dishes it right back at him. Juan's mother is quiet, but watchful. Sometimes she stares at things, and she had nervous fingers around a glass of raspberry juice at dinner. Her upper lip is thinner than her full lower one. So she looks like she is biting her upper lip constantly.

May 21, 1978

Miss O'Keeffe had me drive to Eleanor Caponigro's this morning to her place in Tesuque to pick up copies of the Stieglitz-O'Keeffe letters that were being considered for the book of the Metropolitan show that Eleanor is designing. Eleanor was curious to know what was the "ugliness" that crept in as Stieglitz wrote in approximately 1917. She supposed it had something to do with what Miss O'Keeffe told her about two people getting to know each other so well they can destroy each other.

In the letters I read to her from Barbara Rose for the manuscript about the Stieglitz-O'Keeffe correspondence, we read in the thirties up to about 1935. Stieglitz referred a number of times to her illness. I inquired about what sent her to the hospital. She said she struggled with Stieglitz to do a huge canvas of flowers on a wall. He did not want her to do it at all. She insisted and insisted,

then finally got the opportunity. She had the canvas stuck to the wall, walked in with all her equipment, only to watch this vast amount of canvas crumple to the floor. That was so disappointing to her that she turned around, walked away, and never returned there. She said she just couldn't take it after the struggle to get that far. She went into the hospital with a high fever. Nerves, maybe, she said. They thought for a while that she was having a relapse of typhoid fever she had when she was younger.

I noticed a few things about Eleanor Caponigro. In her work room, there was a photo of Gurdjieff. There was also a washer and dryer there. Next to her adobe against a hill was an irrigation ditch waterfall with a "watch duck" that hissed at me regularly like a dog barking. She asked me if I thought the Metropolitan book should have excerpts from the Stieglitz-O'Keeffe correspondence. She doesn't think so. I said that I didn't know, but perhaps the book would have wider appeal with words, too, because there are word people, then there are eye people. She seemed to listen to me, a small wonder after our previous slightly abrasive encounter.

May 29, 1978, Monday

Last weekend I was with Georgia O'Keeffe as well as the previous weekend. I have felt too busy to be able to write in this journal, but now I have several hours to spend with it.

I'm waiting for a call from Miss O'Keeffe to see if I will work more for her this week. She may want me to work with Pita in shuffling together several manuscripts taken from the Stieglitz-O'Keeffe letters.

Yesterday she and I had the Barbara Rose manuscript spread on the marble table next to Juan's small purple pot. Then we had the manuscript done by Donald Gallup for the quotes in the Metropolitan book about the photos by Stieglitz of Miss O'Keeffe. I noticed an airy page. The typing from Gallup was done similar to the form of O'Keeffe's writing. There were stacked colons or question marks, a variety of dashes.

She asked me to read the Gallup manuscript like it was written. When I said I would have to change my breathing to do that, she nearly fell out of the low Eames chair she was sitting on.

Then she made some comment about my doing too many Buddhist breathing exercises. She was interested when I said it looked much like poetry, and her form was just as interesting as her content. Barbara Rose had been interested only in putting down the content, the words. So Miss O'Keeffe will suggest that the form be true to her in the book. She laughed, pleased, when I said it was a typesetter's nightmare to look at one of her pages. I suggested also that one of the illustrations could be one of her letters. One page of a written letter would show her hand and her design, also a photo of one of her envelopes, which was probably addressed in a particular way. I remembered her writing somewhere that she taught her Texas Normal School students that their art lessons could be used for everything from designing a house to addressing an envelope.

On Saturday when I was reading to her from the last ten years of letters between Stieglitz and O'Keeffe, Miss O'Keeffe was particularly struck by a quote from Gerald Heard, which she said she had looked for to put into her written piece on clay. She found it written in wet sand with a stick where he had been walking shortly before. She asked me to copy it in large handwriting for her to read later, then placed it in her lap under crossed hands. She has a very elegant, conscious way of moving and placing her hands, holding a few fingers, gesturing thoughtfully, her middle finger stroking her upper lip, nail to pursed lips, her eyes looking faraway or far inward.

The Heard quote:

Do not act as though Know that you
 be are in the presence
You were in the presence and you will

There was more white space between the two sections on the page. She seemed delighted that you have to go back to pick up the "be."

July 30, 1978

(I went to Boulder to serve as apprentice to Allen Ginsberg at Naropa Institute. While I was there, he asked if I could arrange for him to meet Miss O'Keeffe while he was in Santa Fe for a reading.)

—*Sunday night, Pojoaque, New Mexico*

One of the good days of my life, today was. This afternoon from four o'clock until six o'clock I got to be around Georgia O'Keeffe and Allen Ginsberg. It was a gift I could give her to arrange through Juan Hamilton for this meeting.

Peter Orlovsky and Allen flew into Santa Fe this weekend to do a benefit reading on Saturday night at the Armory for the Arts to make money for the Tibetan Buddhist community there. This afternoon we drove through Abiquiu up to Ghost Ranch where Miss O'Keeffe and Juan waited. During the drive, Allen did his homework by reading a chapter on Stieglitz out of Bram Dijkstra's book *Hieroglyphics of a New Speech: Cubism, Stieglitz, and the Early Poetry of William Carlos Williams*, which Juan suggested I have him read since that is the book that O'Keeffe believes makes the most sense about Stieglitz. I told him briefly about a film made about her life and briefly about her autobiography, something about her relationship to Stieglitz and her art. Peter and Allen were very struck by the fabulous geology around Ghost Ranch. Peter was interested to see that Allen saw much of the beauty saying, "Put your visor up, Allen, so you can see more."

When we drove up to the Ghost Ranch house under a deep blue cloudy sky, there was a yellow paper flapping on the screen at the kitchen dining door. While Allen was in the bathroom, Peter drank two glasses of water, one from the Jemez Mountain water at Abiquiu in a glass jar, the other from the tap at the

Ghost Ranch house. "There is a difference," he said. Then Peter went out into the patio among the sage and he examined a number of rocks Miss O'Keeffe has arranged around the place on bancos, low benches, and tables. He would turn a rock or a geode around and around then deeply sniff of it. Three or four times he did that.

Allen came out of the bathroom and we walked around the potting shed toward the cliffs. Jingo and Inca appeared on the other side of the arroyo, woofing and snorting about our presence. We walked through the low trees around the shed, and there was Miss O'Keeffe across the road, walking with her cane, and there was Juan next to her with his cane. We walked over. I yelled out hi and waved. Juan said, "Good afternoon." We met at the road, and Allen and Miss O'Keeffe shook hands. Then Peter and Juan and all shook hands. Miss O'Keeffe and I greeted each other with smiles. Her eyes were laughing.

"Well, hello. How is Colorado?"

"Pretty good. I'll be coming back soon."

Then Miss O'Keeffe scolded, "Well did you get the raspberry juice and crushed ice ready?" We laughed at the old roles.

We walked slowly back to her house with Allen talking to her about how she found the place, found the cliffs years ago while looking for a place to live. We walked into the kitchen and Juan started making crushed ice and raspberries. Miss O'Keeffe asked me to finish fixing the drinks, which I did with humor because somehow I knew I would end up in the kitchen, whatever. I will try to sketch briefly what transpired and as inspiration hits, fill in more detail.

Miss O'Keeffe sat on her low black Eames chair, the very comfortable one that is easy to carry around

(I did not write anymore here. I don't know what interrupted me, but I did not write anymore for over ten days. What I remember about that visit was Allen sitting with Miss O'Keeffe on the south porch of the Ghost Ranch house. He showed her how he meditates in the Tibetan Buddhist tradition and gave her instructions, but she didn't mimic him.

Then he asked her what she believed, and she gestured with an open hand up and arm outstretched in a semi circle moving in front of her and said, "It's hard to say." I looked as she gestured and saw Pedernal to the south and the sage and the clouds and the blue sky and the rocks she had gathered and all the beauty that surrounded her there. Later as I drove Allen and Peter back to Santa Fe, I nearly drove off the road when Allen called her a witch. Then he said he was surprised at how little money she had, and I explained her simple surroundings did not reveal her money wealth.)

August 26, 1978, Santa Fe

—*Saturday morning, 8:00*

Happy day today—saw sun rise off the Sandia Mountains on the road north to Abiquiu to work with Miss O'Keeffe. I found myself smiling, driving, no music, the sound of the car on the road enough with the rhythm of my breath, the light on the arroyo hills before Santo Domingo, that deepmost place always reminds me of the colors in a William Blake watercolor painting there in the road cut on I-25, good light with soft edges by grass.

—*Afternoon, 2:20*

Miss O'Keeffe is in her bedroom, trying to rest. She said she did too much yesterday. I fixed her a lunch of steamed turkey, fresh corn, salad with fresh lovage, basil, tarragon along with a small glass of beer and croissants with Alouette, that French herb cheese Margaret gets in Santa Fe, and for dessert, a melon I have ripened for four days, plus mint tea.

When I walked into the studio at 10:00 a.m., the only thing I saw was Miss O'Keeffe. There she sat by the telephone dressed in her blue dress, that draped design she has many dresses made like. It looks like a loose summer coat. Over that she had a white cover around her shoulders and over her lap and covering most of her legs. Her hair was covered with a thin white cotton scarf like a huge handkerchief. She had it pinned back like an Arab.

I sat on a black stool and presented the sack of goodies to her. She seemed pleased, "We like to have you come and cook for us." Then I noticed the huge painting above and to her right on the east wall. It seems about six feet by six feet.

CR 1460, *Sky Above the Flat White Cloud II*, 1960/1964, Georgia O'Keeffe, © Georgia O'Keeffe Museum, Image courtesy of the Georgia O'Keeffe Museum

This is similar to what I saw. The sketch in my journal was of a perfectly square canvas with a band of green color above the white clouds. The other colors were the same as they are on this canvas. There was a thin white frame around the work I sketched.

I said, "Wow!" or something to that effect. She said I was to be impressed with that. When Juan hung it, it took him all morning, and he thought he had done a full day's work. She said it was a painting of what she saw one day from an airplane, a long floor of clouds extended to the horizon. It is spacious and light and carries this room. I mean the tone of the room is airier for the painting on the wall.

—9:40 p.m.

Leaning against the wall on the shelf to the south is a number of drawings (about twelve) framed and leaning face-to-the-wall. Two are face out, which Miss O'Keeffe said were very early drawings, ones she did at twenty-five, sitting in the floor with her work propped against her closet door.

The bells in the village church were ringing happily for Santa Rosa day. On my drive up, at about a half mile before Abiquiu, I drove slowly past people walking away from the village toward the ruins of the old church where I had seen an altar decked out in flowers and banners.

As the bells rang, Miss O'Keeffe and I walked through her garden. "A first rate garden," she said. We walked out from the patio with the black door through the corridor with Japanese shell chimes and garden tools. She said for me to go first because she is slower. We walked a circle through the plants picking flowers, a five-petaled blue wonder she doesn't recognize, and herbs for lunch. She asked me to choose the largest of a dozen eggplants ripening so she could reach down and hold it. She chatted briefly with Estiben who was weeding by a cilantro plot. She carried her cane and walked carefully as if in the dark in a place she knows. I forget how blind she is sometimes. This evening as we sat in the early night air and she couldn't spot the evening star for a while, I saw how dull her sight is.

Before we went to the garden, she showed me the room Juan had made for her in the bedroom where I used to stay. The room was nearly empty. Beside the door was a bed, about the size of a twin bed. It seemed to have connections that would make it like a hospital.

Friday, October 13, Abiquiu

Here I am in Miss O'Keeffe's kitchen, sitting at a plywood table supported by sawhorses, gazing at foliage of an Amaryllis. There is car noise outside. She's back from Las Vegas. I'll cook dinner now.

—10:00 p.m.

In bed in the studio under a black and white checked wool cover among white sheets, shook a fat hairy brown spider off the foot of the bed before climbing in.

For dinner we had tomato soup with potatoes, onions, lovage, and fresh tarragon plus mushrooms sautéed in butter and garlic with bread, butter, and cheese. For dessert mint tea, carob cake, custard, sliced fresh apples. After supper we came over to the studio and bedroom for her to find the Chinese blouse that . . .

(The writing stops here. Something interrupted me. I remember she gave me a black silk Chinese shirt that someone had given her, but she couldn't wear because the sleeves were about a foot too long, which was sort of humorous, but she said it was traditional to keep one's hands warm or shake over your wrists in a fashionable way. She also had a very worn-thin white silk blouse with tiny flowers, very fragile, that she gave me to wear under the black one. Then she presented me with a silk scarf with Japanese writing that said "Long Life" which someone had given her. For me these became personal treasures.)

October 28, 1978, Saturday morning, Abiquiu

Last night Miss O'Keeffe and I sat by her phone in the studio. She dressed in white robe (brief interruption to put garters on her underwear) with hands folded, looking content, white and grey hair brought up in a swoop in back caught by a grey comb and large grey pins. She showed me the unbound version of the Metropolitan book of photographs of her by Stieglitz, said the Metropolitan will put out an issue in a box, and Viking will put out an issue without a box for $10 more. She asked if I thought it would sell for $25 or $35. She said she thought that a photographer should be able to afford that if he was doing anything at all.

She laughingly told me the Metropolitan Museum had made a huge banner the size of her studio, three of them, to hang on the outside of the Met with huge letters saying, "Georgia O'Keeffe by Alfred Stieglitz." She said she wondered if she went through life like anyone else, would she get bored. She thought it a little excessive if the banner's length were the width

of her studio, but it was the length of her studio. They sent a copy of the fabric and ink. It was light brown with a yellow-orange. They had it changed to browns, I believe.

She mused about what Alfred would do if he saw those banners. She said he would probably stand there thinking, looking up at the banner with that handkerchief hanging from his teeth, then he would turn away and walk along thinking of something else. She laughed and said that Alfred would say, "So the world has come to this?"

She asked if I thought the letters between her and Stieglitz would be interesting to someone who didn't know either of them. She never thought of herself as a writer, she said, but lately there seems to be some interest in her writing. I went to answer the gate, stir the sauerkraut, leaving her to talk to Fernando Lopez, then brushed out a flannel or woolen grey suit in the sunlight.

In the meantime, Claudia called to arrange to arrive Monday for a stay of a couple weeks.

Miss O'Keeffe said last evening that she thought the Emma Goldman–Alexander Berkman letters were the most interesting ones she has read in her reading of various sets of letters. She wondered if letters by Stieglitz and her would be of any interest like those. I assured her yes, though that wasn't the question really. Many people know of her and of Stieglitz and would be interested.

—*Afternoon*

Miss O'Keeffe is in the sun on her recliner chair, black cushion, white headrest. She is wearing a grey suit, white shirt, grey shoes. We listened to Joni Mitchell's *Blue* album. She was warming her legs and knees in the sunshine. I remember last evening she said one of her bad memories was riding in the rain, getting her knees wet and feeling the pain, really unpleasant. She said finally she got a raincoat like they have in Hawaii, made in China, a muslin one with oil poured over it, a real oilcloth.

Over there by the right speaker, some hedge clippers are hung, blade up, as if it is a sculpture, a spring in the middle, dark brown handholds.

At lunch Miss O'Keeffe was pretty funny, holding her napkin over her eyes, then over her nose as if to cry when I told her of my personal dilemma. She was pretending to cry for me. It was pretty good. "You're not going to get married, are you?" she asked pretty fiercely. "I don't know. I don't think so."

Then she quickly told me that Pita is pregnant, to deliver in January and no one knows the father. She intends to keep working and support the baby on her own. If anyone knows who the father is, they haven't told Miss O'Keeffe. And she doesn't ask.

We folded many of Miss O'Keeffe's smock dresses and placed them in the big chest by the door. "Goodbye to summer," she said. We got to the last Joni Mitchell song on side one, and she said, "That's enough for me," and went over to the book room, I presume.

We pulled out boxes with photographs in them, one box of proofs for the National Gallery, one photo per box.

November 9, 1978

How could I possibly leave my work with Miss O'Keeffe? She seems to teach me a new secret when I'm not even aware of what's going on until much later.

November 10, 1978, Friday

In the Outside Inn Café in Santa Fe, feeling fine. Snow is on the mountain, gradations of grey in the sky, here and there a brilliant yellow tree in places I had never noticed trees before.

—Abiquiu, 7:15 p.m.

I met the man who runs the McCurdy School at the gate. He was carrying out a box of magazines and books that Miss O'Keeffe gave him.

November 25, 1978, Saturday

The spaghetti squash is sizzling in the 375-degree oven, and the kale is steaming. Four red tomatoes are on the black-checkered oilcloth, ready to be peeled. I will dress a salad of watercress, and for dessert serve junket pudding and raspberries with mint tea. Barbara Rose is in the studio, reading another packet of letters between her and Stieglitz. Barbara Rose is a young, energetic woman who looks like a choirboy with her short hair, just below her ears. When I walked in, she gushed to Miss O'Keeffe about our dinner that she never goes away from here hungry, and her husband always exclaims how healthy she looks when she gets home.

November 6, 1978

For Miss O'Keefe's birthday I have $3.50 worth of candied ginger plus a linen handkerchief with a very plain edge. I am to stay in this part of the world (meaning the kitchen) while they work on the letters.

This morning Miss O'Keeffe described Barbara Rose as one of the smart women. "She has read more books than I have, and she gets around the world." She's an art historian, and Jewish. Her father told her she had two things against her when she announced to him that she was going to be an art historian. She's a Jew and she's a woman. Miss O'Keeffe said Barbara Rose was not supposed to be at the end of that movie by Perry Miller Adato, but there she was because she made friends with the director. Miss O'Keeffe said the lawyer finally wrote up a contract with Barbara Rose, I assume for the use of the letters from the Stieglitz archive.

I have my own little melodrama going on. Beautiful RS who came to stay with me over Thanksgiving before he begins work with a firm in Denver is now at Ghost Ranch among the cliffs in "Cottonwood." Miss O'Keeffe arranged that for him when she called telling me I was the only one to stay with her. Pita is involved with a Saint Tomás Day in the village, and Margaret is in New York. RS and I sat across from each other, and he suggested that he stay at Ghost Ranch. What a dilemma that was. Miss

O'Keeffe let me go walk around the Ranch for an hour this afternoon while she napped. RS and I walked among the red hills and photographed each other. The big drama is that he has proposed marriage on Thanksgiving. I am wearing his grandmother's silver wedding ring, as a reminder of his love, a ring I had returned to him and he brought back. Now he wants me to come to Denver. The thought of being away from this wonderful land and losing my work with Miss O'Keeffe grieves me. Work or a beautiful man or my land. What to do? RS is very persistent.

Miss O'Keeffe and I had a talk over lunch about him. "Has he done anything?" I said he had a counseling job and an administrator's job and five years on a farm. She said, "I bet he had only done those jobs for one year at a time." I asked her how can you know if a man says something whether he will actually do what he says. She replied that time does its work, and *he* probably doesn't really know what he will do. He was divorced eight years ago. She said he's not likely to do something foolish then. "But it didn't work out with the first wife," she reminded me.

She kidded that I wouldn't be coming to work weekends again before long. I asked her not to pack me off yet. I hadn't made a decision. "You mean you didn't say yes right away?" No, I didn't say yes right away.

RS is up at Ghost Ranch. I am here in Miss O'Keeffe's bedroom while Barbara Rose and Miss O'Keeffe talk about the letters in the studio. Too much on my mind. Tired.

November 25, 1978, Abiquiu

I am seated on a Barwa chair in Miss O'Keeffe's bedroom while she and Barbara Rose work on the Stieglitz-O'Keeffe letters in the studio. I hear Barbara Rose's voice, mostly, reading with an occasional question to clarify who someone is or when Miss O'Keeffe first did this or that.

At dinner Barbara Rose commented that with such a large number of letters, she was saying they fall mainly into three categories: one which clarifies when Stieglitz did this or that print

or when she did a painting or when they were where; another which is of interest to the general public; and finally the letters which are of such a privately personal nature that they should perhaps not even be published yet. For that latter category, Barbara Rose suggests Miss O'Keeffe allow different scholars to work with the more personal ones occasionally but not release them yet for general reading.

I am politely restraining my curiosity and not interfering with artist and art historian at work. Gosh, I'd like to be a part of the book.

Barbara Rose said the letters in the Yale collection need to be typed, transcribed. She said the paper is falling apart. Miss O'Keeffe raised her eyebrows and leaned back from her meal saying, "Another thing." Barbara Rose said that Yale had the responsibility to keep the letters in good form in their collection and they should arrange to transcribe them.

Barbara Rose also complimented "that girl at the National Gallery" cataloging the Stieglitz photographs. (*I assume that is Sarah Greenough who used to be my neighbor in Albuquerque. She and Meridel Rubenstein were roommates.*) "She is doing a fine job, but it would help her to have the Yale letters transcribed to help date the photos," Barbara Rose said. Sarah is guessing at the dates for some of the photos at this point.

They talked briefly about J. Carter Brown, head of the National Gallery. Barbara Rose went to school with him and said he wasn't bright, but he had connections. His first wife was a Mellon. He has married again, a beautiful socialite woman. Miss O'Keeffe said she was not impressed by Brown when she met him. Miss O'Keeffe said the previous head of the National Gallery was not special either (Walker). He tended to yell on the telephone.

They talked of Dove and Hartley. Miss O'Keeffe said that Stieglitz said Hartley always wrote his letters like he knew they were going to be published. Barbara Rose said that a volume of Hartley letters was out. Miss O'Keeffe sounded slightly interested.

Then she began reminiscing about Dove.

O'Keeffe in white coat dress
at the studio sliding door
with red chow dog Jingo.
She said, "Let's get this over with."
I said,
"Good-bye."
shook her hand.
She said,
"Good-bye."
I said, "See you next time."
She said,
"Good-bye."
I left by the big gate.
Last time I saw her.
She simply stood there
in the evening light.

<div align="right">

July 1979
C. S. Merrill
O'Keeffe, Days in a Life

</div>

[1979]

January 12, 1979

—3:20 p.m., Santa Fe, Outside Inn Café

I am on my way to Abiquiu to work for Miss O'Keeffe. She called Wednesday evening when I was over at KM's reading for my master's exam in her library. Miss O'Keeffe called back Thursday morning with "Greetings of the new year to you." I told her for the holidays I had gone into the snowy mountains out of the city into another part of the world. She asked how I would like to come into the Abiquiu world. I effused back that I would be there on Friday at 5:00.

In December I only worked one weekend, December 15–17. We had a visitor, a con man. As a result of the way we handled that incident, I was not sure I would be asked back to work. A fellow with black oily hair sneaked in through the old door by the library and came to the studio door, calling himself Leroy Rubidoux. He wore a light blue nylon jacket, new Lee trousers, light blue shirt, new dark brown heavy work shoes with darker soles. He had a smooth voice, oily as his hair, and slitty dark eyes. He drove a white Chevy sedan with rust on the bottom, license red on white: APN 245 or something close to that. His story was that Howard Hughes and J. Paul Getty had left him a lot of money,

but he wouldn't receive it for three years, and in the meantime, he wanted Miss O'Keeffe to lend him a large amount of money because he was a trained welder, but couldn't find a job.

At the mention of Howard Hughes, I went to the bedroom across the courtyard to call Juan, who was not home, then returned to Miss O'Keeffe. Next, I was going to call Johnny Jaramillo, have him jump the fence or come in by the garden gate and insist that the man leave. When I got back to the studio, the man had moved over closer to Miss O'Keeffe and was holding a manila folder with blank typing paper, expectantly, in his hands. She and I both insisted he must leave because she and I had work to do.

He narrowed his eyes, leaned closer with a harder voice, saying, "Don't tell anyone I've been here. After what I've told you, they may bother you. Don't tell anyone about me." I led him to a door wishing him good luck (as a criminal) then, outside, suggested how he might locate a welding job. At the gate he narrowed his eyes again and in that harsher voice said, "Don't tell anyone I was here. If they ask, I was just getting directions. Otherwise, some people may bother you about me." A threat! I was pleased to see him on the other side of the latches and bolts on the old gate and squinted through the cracks after his license. He had a fat soft hand, I remember. What a yucky thing to have happen to an old woman, not to mention Miss O'Keeffe; to have a con man go for her money is just ghastly. When I went back to the studio, she was pacing around nervously, apologizing for having me go out with him alone. We put nails under the swivel door blocks on the studio doors so that someone pulling back on the door

wouldn't let the latch swivel down. She made me promise not to tell Juan, because he would "tear the roof off."

I distracted her by playing the National Geographic record of whale sounds, something she stood next to the speaker to hear clearly, saying, "Imagine! How eerie." When I left at 5:30, she said, "We have our little secret, now." I went to the kitchen with Margaret Wood and told her the whole story and told her to tell Juan since I had been told not to tell him. Then I hit a snowy, icy road, fishtailing on the bridges. Next day I called Juan, but he wasn't there. A week later Juan called me in a rage. Furious that I hadn't called him and told him the story, he yelled at me and I spoke back firmly and stated that I had told Margaret to tell him the whole story. Well, she hadn't, and Miss O'Keeffe was having nightmares and putting locks on all the doors without telling anyone why. Juan finally sat her down and demanded to know what was going on. He and I agreed I would inform him of anything that might endanger her, even if she forbade me to do so. Juan said as a conclusion what happened in Italy (the Moro incident, I suppose) could happen here, and we would all feel horrible if something happened to Miss O'Keeffe. Indeed.

On to Abiquiu. It's rainy, snowy, and grey today.

Saturday, January 13, 1978

There is snow on the mountain and ice in the walkway.

Sunny day. The clouds broke this morning after hiding the full moon from sight. A number of times I pulled the curtain out and looked past the long horns on the windowsill to see if it was morning yet. I slept very fitfully and had a bizarre dream about a woman with very frizzy hair who lived in an apartment where I lived. She had an aquarium of rare fish and could reach her hand in through special slots that wouldn't let out the water. Two Navajo friends and I got very frightened when one of her fish swam out of the frizzy-headed woman's room, swimming in air!

February 23, 1979, Friday

Yesterday, once again, Miss O'Keeffe didn't call me for weekend work. I called Margaret Wood, the night shift person, to see what was going on. She said a new person was being tried this weekend and another woman, wife of a goat farmer, was working days now, and Margaret was working nights including weekends. I called Juan to see if I was being phased out. He asked who had told me that. He said that he was the only one to decide that, and no, I wasn't being phased out if I was willing to be there weekends for nights only. I said I could probably find ways to spend my days. Juan said jokingly I could go up to his house and help him write his book, *Desire Under the Chiles*. He proceeded to tell me about his latest review. There was a disastrous one in *People* magazine, the result of sensationalist reporters who spent six hours with him and his pots and came away with his most outrageous statements about O'Keeffe, such as what he needed was a 26-year-old Georgia O'Keeffe. Somewhere they turned up an odd photograph of him having his hair combed by Miss O'Keeffe, and printed it. In the *Arts* magazine, February, there was a three-page review by Barbara Rose that he seemed pleased with. I managed to find it yesterday and was impressed with her language and her diplomacy. She seemed to catch the oriental and Indian influences well in words, and her mention of narcissistic self-revelation in the New York art scene was well said, it seems to me. I wonder, however, about her prediction that he will receive European influences now.

Miss O'Keeffe asked through Juan how I did on my exam. I responded I didn't want to talk about it, and Juan shouted out to her I wasn't talking about it, and that must mean I failed it.

Juan said he is certainly pleased that he isn't being sued for an unimportant amount by Doris Bry. It's still $13.4 million.

I remembered this morning how Miss O'Keeffe called me Friday morning before my M.A. Examination to ask me to go up and work for her. I told her I was sitting for my exam. She

talked with me for about five minutes about preparations. She said, "Work hard, and in the right direction." I wrote that on a notecard which I keep on my desk or in my notebook.

February 27, 1979

Every other weekend has gone to Miss O'Keeffe until this last month. She seems to have found someone close by running a goat farm to be there on weekends.

March 3, 1979

It looks like I am not working for Miss O'Keeffe regularly anymore. I called and found another woman who lives closer is doing the weekends now. I have more weekends for what I think I have to do. I've been thinking about the necessity of keeping private for keeping integrity.

Sunday, April 22, 1979, Abiquiu

Here I am working for Miss O'Keeffe again after not having seen her since January when she called me to work, and I couldn't because I was taking my M.A. exam. Last Tuesday evening, she called just as EM and AD came in before the reading I had arranged for them at the Central Torta. Nanao Sakaki (*a poet friend visiting from Japan*) was doing something down at my trunk with his pack and translating work as I talked to her.

"How are you?" she said.

"Couldn't be better," I replied.

"Well I'm pretty fine myself."

"Yes, I can come up this Friday. I'll be there at 5:00, yes."

"Very good."

Here I am in the anteroom off Miss O'Keeffe's studio, able to look north and west at the big mesa she told me yesterday the boys of Abiquiu wanted to write "Abiquiu" on years ago. "It was a great fight," she said. A teacher from the high school came to say he had to live with those boys, and wouldn't she reconsider.

She admonished him that she *really* had to live with those boys, and she had to live with the mesa as well.

I just gave Miss O'Keeffe her morning yogurt at 10:45 after reading to her from the *Book of Tea* for about an hour. She is very sleepy, so she is resting under her black quilt and white wool cover on top of her made-up bed. We have been reading Eliot Porter's *Antarctica*, because the Porters are coming for a meal in a week.

She listens quietly with her dark, olive-spotted, spare hands with heavy veins placed one on the other in her lap in repose. Sometimes she breathes heavily, puffing out her lips, with her silvery thin hair in a twisted knot secured at the back with comb and three clear hairpins. When she dozes, I keep reading aloud because I wake her if I stop, and sleep is dear to her.

Sometimes she will jump after I have been silent for three or four minutes, saying, "I'm not asleep," and I'll pick up and read on. This morning she dozed, and I dared to quit reading, and she stayed asleep. There was blue sky with cumulus clouds along with Truchas Peak and Wheeler Peak hazy in the distance. The Chama River was full to over the edges below, brown cattle grazing the fields beneath this hill, one white horse, a bird across the arroyo, the wind quiet. Old Miss O'Keeffe is there in her Eddie Bauer thermal underwear insulated with goose down, elegant cotton shirt and black spider-thin shawl, black suede slippers. That was an utterly peaceful moment. Now I'm off to fix a lunch of quiche, seaweed, spinach, watercress salad, and fruit.

—*11:30 a.m.*

There's much to write. Much. I think about writing constantly, plan how I might put something down, but seem seldom to find the leisure, the quiet. Signe just brought me my half-gallon of goat milk.

—*3:00 p.m.*

Jackie Suazo is visiting this afternoon. He is a man in his fifties who has a job investigating job discrimination cases for the

state. Miss O'Keeffe told me to stay here in the studio while he was here because he won't ask for money while I'm here.

They are reminiscing about trips into the hills. She went with Johnny Jaramillo (Jackie's half-brother, same father) up into the mountains where there was a large deposit of black obsidian.

Jackie at nine years old attached himself to Miss O'Keeffe and made himself at home. He had a grandfather who was a Penitente, a man with beautifully shaped ears, Miss O'Keeffe said. This old man would wake Jackie in the night to see the evening star. Once Miss O'Keeffe saw a boy in the village stalking around like he was looking for someone to beat up. (*This was one of her favorite stories which she had a tendency to retell, sometimes adding a new detail.*)

She said to herself, "Why, he has a cap like Jackie's. Why it's Jackie!"

She asked him why he went around like that, and he said nobody out there liked him. She and Jackie just reminisced about the boys who wanted to put the "A" on the mesa. They took rocks and cans of paint up there, but they got stopped. Jackie said nobody was likely to do anything like that with him gone.

I'm seated at Miss O'Keeffe's desk. In front of me is a four-inch-high blue glass vase with fine rare Jonquils. There is a polished brown stone in the shape of a heart to the left of the vase. Behind the flowers to the right is a small open pocketknife, bronze and black, next to a white form, one of Miss O'Keeffe's early sculptures, the one that looks like a hooded being, bent at the shoulder, gentle flowing, upright, on a square base.

Miss O'Keeffe reminisced this morning about Jackie and her planting chrysanthemums in the garden. When they finished, she said they must pray over the plants so they will grow. She laughed as she remembered that he looked at her as if her prayer wouldn't matter much since she wasn't much use to God on earth. This morning she reminisced about Jackie asking for $12 for new shoes. He was going to Mass and felt people would laugh at him if he walked down the aisle with his old shoes on. She finally

relented and gave him the money which he worked off around the house. He always worked off whatever she gave him. She told me at breakfast Jackie is the closest to a child she has raised.

There was a Dutch physicist who wanted her and Stieglitz to raise his thirteen-year-old daughter, and they came to a meal one day. The daughter copied what Stieglitz did, thinking it was important. Stieglitz was absent-minded and was apt to put his coffee cup beside the saucer which the little girl copied. Miss O'Keeffe had to explain. Well, she and Stieglitz didn't take on the raising of the little girl. The man's wife taught something in Russia every other season and they didn't have much of a home. They had an institutionalized son who was autistic, just a vegetable. Just before World War II, Miss O'Keeffe said the man took the son out of the institution and killed him, then shot himself. It left a mark on her. She has told this story before. She mentioned the man was one of the people who worked with Einstein.

Monday, April 23, 1979, Albuquerque

Miss O'Keeffe remembered climbing to a tall place with friends to watch a black snakey tornado (she called it a hurricane) miles away as it flattened the woods and houses. They drove through the area and saw the destruction.

She remembered climbing onto a meat block with girl-friends and jumping off. She was appalled by a friend, Leena, who jumped off, skirts flying, with nothing underneath. Miss O'Keeffe always wore underwear, and there was Leena, all free underneath.

Tuesday, April 24, 1979

I was sitting with Miss O'Keeffe at the noon meal Sunday with my back to the patio, looking out at the roofless room. In the passage to the garden, Japanese wind chimes played in the breeze. I had a body tone change as I looked toward the red stone in the niche in the roofless room. That red stone looks like the auricles and ventricles of a heart. It was startling in the complacency of lunch, with Miss O'Keeffe to my right with the niche with

a brown wooden Buddha surrounded by smooth, carefully selected stones. I realized that the roofless room appeared to be the empty version of the stage for my play (*Ever Since Yesterday Evening*.) There was a heavy table in the middle. Toward the back was a big stump like I imagined the plant at the window was on. To the left an open window, to the right the door to the kitchen, and the glass door separated the dining room from the roofless room. The dining room seemed like the space for the audience. There was the stage in front of me. I remembered sitting on a chair in the large bathroom looking at myself in a mirror across the room and feeling the whole character and pathos of Claire (*the main character in the one-act play*) but without the form of a play, poem, story, or even a novel. That must have been almost exactly a year ago.

Miss O'Keeffe's lightly tapping her plate with utensils in the process of lunch brought me out of my reverie into the ordinary space of careful attention to what we eat and how we eat. I remembered why it is that I am compelled to spend weekends there with her, fatiguing myself with travel and trying to keep her comfortable, at ease. I feel almost reverent toward her and the elegant quiet she surrounds herself with. Her way of life is art embodied. I enter her art by moving through shared space on weekends.

She satisfies what food cannot, no matter how filling.

May 4, 1979, Friday

El Paragua Restaurant, Española.
On my way to Abiquiu to Miss O'Keeffe's.

May 5, 1979

—DREAM

Last Wednesday before the money presentation and press interview for my play, I took a short nap when I had another of my vision dreams of a bee hovering in an upward pointing triangle.

I remembered it today as I gathered dandelions beneath Miss O'Keeffe's blooming apple tree humming with bees. The wings were moving like they were cooling their hive. It seemed pretty special because I felt calmed after waking up.

Miss O'Keeffe and I are listening to Pachelbel's Canon in D right now. The studio smells of turpentine because she has been cleaning brushes. She's wearing an apron full of tiny patterns and pink, red, blue, yellow rickrack, a very uncharacteristic get up. I just got through locating something for her to scour things with. The apron looks like something a midwest farm woman would wear.

I was so happy yesterday evening when she showed me an eight-foot-tall painting of massive city buildings. It is similar to one in her book and similar to the one in the W. C. Williams show at the Whitney in December 1978. Today we went on this morning to see it in the full light. There are two upward-feeling black shapes on either side with white blurry circles of starlight in the deep blue upper part. There is at the bottom a white lamp and to the left a hint of a light as though hidden by the front light. The left building has a point that touches the top of the canvas. It is in there among the *Day with Juan* series. The white one (the one I assisted with) on white is on the north bedroom wall. On the west wall is a new one with waves of blue in the sky with no attempt to fully merge the bands of different color. Behind the two easels holding the buildings is one of the blue sky and grey monolith *Day with Juan* series that has the monolith extend right off the top—a tall one. In the center of the room are two tables containing various porcelain dishes. Some look like round chemistry dishes with little pouring spouts on the shallow bowls. There are various shades of blues, greys, whites in dried condition here and there.

Last evening I commented to Miss O'Keeffe that a large piece of white watercolor paper looked particularly good with its rough surface and curly edges. She said, "Yes, it'll never look so fine after something is drawn on."

The news of a fire engine in town brings her hope her insurance may go down. She's been telling me how the men will practice on old tires doused with kerosene. There will be a smaller crew in Cañones to fight a fire until Abiquiu arrives with its volunteers.

The lawsuit with Doris seems to still have folks in a light sweat in this household. Miss O'Keeffe said that Juan read her Doris's deposition in his case, and she said that Doris didn't seem to understand the meanings of simple words, like *fact*. The lawyers jump all over her for assumptions or suppositions and want to know exactly who was somewhere when a certain transaction occurred. Miss O'Keeffe said some of those things happened so long ago that it is difficult to recall exactly who was there and exactly what was said.

I saw Juan on the road down at Bode's general store and gas station at the foot of the hill. He was in the Mercedes, driving up to Miss O'Keeffe's to pick up some food for his meal tonight. He's having a friend from Embudo who is an architect from Vermont who will look over Juan's house. He took a couple bottles of Esther's wine from the closet in the roofless room, a still half-frozen roast and some raspberries "because I like them so much." That's a joke between them, Miss O'Keeffe explained because they have had too many raspberries.

Sunday, May 6, 1979

Today Nanao Sakaki visited Miss O'Keeffe to prepare her evening meal. She is very interested to meet him and to try his cooking. I talked him up for a couple of days then asked her if she was interested in sampling some new cooking. Already I introduced her to his wakame lemon soy sauce and dried fish. He is a poet from Japan, translator of Gary Snyder's *Turtle Island*, and a famous underground free spirit. None of that would interest her, so I mostly mentioned tea ceremony, cooking, good stories from Japan, and some of his comments about meditation including the one where Nanao said, "Meditators today, the young ones,

seem almost dead. One must sit in quiet but also must be burning inside." On one of our walks around the driveway (6–12 times for a half mile or a full mile), she seemed interested in that meditation comment.

Yesterday, Juan said about *his* lawsuit with Doris Bry that it was good mantra practice. (I assume he meant that he had to repeat things over and over.) Miss O'Keeffe said that her lawyers seem to have some good private information that may close her case with Doris in O'Keeffe's favor, which will favorably affect Juan's case.

Two years almost. This has been going on long enough now!

I told Miss O'Keeffe that I remembered how broken down she would be for a couple of days after Doris left. Miss O'Keeffe would almost want to just stay in bed but somehow managed to struggle about. Miss O'Keeffe said humorously she might have me testify.

—9:15, Studio

Breakfast of orange juice with lecithin, wheat germ on banana, milk, coffee, grapefruit. Miss O'Keeffe started talking about her "farm life," her "Lake George life." She spoke warmly of Paul Rosenfeld who had a room with his own desk and chair for writing. Miss O'Keeffe said she thought he must be a fine writer, at least all the men thought so. For her his writing was like a colored balloon that floated way out there somewhere, but didn't come down to earth with her. She said every afternoon at four he would promptly walk two miles to the post office and back to mail a letter to a girlfriend. When he returned, he always wanted toast with butter and honey with a cup of tea. She said she could always tell by the creak of his chair whether he had an idea that he wanted to work out with Stieglitz. When Paul and Stieglitz would talk, Paul, as a great friend, always seemed to agree, though it wouldn't have mattered to Stieglitz if he had disagreed. Many of the young men, she said, would listen to

him and repeat what he said back to him, and then go off and not make up a thing of their own. Paul said he always agreed with Alfred when he was with him because he could be so convincing. Then he would go off and find that he had separate thoughts of his own.

She said Paul died a week after Alfred died, and she had to advise Paul's sister about how to conduct the funeral. Miss O'Keeffe received his chair and desk after his death. The chair was very stiff, old-fashioned and formal. She said she didn't enjoy sitting in it so she just kept it around and looked at it, but it wasn't fine enough for that, so she sold it. She still has the table at the ranch I think she said.

Remembering Stieglitz, she said something about the carefully arranged dish of mosses and leaves left by her on his table where he often worked facing the window where he would often see a cloud and rush out to photograph it.

May 12, 1979, Saturday

—Abiquiu again

Just finished breakfast and dressing. All this past week has been one long time of finals, papers, students, and grades for me at UNM. Miss O'Keeffe has invited the Porters up for Sunday's noon meal, and we are reading quickly to finish his book *Antarctica*. Miss O'Keeffe has been reading and enjoying *Jade Mountain*, a collection of Tang dynasty poems translated by Witter Bynner. She said she liked them so much because each one is a picture. She thought it had something to do with the idea that they were written by brushwork. I read some of the book to her last night, and she wanted them to be read two times, then complained because I wasn't a poetry reader. She couldn't understand every word I read as she could when I did prose. She said she has learned from reading these legal depositions that you must know exactly what you mean by each word. You mustn't suppose or imagine. You must know.

"For most of the modern poetry," she says, "it's for the birds."

Last night as we walked around the drive nine times before dinner, she was interested in how things were going for my play *Ever Since Yesterday Evening*. She was interested that I had a kerosene lamp in it as one of the essential elements. She said my play might be a wave of the future because, who knows, we may be using them in place of electricity before long. Then she said we would certainly have to go to bed and get up earlier.

She added that she hoped my next play would be a happier one. I asked her what about, and she replied, "Oh, I don't know."

This morning at breakfast of marjoram over boiled eggs, chile, French bread, toast, orange juice, grapefruit and coffee, we had a good talk.

When I said that I stayed up late reading on the *Jade Mountain* after she went to sleep, she asked if I knew of any better. I said the poems made my work look pretty pale. She emphatically returned, "Oh no! You are writing for your time. They were writing for their time. They were lucky not to have anyone before them to be writing like."

Miss O'Keeffe spoke of a woman in New York years ago who chastised her for copying things Chinese, not for being so concerned with or interested in things from the Chinese. Miss O'Keeffe told her to walk down Fifth Avenue and in every window you will see something; material, design, china; that has come to us from the Chinese. The woman was astonished because she was used to thinking things came from the French, and she had studied the French for years.

Miss O'Keeffe said she and her French teacher had a hard time of it. She wouldn't read her French lesson aloud three times to herself and got too many demerits. She thought she could, even at that, read better than most of the kids. She had a great aunt who had studied Latin in college and said it did her no good so Miss O'Keeffe decided not to study that. This great aunt would

visit and take everyone out onto the porch and tell the Greek tales. Miss O'Keeffe said the Greek tales weren't so special to her as the Hans Christian Anderson stories someone told to her.

Sunday

Dreams of deep caves and long instructive conversations, and I awoke tired and peaceful like something was understood finally, but three hours of grogginess bring me finally to 9:00. I built a fire and fixed breakfast at 6:15 a.m., after calling one of my friends. I hung up before Miss O'Keeffe came out of her room.

The sky is empty and clear and the air so agreeable still that Miss O'Keeffe wanted to walk around the driveway six times after breakfast before 8:00 a.m. This morning at 6 a.m., there were hints of long clouds to the north, and Miss O'Keeffe said, "Orville used to say a cloud the size of your hand could do anything."

This morning we are to call Aline and Eliot Porter. Miss O'Keeffe talked of Eliot Porter while we walked this morning.

Later in the morning after dressing, there was a store run. O'Keeffe was telling Candelaria what a good cook she is, and that's why Miss O'Keeffe had her and not me do the lunch and hearing all about "Kika," the new granddaughter, who got a new plaid bonnet yesterday, and Miss O'Keeffe got her bath, vitamins, brewer's yeast and molasses, followed by grapefruit and yogurt. I swept the bedroom and bathroom and now while she is in the kitchen talking to Candy, I sit in the sun by the fragrant sage and try to loosen my shoulder muscles. I wonder what caustic things Juan will dream up to say at lunch today, and I can expect to blush like a teenager as usual. Wonder if when I'm fifty I'll be over with blushing?

Miss O'Keeffe said she wished she had something for Eliot to carve because he's really an accomplished carver. He's so amazing, his children would watch him with amazement at his skill.

May 19, 1979, Saturday (at home)

For breakfast at noon, I made Viennese pancakes from Miss O'Keeffe's recipe. (One egg more than people served; same number of tablespoons of flour, same number of tablespoons of cottage cheese. Serve with cream sauce or syrup and butter.)

June 1, 1979, 6:00 p.m.

Rainy evening in Abiquiu.

I am sitting in Miss O'Keeffe's kitchen with patient old Estiben, Candelaria's father, Pita's grandpa. Miss O'Keeffe went to town to the dentist and intended to return at 4:00, he said. She is late, so I don't begin cooking immediately today. Estiben patiently stared at the gate here and heard some noise I didn't hear and went to the gate as the car arrived. She's here.

July 10, 1979, Tuesday

I mentioned to Nanao Sakaki that once I was reading to O'Keeffe some of her correspondence with Stieglitz where she remembered her experience viewing some Mayan pictographs in a cloister then went to her hotel room and dreamed them onto a wall in her way.

July 14, 1979, Saturday, Abiquiu

Last evening I mentioned my dream of many fast-growing leaves to Miss O'Keeffe, and she smiled saying, "Yes, all those corn leaves growing."

When I arrived, she appreciated the fact that I was thoroughly addled from the heat, so we reclined on two long chairs that she had facing Juan's huge handsome pot. It is new to me and quite striking, the biggest one I've seen. It has a certain elegance, a fineness. "It is one of the best he's done," she said. The shape is elongated and roundish, a little fuller on one side than the other. There is no hole in the top, and the top left is a blunt

wedge-like form. She has placed the pot on the four-foot shelf to the south so you see it against a white wall, on a light wood shelf with sheets on the lower part of the shelf held in place by large and small smooth black and white rocks. When I first saw the pot, I gasped and pointed with quick surprise. This is something like the big black commanding form. It almost seems to grow.

(Here the journal holds a sketch of a simple black pot with the fertile shape of a pregnant belly or a swollen seed or a mysterious egg—something alive. The opening was tiny at the top. The shape of the pot is reminiscent of Miss O'Keeffe's large black rock painting, Black Rock with Blue Sky and White Clouds, *1972.)*

She was wearing a dress designed by someone she said was the best woman designer we've ever had. The shoulders were cut away toward the neck where there is a collar with points. It is crisp looking, and the material increases toward the hem, mid calf, so it is a triangle in brownish-hued aqua. It was very cool-looking, a bluish color that was shaped so it didn't touch the body to restrain or warm.

She told me about a market in Guatemala that she and Juan visited, a market that people get on buses and come down from Iowa to see, but she wouldn't advise anyone to cross the street to see it. There are miles of handwoven material she said. Some are made into a dress or shirt, but mostly yards of material are just hanging there, and there are hundreds of people, including small children that she was amazed were not killed

by being underfoot. There would be one about so high she said, holding her hand about four and a half feet from the ground, leading a babe even smaller, and there were older ones carrying babies on their backs. She said there was not one thing worth having there as far as she was concerned. Juan took a couple of afternoons and found a two-faced head from a prehistoric ruin plus some pieces of lava that he brought back with him.

She said at one point in the trip, they took a twenty-eight-minute plane flight to avoid a three-hour drive over the mountains. I believe this was in Costa Rica. Juan's parents then took the road. She said there were just three people in the small plane including the pilot. They had to put Juan in the co-pilot's seat to balance the plane.

She held her arms out in front of her in an oval with fingertips touching and said, "There were many small clouds just this size with the feeling you could touch them."

On the west end of the studio is that blue, grey, and white rectangular painting that I believe is an aerial view of a river.

CR 1440, *Blue Black and Grey*, 1960, Georgia O'Keeffe, © Georgia O'Keeffe Museum, Image courtesy of the Georgia O'Keeffe Museum.

This is the same canvas that I sketched in my journal.

Next to it to the right is a painting of the white forms you see in the white place close to Abiquiu, stalagmite-like forms in a layer-cake effect. This one is maybe 3′ x 2′ with grey-white pillars against a light blue sky. The usual huge painting to the

east is maybe 6′ x 8′ with huge white space covering over half of the lower portion and above a band of green horizon, then blue green, light blue, blue. The round marble table completely empty except for Kabir, the Findhorn book and two *New Republic* magazines that I brought for her to read. She is listening to the first pages of *One Straw Revolution* by Fukuoka on natural farming in Japan. He is one of Nanao Sakaki's friends in Japan. I brought the book, knowing her interest in organic gardening. She had great sport last night talking about joy and the human spirit in connection with trying to get a new motor for one of her freezers, the old standing, upright one, and trying to get the kitchen and pantry floors waxed.

—Afternoon

This weekend Miss O'Keeffe has an interest in her raspberry drink. The recipe consists of two containers of raspberries mashed with diced mint leaves and one cup of lemon juice poured into three cups of boiled water containing 1 cup of sugar. This mixture is chilled then poured over crushed ice in a glass. This morning was spent with an early breakfast of cheese, chile, coffee, honeydew melon, and French bread toasted and buttered. Then after calling the refrigeration man, we walked six times around the graveled driveway. She wore a crumpled straw hat, a bright turquoise silk coat over a kimono that she had slept in, a grey, black, and white one with many concentric circles on it. In the growing heat, she took off the light coat and let down the kimono sleeves to walk that way. It was a congenial walk. I told her about the small bird in the top of the tree by the gate; the one that sounds like a fingernail on a plate. She said it sounded similar to the one she also heard at Lake George and never saw. Sometimes hears the same song in the marsh below the Abiquiu house as well as in the tree above the driveway. I told her that I heard the same bird in Taos and saw that it was very tiny, and someone told me it was a Towhee.

While I ate breakfast, she told me about Alice DeGroot, who was also friends with Richard, the man she traveled with three

times to Vienna to see the Lipizzaner horse show. Mrs. DeGroot visited recently, and Miss O'Keeffe said she had lost a great deal of weight by continuing to eat exactly what she wanted, but eating only half as much. Miss O'Keeffe said that Mrs. DeGroot used to overeat in the kitchen, afraid of being seen, and now looks much thinner than at that time when Miss O'Keeffe found out from Dorothea that Mrs. DeGroot would be eating honey and bread between meals.

Last night we had an interesting conversation about Maria Chabot. Maria apparently lived with and helped Mary Wheelwright. Her name came up when I mentioned that Maria came to see a film that Nanao Sakaki had brought to New Mexico about a Japanese commune called Suwanose which I showed to twenty people in Albuquerque. Miss O'Keeffe asked about Maria, and we talked about her for a while.

Another stunning sunset. The west is full of brilliant yellow, pink, and orange. The east is a subdued deep blue, with grey and white clouds. Many moods are all around the sky.

Miss O'Keeffe got very tired after dinner and seemed rushed to get into bed. There was some trouble with Jingo's left front paw. Estiben came from home to check it because Jingo wouldn't let me get close and even now growls and barks at me across the room, perhaps because I tried to check the reason for her limp while she was eating. Estiben and I found a slightly roughed-up place, an old cut, and he put some "grease" on her paw. We agreed that it might be just a bruised spot, and after a night she would be better.

I had read Miss O'Keeffe nearly asleep with *One Straw Revolution*. She seems interested and asks me to repeat words to be absolutely clear. Estiben came, then I went back to her room, and her face was fully relaxed and mouth a bit open, breathing deeply, completely asleep in the late golden light. I went over to the other parts of the house and closed windows and doors. In the new studio, I gazed briefly at the tall New York painting with four stars in its sky, much like that poster of the Williams

show, *William Carlos Williams and the American Scene 1920–1940*, at the Whitney. Earlier today when I was brushing and dressing Miss O'Keeffe's fine hair into a French roll with a figure eight at the top of her head, she was talking with Mino Lopez, Pita's brother, asking what he thought of the black on the painting they had worked on together. He thought it was too shiny. She agreed and said Juan wanted something done about the black. Miss O'Keeffe said that they might have to sand it off and try again. Mino wanted to go to the fiesta in Española so he wasn't interested in staying past his responsibility for putting the shine on the fresh wax in the pantry and kitchen. Miss O'Keeffe has said to me that she could make a painter of Mino in a few years. He has been dreaming about painting.

Today Miss O'Keeffe said that Elizabeth Arden was going to bring her something very beautiful, but Richard, the man with the horses over the mountain, told her not to bother. He said that Miss O'Keeffe would prefer a shovel. We had a happy laugh over that.

Reminiscing about a trip to Vienna with Richard, Miss O'Keeffe said that he knew the man who managed the Lipizzaners, so they always got choice seats. When the show began, a man on a large stallion rode in front of them and had the stallion rear up. She said that she was astonished to see herself beneath the stomach of a big white stallion and was afraid that it would land right in her lap. For dinner we had warm corn soup, bread, salad, raspberry drink, fresh zucchini, steamed and buttered. She insisted that I should eat the leftover spicy meatballs and chicken leftovers because I had been cooking. I made two jars of raspberry-currant preserves under her stern direction, and I needed nourishment.

I weighed myself this morning and found myself at 121 pounds. Last time I remember weighing, maybe a couple of months or so back on her scales, I was 135 pounds. New eating habits.

After Miss O'Keeffe's fresh veggies, buttermilk soup, corn soup, raspberry soup, fresh lettuce, good order in eating, and

creating a relaxed space, eating seems interesting though not the center of my world as it has seemed at some obsessed times.

When I commented to her about my surprise at weight loss, she simply said, "Well, you've been walking in the mountains."

July 27, 1979

—*Santa Fe, Outside In Café*

Today I carry the poem dedicated to Georgia O'Keeffe by Nanao Sakaki entitled "Summer Morning Song" that he said is ready for her ears. It's the one that he wrote at my house the week before his poetry reading at Boulder where he read it, then re-worked it with Allen Ginsberg's suggestions on top of my earlier ones about words and punctuation. Here it is, and I am taking along a wild flower guide so she can see an "oyster plant" to understand the poem a little better.

Summer Morning Song
On a summer morning
 Walking in Japanese mountain woods
 A sixteen-year-old boy
 I met my first love—

This round-faced girl
 Slim body, sharp-rayed
 Gold-eyes—not really shy—
 Liked me to look at her
 Dressed up green just for me.

We met in a high meadow.
 I called her "Mountain Lady"—
 Behind a thorn fence
 Watching her lips blooming
 In summer morning light.

Crossing many many winters, grey-headed man
 Finds his way to a new continent
 Walking woods in summer morning light
 I meet my old love.

She's still sixteen-years-old as before
With a round face and edible root—
A native yellow south Asian plant.

What a traveler walking east to Japan
Wandering west to the Rockies
Without fear, without feet.
From my mountain lady's golden face
Shine out beauty, intelligence and patience.

No beginning, no ending to love.
Whenever summer blooms back over earth,
We meet in a high meadow . . .
Weaving fuzzy globe of star-seed cluster
Waiting for another summer to glide.

Don't call my lady
"Oyster Plant."

Nanao Sakaki
Summer Solstice, 1979

—8:30 p.m., Abiquiu

In Miss O'Keeffe's studio at her desk, the sounds of crickets and cicadas from the trees and the garden. When I arrived at about 5:20, the chows Inca and Jingo met me at the gate, as usual, with their punctual, abrupt, gruff barks. I came in the gate carrying my journal, Gregory Bateson's *Mind and Nature*, Fukuoka's *One Straw Revolution*, and the Peterson *Field Guide to Rocky Mountain Wildflowers*, all things that might amuse her and that interest me if she insists on dozing while I read to her.

She was at the screen of the studio cautiously calling out, "Carol?" in her husky high voice. She was wearing a very light gauzy kimono embroidered white on white cotton with three or four large flowers. I carried books, suitcase, purse, and a sack of peaches and pecans to the studio door.

When we went in, I looked to the south wall to see what was on display. There is her shelf there, blanked on the left by

the sink and on the right by big 2½" thick boxes full of records (Schnabel, Schubert, Monteverdi, Haydn, Beethoven, Vivaldi, Mozart, Bach, and some single albums), there is one of the large paintings from the *Day with Juan* series. It appears approximately five feet by six feet. Blending is not subtle between shades so it looks to me like viewing waves from above.

CR 1631, *Untitled (From a Day with Juan)*, 1976/1977, Georgia O'Keeffe, © Georgia O'Keeffe Museum, Image courtesy of the Georgia O'Keeffe Museum.

This is the same painting that I sketched in my journal.

In front of the paintings was her strong white sculpture of round forms and curls.

CR 1135, *Abstraction*, 1946 (cast 1979/1980), Georgia O'Keeffe, © Georgia O'Keeffe Museum, Image courtesy of the Georgia O'Keeffe Museum.

This is the same image that I sketched in my journal.

This sketch does it no justice. It is about four feet tall, sitting under and in front of the painting. Striking contrast, the

angular statement with this curvy three-dimensional form. I find it pleasing, and I told her so. She said Juan found it "tricky" in his words.

Then we went to the south door to the studio, struggled with a stuck screen and sat in the wind, watching clouds. The west wind had followed me from Albuquerque, it seemed. I was often maneuvering my friend KM's truck to allow for the jostle of that wind.

There, among the chamisa bushes and low plants in a couple of canvas chairs, we discussed first my play and whether it got a good review. I quoted the sentence about "powerful drama acted with compassion and warmth." She said, "Pretty good," and told me of something in a *Hudson Review* about some man's visit out here.

She said she fell sound asleep while Pita read it to her. She said she couldn't make it to the play because she just wasn't up to it. We settled what was for supper, and she went off to straighten her hair before the meal of chilled cooked vegetables, toast with Alouette, peaches, slices of banana bread, followed much later by junket and Foenugreek tea. On the table was a white pitcher containing yellow day lilies and branches of salt cedar. Over the fireplace was the large black African mask with extended eyes and movable mouth. This is the one that Juan doesn't want over the table on the south wall where there is usually a painting because he says he doesn't like it sticking out its tongue at him.

Miss O'Keeffe went to bed early by 8:00, commenting on how dark it was at that hour. I observed the clouds in the west made it appear darker. I opened her curtains "so it wouldn't be so depressing."

She said she would hear Nanao Sakaki's poem tomorrow. When I mentioned that he was in the Sierras on a walking meditation, she began reminiscing about two weeks spent in the Sierras. Just a couple of sentences about enjoying that time.

She, just like Nanao did after the play, asked me if I had started another play and seemed pleased, or at any rate, quiet

when I said that I had done several poems this week and had two plays in mind, one of which would require much research, and the other much thought and time.

July 28, 1979

This morning on our walk six times around the drive, Miss O'Keeffe told me a funny story about Georgia, niece of Stieglitz. She was so thin that people were often putting her out of ladies' rooms telling her that boys didn't belong there. "I'm not a boy," she would insist. "Oh no, you don't belong here," they would say. Also, Georgia's hair was thick as a doormat, and Miss O'Keeffe could take a fistful and cut it off. After about three days of combing, grabbing a fistful and cutting into the mat, it would look fine. It always put her mother into a stitch to see Georgia's hair handled so. Miss O'Keeffe told me it was one of Georgia's pleasures to go into the Canadian mountains, make a first ascent, and photograph all around on the way. She married a mountain climber and lives in the mountains of Switzerland. Georgia and Miss O'Keeffe once carried liquor from Canada to the U.S. strapped to the inside of Georgia's thighs. At the border they declared nothing of value to carry into the country. This was during prohibition time. One of the strings broke on one of the bottles, which came crashing down. The guard looked at Miss O'Keeffe, who was older, as if she was responsible, and Miss O'Keeffe said that she would never have thought of strapping Georgia up like that.

Miss O'Keeffe said she remembered when Stieglitz first did photographs of her hands. They were walking up Fifth Avenue, and there was a screen with hands. No one would have thought of doing hands like that before Stieglitz's portraits of her hands.

—Saturday evening, 7:00 p.m.

Sitting at the north door to the studio in the little glassed-in space. Meadowlarks are singing. The sun is setting. There are

many clouds after a thunderstorm. Miss O'Keeffe was so fatigued by working with Eleanor Caponigro that she went to bed at 6:00, after I braided her hair. I brought her dinner out to her (salad, steamed chard, cheese, bread, apple sauce) but she sat in bed and fell asleep over it. When I returned, there she sat quietly dozing, hands on either side of her like guardian lions at the entrances of museums. They had discussed the Stieglitz archive at the National Gallery, much talk of selling a set of books, arranging the volumes by place, person, or mode. Perhaps a Lake George series, O'Keeffe portrait, equivalents. Eleanor wants to do the book design, I'm sure. Sarah Greenough had already done some preliminary work, and they are doing additional things. Miss O'Keeffe has stories to tell about a number of photos. While they were talking, I copied about thirty recipes from the red kitchen notebook to take home, study, practice, and invent from so that I can amuse her palate and further refine my cooking.

I'd also like to easily put together dishes in one pot, camping, using wild plants and a few things that I bring.

I found out why I am not to work past Sunday morning. Some half a dozen people are coming for lunch who have something to do with the law case and Juan. Juan probably doesn't want me around to overhear some rich gossip, and I'm only too pleased to miss such an affair. That is really a tough afternoon to deal with satisfying so many appetites. Frank Taplin and his wife are two. That's all I know.

Miss O'Keeffe got word from Jackie Suazo today that it was reported in yesterday's paper that she won her suit concerning three paintings once stolen in 1946 that a man was trying to sell to a dealer friend of hers. When she found out, she sued for possession, and after several years of appeals, they are finally hers with one judge against her and two in her favor.

I read Nanao Sakaki's poem to her this morning after breakfast when she seemed rested and relatively receptive. She only asked if there was such a plant as an oyster plant. "Yes there is. It is sometimes called salsify."

A couple of weeks ago when I was working here, she told me of the first time she remembers reading anything. She spotted a pink piece of paper on a brush pile that told of a fight between Corbett and Fitzsimmons.

Stieglitz liked to read the sports page, she said. This was something none of his friends would guess.

She showed me the poster for the Santa Fe Chamber Music Festival and told me it was a trumpet flower, but not like the ones they have here, more like the ones in Central America.

She said that a red barn she recently painted came to her in a dream. She said it was the only painting that she had dreamed first.

I remember her comment about why so many Chicano families are buying trailers. She said it is easy for them to have indoor plumbing then. Everything is right there.

It's 7:30. I was in the anteroom and didn't hear her call. She came to the door of the bathroom to shout my name. When I rushed into the bedroom, it was to rearrange some covers, and nothing suited her. Finally, I got a shouted, "For Christ's sake, get out of here!" I stood in the doorway, silent. Then back here, sitting close to her door now, watching more rain over the red mesa. When she is in one of these poisonous moods, it does little good to say anything back unless it is incredibly witty.

I remember weeks back, we went into the bookroom to replace Mayer's *Materials of the Artist*, among other things, and we stumbled upon the unbound portfolio of the *Ching Ming Chang Ho*, a series of reproductions of a thirty foot or more Chinese scrolls introduced in the Metropolitan Museum of Art publication by her old friend Alan Priest. She told me that he was promised a lifetime position by the university, but he was so impossible, so contentious, so difficult, that they decided to let him go, which started a lawsuit. I don't believe she said whether he won or not.

When she was looking at the *Ching Ming*, she spread it out on the bed where I sleep and with her magnifying glass in her hand looked at plate after plate. Her main observation was that

it was remarkable that an artist could maintain that style for so long. She was curious where the outhouses were for so many people along the river and road. She listened as I read about each plate and found the things described in the writing. She seemed interested in the shape of the bridges, the size of some cartwheels, bigger than people, and the shapes of sails, as I remember.

There was a shy woman painter at the gate who wanted lessons from O'Keeffe. She had been painting for a year and did therapy on the west coast. In a rare generous mood, Miss O'Keeffe gave the young woman five minutes, time to look at one painting and quickly say whose painting it looked like then found out she was camping by the Abiquiu dam and painting the area. Miss O'Keeffe said she would show her a new world and began showing leaves of the *Ching Ming*. The young woman was in awe, like in the presence of someone sacred, barely raising her voice, but began contradicting some of Miss O'Keeffe's mistaken observations, whereupon Miss O'Keeffe said, "Where's your coat? Your painting is very good. Good bye." At the gate, the young woman asked me if she could paint the view from the driveway. I replied only if she wanted to be yelled at. When she asked if Miss O'Keeffe would teach her to paint, I told her she would have to live around Abiquiu awhile. "But she may die soon," the woman said. And I happily locked the gate and left her standing to return to the world of the *Ching Ming*. Some of Miss O'Keeffe's archness is catching, I guess.

Today Miss O'Keeffe asked if I saw anything of my "husband," a man I was engaged to for several months.

"No, none at all."

She said, "Good. Got that over fast with few entanglements."

Truth is, I would go home full of things to write about a weekend here in Abiquiu, impressions, notes, quotes, and he would distract me instead of help me rest to write for a few hours. Once he wrote a hot check for the rent and had to borrow money. Other times, it was various anxieties, he somehow made me out the neglectful person to "waste another weekend

in Abiquiu" when we could have had some time together. Better to be alone without him than in constant confusion.

I would like to re-read what I didn't write about a quiet lunch of Miss O'Keeffe, Mr. and Mrs. Eliot Porter, Dorothy Parsons, Juan and me. Maybe I can just write the high points. Perhaps there are notes tucked into a book somewhere that I can get back to someday.

I remember Eliot Porter eating very slowly, saying, "Food so delicious ought to be savored." Also he shared that he had never been so alone as when he went off from the crowd photographing on a tour of Antarctica. It was utterly quiet. He was wondering what else there was to photograph and seemed interested in my suggestion to photograph from space.

July 30, 1979

Saturday Miss O'Keeffe told me of riding into the Taos mountains with an Indian guide, then when the group got into the high country, they sent the guide back. They became lost, and Miss O'Keeffe said she has no sense of direction. Alan Priest was with them and led them to the Taos Pueblo through brush and whatever. She said that they reached the pueblo at sunset.

Two weeks ago Miss O'Keeffe described another experience of getting lost on the Texas prairie. She and Claudia would go out walking by the Palo Duro Canyon, but if you would leave the depression of the rutted road, there were only acres and acres of grassland with no landmark, nothing to guide you. She said a couple of times she was pretty well frightened by that experience. But you keep walking, try to retrace your steps, but the soil and grasses don't hold your footprints. She said eventually you come upon a road, and you're not lost anymore. When I asked if she could follow the lights from town, she laughed and said that's when she really noticed the evening star, and that's when she painted it. It was a reassurance to see that light. It would shine even before the sun went down.

(One Sunday in July after working all weekend in Abiquiu, I met Miss O'Keeffe at the studio door where she stood in the light from the sunset with her red chow Jingo. She said, "Let's get this over with." I said, "See you next time." She said, "Good bye." That's the last time I saw Miss O'Keeffe. She never called again.)

[Afterword]

That final day in July 1979 was the end of my seven years of weekends working for Miss O'Keeffe. I waited for her call for months, but the phone was silent. I never knew why. I could guess. It was a source of grief for years not to be invited back into the serenity and beauty of her life at Abiquiu and Ghost Ranch.

In retrospect I see that it was perfect timing because I was beginning to behave like her, dress like her, gesture like her. I was losing myself, and I really needed to get on with my life and be thoroughly myself. Once at a meal, one of her guests asked what I would do with my life, and I said I would complete my masters degree and go to teach in China. I spoke quickly, without thinking first, and much to my surprise, that is exactly what I did.

During the seven years of weekends, I learned many important skills for living that I did not appreciate at the time. Now, I may be walking with a friend or teaching children when I find myself saying very often, "Miss O'Keeffe said . . ." And then I recount some story or some insight she shared with me about her life.

The worst part of having worked with Miss O'Keeffe is that it makes the mundane realities of life, such as walking into a giant warehouse store full of ugly merchandise very, very painful after having been in the presence of perfect, absolute beauty in that land around her houses in northern New Mexico. Each

house was consciously designed and often every painting, rock, antler, leaf, shell, feather, flower, bone, skull, driftwood, vase, sculpture, or other treasures around the rooms were carefully placed for maximum effect.

At times, after Miss O'Keeffe's death, I found myself revisiting my journals, devotedly transcribing the passages about moments of spacious serenity when I was alone on weekends with Miss O'Keeffe. The work on this book has been a sanctuary from the vicissitudes that life brings. I hope that it will be useful for the reader.

Corrales, New Mexico
October 2009

[Index]

[Credits]

CR 73
Abstraction, 1916 (cast 1979/1980)
 7/10
Georgia O'Keeffe
White-lacquered bronze
10 x 10 x 1½ (25.4 x 25.4 x 3.8)
Georgia O'Keeffe Museum
Gift of The Burnett Foundation
 (1997.06.07)
© Georgia O'Keeffe Museum

CR 1123
Abstraction, 1946 (cast 1979/1980)
 1/10
Georgia O'Keeffe
White lacquered bronze
10 x 10 x 1½ (25.4 x 25.4 x 3.8)
Georgia O'Keeffe Museum
Gift of The Georgia O'Keeffe
 Foundation (2006.05.192)
© Georgia O'Keeffe Museum

CR 1135
Abstraction, 1946 (cast 1979/1980)
Georgia O'Keeffe
White lacquered bronze
36 x 36 x 4½ (91.4 x 91.4 x 11.4)
Georgia O'Keeffe Museum
Gift of The Georgia O'Keeffe
 Foundation (2006.05.198)
© Georgia O'Keeffe Museum

CR 1263
My Last Door, 1952/1954
Georgia O'Keeffe
Oil on canvas
48 x 84 (121.9 x 213.4)
Georgia O'Keeffe Museum
Gift of The Burnett Foundation
 (1997.06.029)
© Georgia O'Keeffe Museum

CR 1440
Blue Black and Grey, 1960
Georgia O'Keeffe
Oil on canvas
40 x 30 (101.6 x 76.2)
Georgia O'Keeffe Museum
Gift of The Burnett Foundation
 (2007.01.029)
© Georgia O'Keeffe Museum

CR 1460
Sky Above the Flat White Cloud II,
 1960/1964
Georgia O'Keeffe
Oil on canvas
30 x 40 (76.2 x 101.6)
Georgia O'Keeffe Museum
Gift of The Georgia O'Keeffe
 Foundation (2006.05.364)
© Georgia O'Keeffe Museum

CR 1623
Untitled (From a Day with Juan),
 1976/1977
Georgia O'Keeffe
Pastel on paper
25 x 19 (63.5 x 48.26)
Georgia O'Keeffe Museum
Gift of The Georgia O'Keeffe
 Foundation (2006.05.481)
© Georgia O'Keeffe Museum

CR 1631
Untitled (From a Day with Juan),
 1976/1977
Georgia O'Keeffe
Oil on canvas
48 x 72¼ (121.92 x 183.51)
Georgia O'Keeffe Museum
Gift of The Georgia O'Keeffe
 Foundation (2006.05.485)
© Georgia O'Keeffe Museum

CR 1665
Abstraction Dark Green Lines with
 Red and Pink, 1970s
Georgia O'Keeffe
Watercolor on paper
29⁷/₈ x 21⁷/₈ (75.88 x 55.56)
Georgia O'Keeffe Museum
Gift of The Georgia O'Keeffe
 Foundation (2006.05.519)
© Georgia O'Keeffe Museum